THE GREAT
ALONE

Walking the Pacific Crest Trail

TIM VOORS

gestalten

For Cato, Antonia, Tom,
and Herminia

Table of Contents

Gear List 6

The Trail in
Numbers 10

Prologue 14

Campo to Kennedy
Meadows 18

The Pacific Crest Trail 20

Campo 24

Water in the Desert 32

A Trail Name 42

Alone with Myself 43

Homesick 46

Joining the Group 50

Surviving on a Snickers 57

Shots in the Desert Night 62

The Plumber Cowboy 63

The Rat Pack 64

Hiker Heaven &
Hippie Day Care 65

L. A. Aqueduct 70

And Now for Something
Completely Different: Why Do
the Mountains Call? 71

Tehachapi Resupply 75

Wildfires 78

Kennedy Meadows 90

Mount Whitney to
South Lake Tahoe 98

Walking in a State
of Shock 100

The Infamous
Forester Pass 101

Rehab in Bishop 110

Back in the Saddle 114

Yosemite 122

Quitting 133

The Mental Game 141

Ultra-light or Ultra-cool 142

Hike Naked Day 143

And Now for Something
Completely Different: What Does
It Cost to Hike the PCT? 146

Survival Skills 150

Hitch Your Own Hike 151

South Lake Tahoe
to Canada 156

Do I Believe in God? 158

What If I Die
Tomorrow? 163

Narrow Escape 167

Wings 168

Walking in Silence 173

Time Alone Is Good for
Your Relationship 180

Painting for Malala 183

Future Dreams 186

And Now for Something
Completely Different: Where Do
You Leave Your Trash? 190

Girl Power 193

Angels 198

Autumn and Winter
at Once 199

American Hospitality 202

Inspiring Lives 208

The Impatient Man 212

Canada 217

Five Measurable
Goals 219

Family 226

Last but Not Least:
Let's Talk About *You* 227

A Word of Thanks 232

Sources 234

About the Author 238

Imprint 240

Gear List

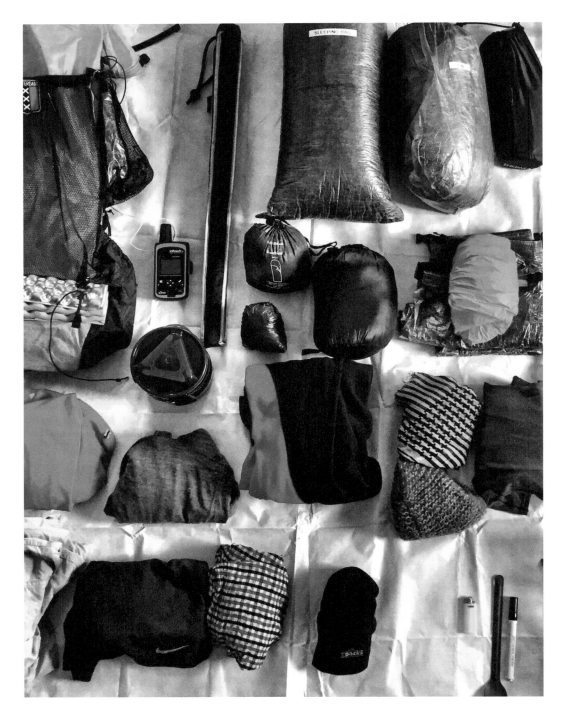

Below is a list of the gear I carried. When relevant, I've listed the approximate weight of each item.

Grand total
23 lb. 10 oz. (10.73 kg)

Big Three

1. Shelter (tent)
Zpacks Duplex Camo
1 lb. 11 oz. (790 g)
2. Backpack
Zpacks Arc Haul—62L
1 lb. 7 oz. (680 g)
3. Sleeping system
Sleeping bag: Zpacks 20 °F
1 lb. 5 oz. (603 g)
Sleeping mat: Therm-a-Rest
NeoAir XLite Regular
12 oz. (363 g)
Sleeping silk travel sheet
4 oz. (134 g)

Kitchen

Camping stove
Jetboil MiniMo
14.6 oz. (415 g)
Food sack
Zpacks Food Bag
0.8 oz. (24 g)
Spoon
Long Titanium Spoon
by Sea to Summit
0.4 oz. (12 g)

Small knife
Victorinox Swiss
Army Knife
0.8 oz. (22 g)
Seat
Therm-a-Rest
Z Seat Pad
2.1 oz. (60 g)
Pack liner
Zpacks Pack Liner
1.9 oz. (54 g)

Clothes (Daily-Use)

Shoes × 6
La Sportiva
Wildcat 3.0
13 oz. (372 g)
Socks × 2
Darn Tough
VermontMerino
Wool Socks
2.3 oz. (67 g)
Gaiters
Dirty Girl Gaiters
1.1 oz. (31 g)
Underwear
Hema
3 oz. (85 g)

Socks × 2
Injinji Men's Trail
Midweight Mini-Crew
Toe Socks
0.7 oz. (22 g)
Sun hat
Columbia
Schooner Bank
Cachalot III Sun Hat
2.2 oz. (62 g)
Fingerless gloves
Columbia Coolhead
Fingerless Gloves
0.6 oz. (17 g)
Sunglasses
Julbo
MonteBianco
Cameleon
1.1 oz. (32 g)
Shirt (long sleeve)
Columbia Silver
Ridge Plaid Long
Sleeve Shirt
7.6 oz. (216 g)
Pants
Columbia Silver
Ridge Convertible
Pants
11.2 oz. (319 g)
Trekking poles
Leki Thermolite
XL Poles
1 lb. (470 g)

Extra Clothes

Down jacket
Patagonia Ultralight
Down Hoody
11 oz. (313 g)
Rain jacket
Zpacks Challenger
Rain Jacket
5.8 oz. (165 g)
Rain pants
Zpacks Challenger
Rain Pants
3.8 oz. (108 g)
Wind breaker
Zpacks Ventum
Wind Shell
Jacket
1.9 oz. (54 g)
Rain mitts
Zpacks Challenger
Rain Mitts
1.0 oz. (28 g)
Gloves, soft
Possumdown
Plain Gloves
1.0 oz. (42 g)
Gloves, hard
Brandless
1.2 oz. (35 g)
Beanie
Zpacks Fleece Hat
1.0 oz. (27 g)
Warm hat
Barts
1.8 oz. (52 g)
Stuff sacks
Zpacks Stuff Sack
Medium and Large
0.6 oz. (17 g)

T-shirt, merino
6.6 oz. (188 g)
T-shirt, synthetic
4.7 oz. (133 g)
Sleeping long johns
6.5 oz. (184 g)
**Sleeping
long-sleeve T-shirt**
8.1 oz. (229 g)
Base layer, fleece
13 oz. (370 g)
Running shorts
Nike
4.3 oz. (122 g)
Waterproof socks
Sealskinz
4 oz. (113 g)
Eye mask for sleeping
0.8 oz. (23 g)
Ski mask
1.1 oz. (32 g)
Wool sleeping socks
2.7 oz. (76 g)
Camp shoes
Fake Crocs
8.2 oz. (232 g)

Sierra Extras

Crampons
Kahtoola
MICROspikes
12.8 oz. (364 g)
Ice axe
Camp Corsa
Nanotech
Ice Axe
7.2 oz. (205 g)
Bear canister
BearVault BV500
2 lb. 9 oz. (1162 g)

First Aid, Toiletries, & Misc.

**Lighter and
waterproof
matches**
0.8 oz. (24 g)
Bug head-net
Sea to Summit
Head Net
1.3 oz. (37 g)
Pens
Marker and
fine-tip pen
Wallet
Homemade
Tyvek wallet
Passport
Permits and visas
PCT & Fire permits
Canadian & U.S. visas

Blister aid
Strapping tape
Giardia antibiotic
Infection antibiotic
Ibuprofen
Toothpaste
Toothbrush
Safety pins
Needle and thread
Superglue
DEET insect repellent
Rehydration tablets
Poison ivy/
oak wash
Zanfel
Hand sanitizer
Toilet paper
Compact
Towel
Lightload
Pack Towel
Sunblock SPF 50
Trash bags
Shit shovel
Deuce of Spades
0.6 oz. (17 g)
Protein powder
ION powder
Vitamin C

Water System

Water bladders × 2
2-Liter Platypus
Collapsible Bottles
2.5 oz. (72 g)
Water tablets
Aquamira Water
Treatment Tablets
0.7 oz. (20 g)
Water bottles × 2
Smartwater
1 Liter
**UV water
purifier**
SteriPEN Ultra
4.9 oz. (140 g)

Electronics

Battery pack
Anker PowerCore
20100
12.5 oz. (355 g)
Phone
iPhone 6
4.6 oz. (130 g)
Phone case
LifeProof
Satellite tracker
Garmin inReach Explorer
12.8 oz. (363 g)
**Wall charger &
cables**
iPhone USB &
wall charger
3.7 oz. (105 g)

Navigation & Survival Pack

Umbrella
Euroschirm
Swing Liteflex
7.3 oz. (207 g)
Compass
Suunto Clipper
0.2 oz. (5 g)
Headlamp
Black Diamond USB
3.3 oz. (95 g)
Fishing kits
4 hooks, line, rudder

The Trail
in Numbers

157 DAYS
25 ZEROS

120 BEERS
1,000 LITERS OF WATER

100 HAMBURGERS
& PIZZAS

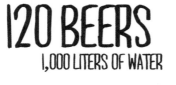

50 SNAKES
ONE FOR DINNER

5 COYOTES
& 100 DEER

10 GUNS
ONE TIME SHOT AT

10 JOINTS
5 WITH A RESULT

2 BEARS
LUCKILY AT A DISTANCE

6 PAIRS OF SHOES
4 PAIRS OF SOCKS

250 PACKS OF NOODLES
100 MISO SOUPS

6 MILLION STEPS
19 LB. (9 KG) WEIGHT LOST

21 RESUPPLY BOXES
2 OF WHICH NEVER ARRIVED

9,500 DOLLARS
8,400 EUROS

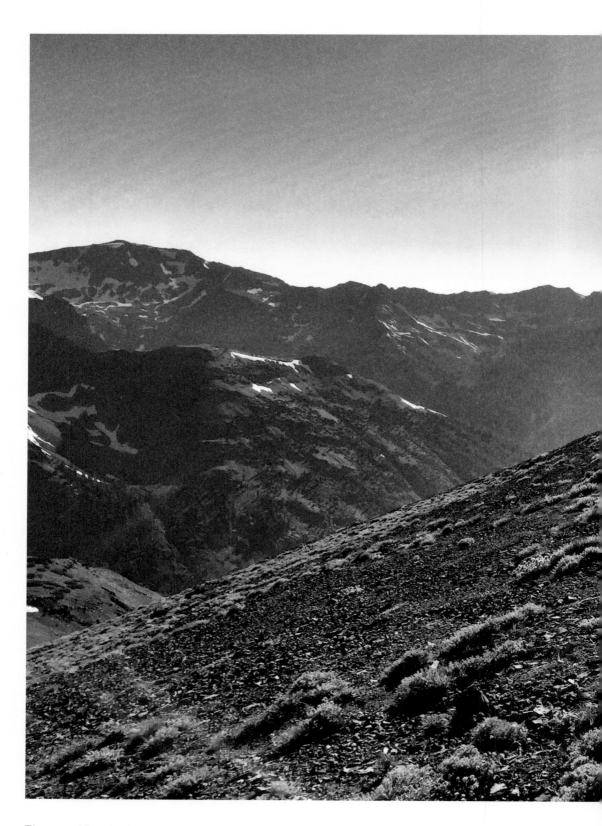

The trail winds over Sonora Pass, Northern California.

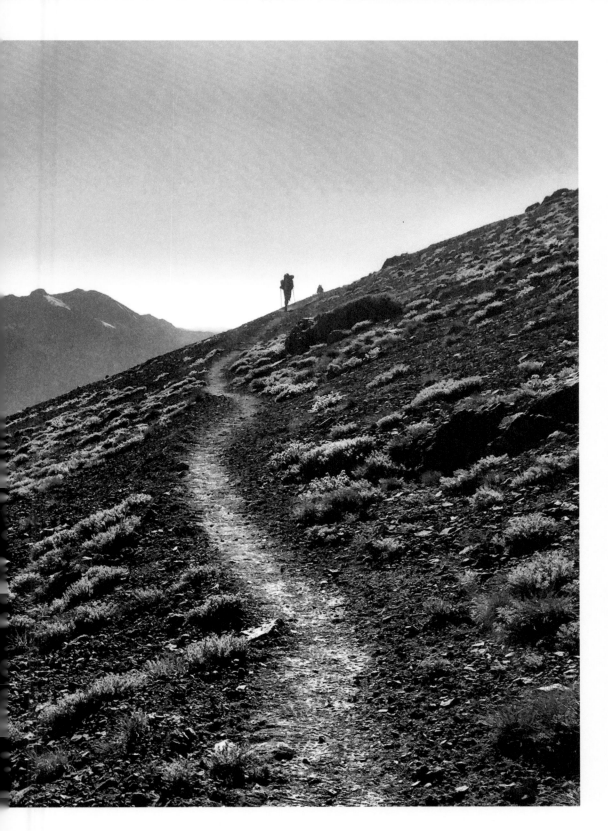

Prologue

Fear

Tears rolled down my face as lightning lit up the sky, like a strobe light blazing across the night. A black wall of clouds rolled toward me, pushed forward by the fierce wind. Snowflakes blew into my eyes.

The combination of the lightning and the approaching snowstorm was the last thing I wanted. I had finally reached the summit of Mount Whitney, at 14,505 feet (4,421 meters), California's highest peak. I was totally exhausted after a six-hour climb at this high altitude. The weather had been pretty calm the whole day, but now that I was on the peak, I could see the thunderstorm coming up from the other side of the mountain. Lightning! Every few seconds a bright bolt shot across the sky, lighting up the thick cauliflower clouds that loomed above. To make matters worse, darkness was closing in; there was no time left to get to safety in the valley below.

On the mountain, there was no real safe haven beyond the 100-year-old emergency shelter with a rickety metal roof. Why hadn't I heard the thunder on the way up? I suddenly regretted my cavalier plan to see the sunset and sunrise from the summit. From where I stood at the edge of the cliff, I could feel the strong wind blow the storm nearer. The roaring thunder marched closer. Tears stained my cheeks. How could I have been so stupid? I rushed to the stone shelter. Still thoroughly gripped by fear, I crept deep into my sleeping bag and rolled into a small ball on the ground. Bang! the thunder roared above. I had no idea how far away it was. Would this be my last night ever? With its old corrugated metal roof, the shelter didn't seem like it could offer sufficient protection. It felt more like an open invitation for lightning to strike.

From within my sleeping bag, I was glad to suddenly hear other voices outside. I wasn't alone anymore, thank God. But with every thunderbolt, the group cheered, louder and louder, laughing and making videos of the storm.

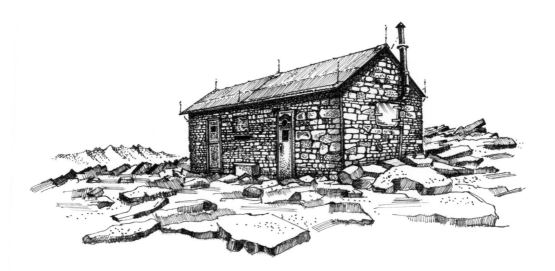

I crawled even deeper into my sleeping bag, feeling small and vulnerable amidst nature's wrath.

Then, after an enormously loud blast of thunder, the youngsters darted inside. They realized we were in a pretty serious situation. They now seemed just as scared as I was.

From where I stood at the edge of the cliff, I could feel the strong wind blow the storm nearer. The roaring thunder marched closer. Tears stained my cheeks. How could I have been so stupid?

At 43, I was clearly the oldest of the bunch. The others were somewhere between 20 and 25. Everyone settled down and began to eat, silently staring as we wondered what was going to happen next. The guy next to me turned on his headlamp, illuminating the rocky surfaces and revealing the names scratched into the walls around us: many others had been stranded here in the past. Most of the faces were new to me. I would be spending the night with these seven other hikers in this tiny shack, no bigger than 12 feet by 12 feet (13 square meters). There were so many bodies crammed into the small space that it wasn't going to be easy for all eight of us to sleep. After extensive experimentation, we managed to fit everyone in, alternating sideways as we lay in the shelter. But it was still too tight, so one of the young hikers volunteered to sleep upright on the bench in the corner. The darkness was lit only by the lightning, flashing in intervals through the small window.

"Who knows a joke?" a voice spoke quietly. One by one, we began to share jokes and stories with each other, keeping our spirits high and the reality of the storm at bay. Someone told an unfathomably long joke with a pretty bad punch line, but it distracted my mind from fear for a while. The wind continued to howl and rage, but we shared intimate stories and future dreams. It wasn't easy to hear everything clearly,

"Safely down the mountain, safely down the mountain," repeated in my mind like a mantra.

but the sound of voices gave me a lot of comfort. Perhaps, a false sense of security. Snowflakes whirled in from a wide crack under the door, and I felt my sleeping bag slowly turn damp. I sat up and wrapped my raincoat around my feet, hoping to stay dry.

I was startled awake in the middle of the night. The door crashed open with a loud thump, and two of the hikers clambered into the hut, shouting like crazy, carrying a cloud of snow with them. They'd gone outside to pee, but had suddenly found themselves surrounded by an enormous ball of blue light and had dived back into the hut for cover. No one could make out exactly what the light had been. Perhaps it was static energy created by the storm? Perhaps a kind of lightning? Someone suggested it may be St. Elmo's fire, a kind of electric discharge that hangs in the air. It didn't matter; they were terrified. I also needed to go to the toilet, but didn't dare venture outside while the storm was raging. There was no other option but to pee in my drinking bottle. When everyone had settled down,

I quietly tried to relieve myself as discreetly as possible. It's hard enough to take a leak in a urinal with someone standing next to you! Afterwards I slid the warm flask into my sleeping bag, hoping it would heat up my sleeping bag a little.

There was another burst of lightning. I couldn't get the thought out of my mind: an image of eight charred bodies, melted in shriveled sleeping bags.

I woke to find that it was totally quiet outside. I got up and forced open the heavy door with both hands, seeing before me a thick layer of snow in the morning light. It was as if the mountains were covered in powdered sugar, glistening and sparkling under the morning sun. It looked like Christmas. But it was high summer. I went back to the cabin: I had to get off the mountain as soon as possible. The weather could turn at any moment.

We decided to descend together as a group, helping each other during the steeper, sketchier sections. The group wasn't well prepared for these unexpected circumstances, and

only four of us had microspikes with us. As I was the only one with an ice axe, I was sent out front, where I tried to hack a new path in the icy snow. The pace was slow as we carefully followed the contours of the switchbacks down the mountain. There was an excitement in making virgin tracks, but the snow was so deep at points that we frequently lost our way and had to backtrack.

I woke to find that it was totally quiet outside. I got up and forced open the heavy door with both hands, seeing before me a thick layer of snow in the morning light. It looked like Christmas.

Some parts of the trail were particularly challenging. We had to hack new steps into the steep slope. One short section, just 60 feet (18 meters) long, took us more than an hour to cross. To the left of the trail, the mountain dropped off into nothing. We watched every step. But still, I was glad to be descending, longing to crawl into the comfort of my tent in the valley below, to eat something after the long night. "Safely down the mountain, safely down the mountain," repeated in my mind like a mantra.

We bumped into a park ranger just as it began to snow once more. I felt immensely relieved to see him, in safe hands at last. The feeling didn't last long. After a short chat, he abruptly wrote out a fine: apparently, it was forbidden to camp on top of Mount Whitney.

The group dispersed. I arrived back in the valley hours later and utterly exhausted. My tent had practically collapsed under the weight of the snow. Still, I clambered into its narrow shelter, feeling some relief. And there, safe but still hungry, I fell straight to sleep.

Campo to Kennedy Meadows

Mile 0 – 702

"The physical journey was hot, dry, and arduous. I quickly learned not to romanticize the wilderness."

The Pacific Crest Trail

Mile 0 - 2,650

Why did I walk the length of America for six months? You could also ask: why not? That is a question that would make more sense to me. Why do I spend more than 40 hours a week behind a computer screen? Why do I spend so little time in nature? Why do I never take time to be alone?

As a child I once read an article about the Pacific Crest Trail (PCT) in *National Geographic;* it was the story of two men who walked 2,650 miles (4,265 kilometers) from Mexico to Canada with huge packs. I was mesmerized, and it captured my imagination, as I, too, dreamed of adventures in the wilderness. I've always remembered that story, but never believed I would actually embark on such a lengthy trail. It was too far out of my comfort zone.

But then, at the age of 42, I hiked the 88 Temples Trail, an 815-mile (1,311-kilometer) Buddhist pilgrimage through Japan. There, for the first time, I experienced how addictive it could be to hike alone. I was in nature for weeks on end. The Japanese mountains, exquisite temples, and generous hospitality overwhelmed me. And to my surprise, I managed to complete the trail in six weeks without any notable injuries. For the first time, it dawned on me that I could venture out on my American dream one day. It might actually be feasible. In time, I felt ready for the pinnacle of all trails.

When I shared my plans with friends and colleagues, the news was welcomed with mixed reactions. From some I got enthusiastic support, but from others there were frowns and question marks. Half a year away from your family was pretty extreme, and of course, in some ways, it was. Yet it didn't feel like an eternity to me. After all, what are six months in a lifetime? After having worked hard for 20 years in shiny office buildings, I felt the need for more adventure in my life. City life gives me lots of energy, with endless external stimuli and the comfort of family and friends. In nature, I hoped to slow down and look within, as well as confront the uncertainty of discovering what lay beyond the unfamiliar horizon. If the city was inhalation, time in nature was exhalation. I realized that I needed them both to flourish. As John Muir once put it, "Keep close to Nature's heart … and break clear away, once in a while, and climb a mountain or spend a week in the woods. Wash your spirit clean."

Why do I spend more than 40 hours a week behind a computer screen? Why do I spend so little time in nature? Why do I never take time to be alone?

I could have waited until my retirement of course, but I'm impatient and I wanted it now. I found the idea of spending time alone immensely appealing, but still I felt terribly anxious about the effect it could have on me. I had little experience with walking in solitude. I had never lived alone, having spent my whole life in the company of others. I always went on vacations with family or friends. Just an ordinary, self-employed 40-something who'd been married for 20 years—a father of three who mowed the lawn every Sunday. I was definitely no thrill-seeker. But time had flown, and it felt like so much of my life had gone by in the blink of an eye.

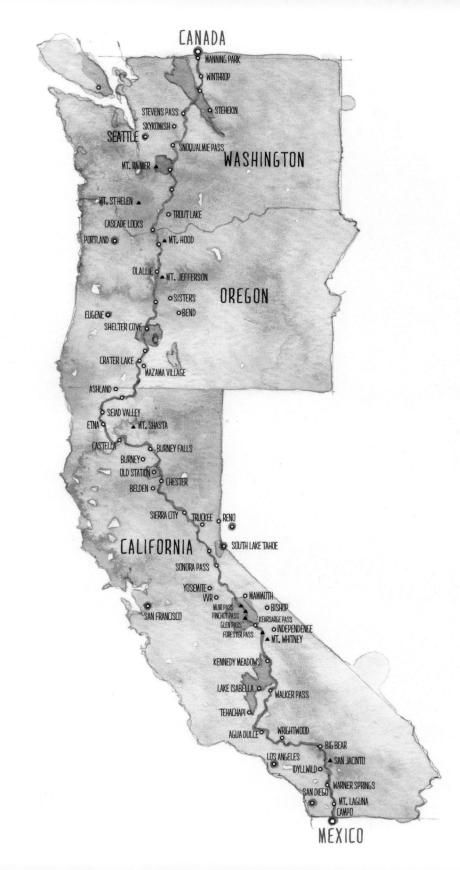

CANADA

MANNING PARK

WINTHROP

STEHEKIN

STEVENS PASS

SKYKOMISH

SEATTLE

SNOQUALMIE PASS

WASHINGTON

MT. RAINIER

MT. ST HELEN

TROUT LAKE

CASCADE LOCKS

PORTLAND

MT. HOOD

OLALLIE

MT. JEFFERSON

OREGON

SISTERS

BEND

EUGENE

SHELTER COVE

CRATER LAKE

MAZAMA VILLAGE

ASHLAND

SEIAD VALLEY

ETNA

MT. SHASTA

CASTELLA

BURNEY FALLS

BURNEY

OLD STATION

CHESTER

BELDEN

SIERRA CITY

TRUCKEE

RENO

SOUTH LAKE TAHOE

CALIFORNIA

SONORA PASS

YOSEMITE

VVR

MAMMOTH

MUIR PASS

BISHOP

PINCHOT PASS

KEARSARGE PASS

GLEN PASS

INDEPENDENCE

SAN FRANCISCO

FORESTER PASS

MT. WHITNEY

KENNEDY MEADOWS

LAKE ISABELLA

WALKER PASS

TEHACHAPI

AGUA DULCE

WRIGHTWOOD

BIG BEAR

LOS ANGELES

SAN JACINTO

IDYLLWILD

WARNER SPRINGS

SAN DIEGO

MT. LAGUNA

CAMPO

MEXICO

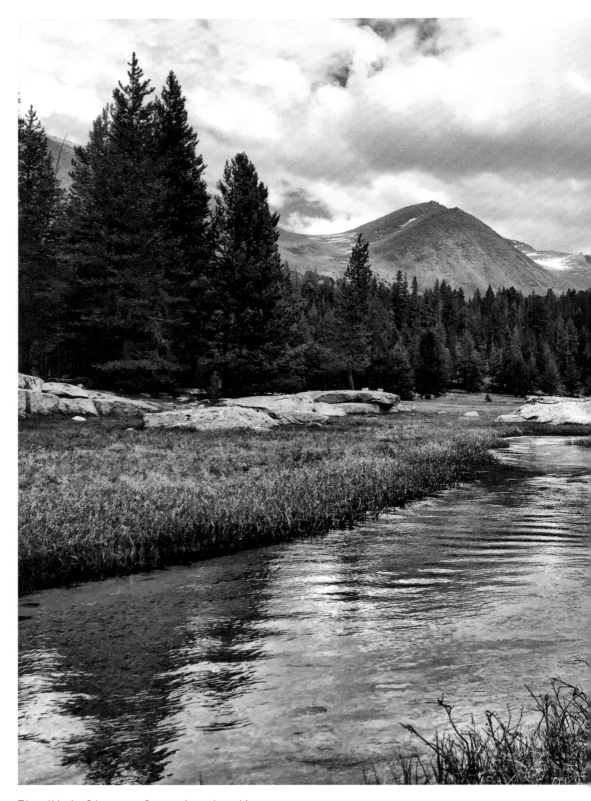

The High Sierras loom in the distance
as I ford yet another river.

I didn't have some preconception that the trail would totally change me, but I hoped I could take something from the journey to move forward with. There wasn't one reason or some big problem I had to solve out there. Rather, there were multiple questions I was working on as I walked, thinking and reflecting. The reason I gave myself before I left was that I needed diversity. Diversity in the palate of my life, next to the long hours, months, and years of work and the routine. I needed something to counterbalance city life. But mostly, I needed to challenge myself again. To learn a new craft. Overcome my fears. A long walk in the wilderness from Mexico to Canada seemed scary. But it was also exciting, challenging, and something completely different.

I wanted to experience what it meant to be totally self-reliant, to carry everything I needed on my back as I walked through the vast wilderness. Free to sleep under the stars, meet new people, walk alone with my thoughts. I wanted the freedom to create my own path. Just the thought of temporarily distancing myself from the constant pressure in Amsterdam—to do whatever I wanted in my own rhythm—was thrilling. But the excitement was not all positive. Fear rolled beneath it: there'd be lots of obstacles and dangers on the trail. Realities like rattlesnakes, mountain lions, and mother bears. Raging rivers or wildfires. There would be blistering heat in the desert and freezing snowstorms in the high mountains.

The most difficult part of my journey would be not seeing my family for such a long time. My wife had recently been on a long hike through Spain to Santiago de Compostela for four weeks. I was lucky; since she herself was a hiker, too, she understood. She said it was healthy to go out into the world by yourself from time to time. Our children, too, accepted my somewhat outrageous proposal. So, with all the lights turned green, my journey could begin.

Campo

Mile 0

"This is it," I whispered in the early morning darkness. I was about to set foot in the desert, a dry, barren landscape totally foreign to me. Adrenaline rushed through my body. It had taken more than a year of preparation to get here.

The sun still hung beneath the horizon, so I switched on my headlamp to check all my gear one last time. I couldn't risk leaving anything behind, as there were no stores where I was going. I wasn't particularly hungry, but thought it would be wise to eat as many calories as I could before the long day ahead of me. There would only be water after 20 miles (32 kilometers). I packed seven extra liters to carry with me, on top of all my food and gear. It was going to be a tough, hot day. I took a bite of oatmeal. I needed every bit of help I could get and was grateful for the warm breakfast.

It was still dark when Jack arrived to pick me up in San Diego to drive me to the Mexican border. Jack was a former school teacher who spent his retirement helping hikers get to the trailhead in Campo. He had hiked the trail

himself 35 years ago, when it was all very different. "My backpack weighed about 44 pounds (18 kilograms)," he said, keeping his eyes to the road. "These days everyone hikes with that ultralight gear. I don't understand all the rush y'all have these days. We found 15 miles (24 kilometers) a day just fine, while you guys now do more than 25 (40 kilometers)." I listened intently, curious that the trail had interested Jack for so many decades. Would I be just as captivated and involved with the trail in 35 years' time? Jack seemed the epitome of a Trail Angel, and cared deeply about the hiking community and the Pacific Crest Trail as a whole.

"Take your time," he said. "It's once in a lifetime, son. The trail's never let me go, even after all these years."

As we drove, the industrial outskirts of San Diego slid by. I could clearly feel the pressure mount as we climbed steadily from sea level to 3,000 feet (914 meters), into the arid, rocky hills towards Campo. White pickup trucks with green border-control stickers occasionally passed as we grew ever closer to the Mexican border. A Homeland Security helicopter circled above us, a scene more from a movie than my everyday life. It was strange to think how important this border was to so many different people. Some saw it as a bridge to a better future, while for others, it was a barrier of protection. Borders have always divided people and possibilities, but seeing a tall metal wall in front of my eyes was something different. It was hard to fathom, compared to my tiny home country, the Netherlands, with its borders open to all neighboring lands.

"End of the line buddy." Jack parked the truck next to the border wall. I pulled my backpack out of the cargo bed and thanked him for the ride. "Remember: don't rush!" he yelled as he drove off into the dawn. I waved and walked to the high wall, placing my hand on the metal barrier that separates the United States from Mexico.

It felt cold. "Get home safe," I whispered to myself. "Get home safe." The Southern Terminus monument marks the official starting point of the Pacific Crest Trail. With engraved capital letters, the entire length of the trail was spelled out across it: MEXICO TO CANADA 2,650 MILES.

After a year of planning, reading, research, saving, and training, I was here. But a small voice whispered: I had no idea what I was getting myself into.

It was time to get going. I took a selfie in front of the monument, heaved my heavy backpack on, turned my nose northward, and started walking. The trail that stretched ahead of me, no more than a foot (30 centimeters) wide, would lead me through California, Oregon, and Washington. After a year of planning, reading, research, saving, and training, I was here. But a small voice whispered: I had no idea what I was getting myself into. The only thing I hoped for was to reach Canada in one piece.

All my senses were completely alert during those first few miles. My eyes spun in every direction, searching for snakes hidden in the undergrowth. I soon noticed that the desert I was walking through was nothing like I had expected. There were no vast sand plains with undulating dunes like the African Sahara. I was walking through rugged mountains, overgrown with seasoned brush and razor-sharp cactuses. It looked a lot like a Western set. Tiny cactus flowers appeared as I walked: from bright pink to lime green, orange, and lemon yellow. The shapes and color combinations were completely alien to me, but I couldn't get enough. With every flower I came across, I stopped to take a picture. At this rate, I was never going to make it to Canada.

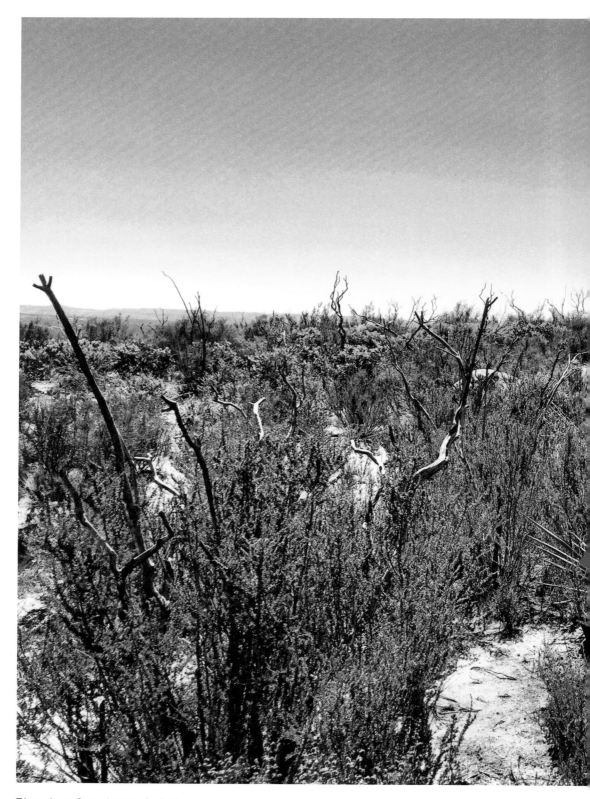

The dry Southern California desert
near Campo is brimming with life.

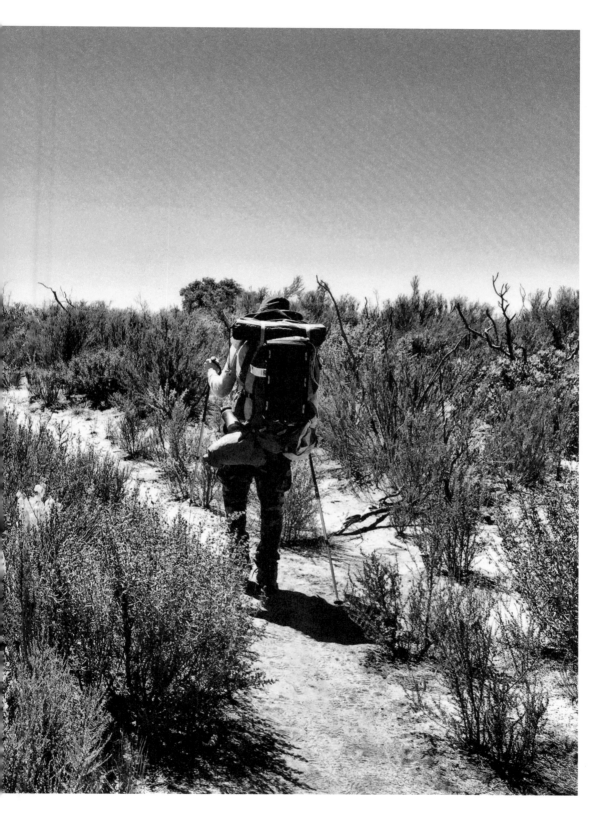

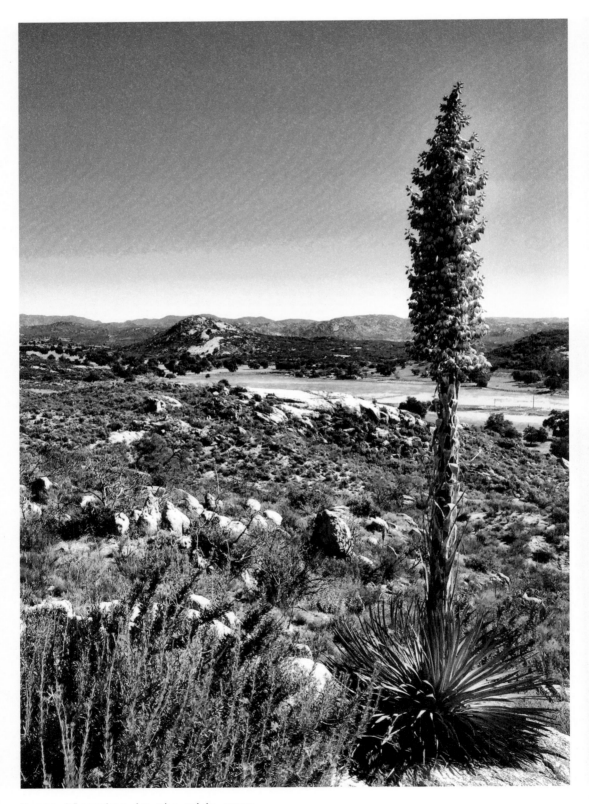

Yucca blooming in the wide-open
planes before Warner Springs.

But I wanted to take it easy and enjoyed every flower I saw. There was life in the desert. Diving birds, busy ants, lazy lizards, and the continuous song of the crickets. Like a child on his first day at school, I was dazed by its newness. But my joy soon turned to disappointment as I saw the one-mile marker. It felt like I had been walking for hours. Psychologically, these miles were going to take some getting used to. They felt a lot longer than the kilometers back home.

Despite the beautiful surroundings, I still constantly looked over my shoulder, anxious about any unexpected sound in the shrubbery. Gradually I would need to find a rhythm, walking alone through the open country. My attention shifted between my back and my legs as they, too, adjusted to the new circumstances. There was little to no shelter from the hot sun, so I quickly opened my silver umbrella. When I'd first gotten it, I thought it was crazy, but thanks to the shade it provided, my body temperature began to drop. Before leaving, I had jerry-rigged a system with Velcro tape to fasten the umbrella to my backpack, leaving my hands free for my trekking poles. These also served as my tent poles. Two birds, one stone: it saved me 12 ounces (340 grams) of weight, which I was quite pleased about. But now that was on the trail, I realized I had no idea how to use the poles properly. They felt weird in my hands, and I was self-conscious even though no one could see me. I would need to learn how best to use them, especially to support my knees during steep descents.

In no time, my shirt was completely soaked through. My mouth craved for a drink, and my seven liters of water were drying up fast. I began to worry whether I could reach the next water source before dark. My map showed a small lake within nine miles (14.5 kilometers), but my pace was pretty slow, and it was already getting late. When I finally saw Lake Morena in the distance, my last bottle of water was almost empty.

Water! With renewed energy, I trudged down the mountain and filled my empty bottles from the cool lake.

At the airport, my 13-year-old daughter had given me some advice. She had asked me to always carry one extra liter of water wherever I went, so that I would never be without. I'd been touched by her words, but, above all, by her practical advice and insight. She could capture the essence of the risks I might face and was able to make a clear distinction between the essential and trivial issues. Already on day one, I had needed her guidance. I thought back on her words often, swelling with gratitude whenever I arrived at a river with a full bottle. Better safe than sorry, she always said. Once I had filled my bottles at the lake, I jumped in with all my clothes on to wash away the sweat and dust of the day.

> At the airport, my 13-year-old daughter had given me some advice. She had asked me to always carry one extra liter of water wherever I went, so that I would never be without.

When I climbed back up the bank, dripping from head to toe, I noticed an enormous family campground on the opposite shore. This was not the wilderness I had thought it was.

I set up my tent on a distant patch of grass, as far away as possible from the barbecues and dogs. My stomach growled. I boiled some water on the flimsy gas burner and poured it into my freeze-dried spaghetti Bolognese. Spaghetti had never tasted so good. With pain in my feet, I treated myself to a dessert of two ibuprofen before crawling, exhausted, into my sleeping bag.

Pffff, what a day! What an endless, empty land. I hadn't seen a single soul until the lake.

It had been a strange experience to walk totally alone, so insignificant in this indifferent landscape. But then there had been the campsite: some semblance of civilization.

The trail meandered through rocky hills and deserted valleys. I couldn't believe that only a week ago, I was back in Amsterdam with my family.

It was a freezing night, and the cold woke me up several times. A thin sheet of ice coated my tent the following morning. I got up early, quickly packed my stuff, and left the campground in a thick layer of clothes. But within two hours the cold night seemed a distant dream. Sweat began to trickle down my face. What was this? I couldn't comprehend the extreme shifts in temperature. By noon the heat was so intense that I could feel its potential danger. Only two years earlier, a 19-year-old boy died from heat stroke on exactly this same section of the trail.

On the second day, everything felt even heavier than the first. My backpack base weight was around 22 pounds (10 kilograms), but the additional food and water made it feel like I was carrying a bag of cement. The rhythm of my steps slowly battered my feet, and soon I could feel the blisters growing bigger. I was used to wearing high, leather boots in the mountains, but for the PCT I had chosen low trail runners that were light and dried out easily. But with the lack of support, my ankles had to get used to the uneven terrain. I knew I would be lost without my feet, so I did everything I could to take care of them. To prevent too many blisters, I wore two pairs of socks: merino and toe socks. I changed them twice a day and dried my feet in the warm sun. I hung the sweaty, used pairs on the back of my backpack

to dry, clipped with an old safety pin. And gradually, I entered a steady flow and began to feel more and more at ease in this new environment. The trail meandered through rocky hills and deserted valleys. I couldn't believe that only a week ago, I was back in Amsterdam with my family.

After a couple of hours on the trail I froze in my tracks. It lay curled up in the middle of the trail, the Queen of the Desert, an enormous rattlesnake. It was sunbathing peacefully, soaking up the heat. But in my terror, I instinctively jumped backwards. What a beast! What a beauty! But how to continue? Walking around her was not an option, as the mountain fell steeply on either side of the trail. Jumping over her didn't seem like the smartest thing to do either. And the snake made no indication of moving any time soon. This was going to be a waiting game, but after some time I lost my patience and kicked some dust in her direction. To my surprise, she suddenly started moving. She didn't like dust in her eyes. Who could blame her? I tried it again. Ever so graciously, she slid slowly into the bushes. But still I didn't feel safe. After all, she could come back and kill me with a single blow. Though it probably wouldn't be that dramatic, I still waited

It lay curled up in the middle of the trail, the Queen of the Desert, an enormous rattlesnake. It was sunbathing peacefully, soaking up the heat. What a beast! What a beauty!

a few minutes until I couldn't see her anymore. Then, I took a huge leap and ran as fast as I could. My heart throbbed in my throat as I came to a halt. For the rest of the day I was as alert as I had ever been, my eyes scanning for movement in the distance ahead.

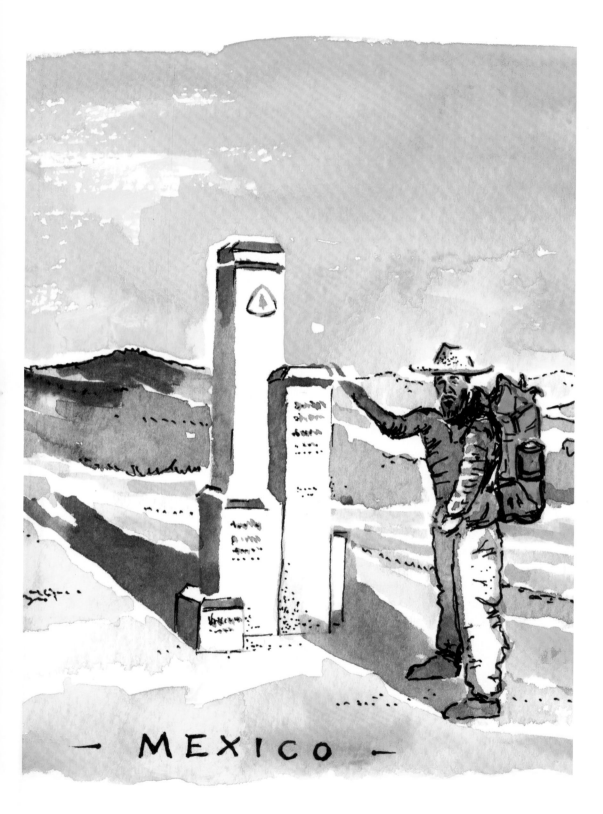

- MEXICO -

It soon became clear that I had totally underestimated the trail. The mountain tracks were steeper, the sun hotter, the snakes bigger, and the distances between water sources longer than I had imagined. The weight on my back, with all that extra water, was also a lot tougher to handle. It dawned on me what the word "wilderness" actually meant: not romantic and beautiful, but desolate, painful, scary, dry, and dangerous. I thought I had trained pretty well back home, but the flat Dutch landscape could not have prepared me for these mountainous trails. Even the difference in altitude was a battle. I was short of breath and had headaches every night. Living at 10 feet (3 meters) below sea level is clearly very different to walking at 3,000 feet (914 meters).

Water in the Desert

Mile 47

The hard desert ground was covered in a fine layer of ocher dust. Cracks in the dirt spread in all directions, laying bare the effects of the drought that had held this land hostage for so many years. The dry wind had stripped every living thing of its dignity, scrub amidst sand. This was no place for people; it baffled me as to how the desert rats, lizards, and birds managed to survive here year-round.

There was very little water to be found, and I often had to walk a few extra miles off the trail to find a spring. But I had other means for bringing the trail to life: the Guthook app, an interactive map of the PCT. Through the digital world of the app, I nearly always managed to

find hidden water sources. I checked it again and again each day to see where I was, tracking my way back if I got lost. I came to value it like a treasure, this small thing that contained trail notes, camping spots, roads, towns, and—above all—water sources. Other hikers left comments to indicate the quality and quantity of water, and with their time-stamps, I could judge whether a spring might have dried up or not. People also left warnings: a dangerous river in the mountains, for one, and how to get across.

The dry wind had stripped every living thing of its dignity. It baffled me as to how the desert rats, lizards, and birds managed to survive here year-round.

I also occasionally checked the Water Report, a crowdsourced compilation of information for the Pacific Crest Trail, indicating the most recent water levels. I pieced together information between their reports and the comments on Guthook, and combined they gave me enough information to head into the dry desert with some peace of mind. Water is the most important thing under the bright sun, and these small details eased the journey. I had maps on my phone, but I also carried some hardly used paper maps and a small compass. After a few weeks, I threw them away to save weight. I carried a large 20,000 milliamp-hour power bank, which was also pretty heavy, but it could recharge my phone 12 times, as well as my headlamp, MP3 player, water filter, and GPS device.

The water I came across in the desert wasn't always great, often stagnant and green. I didn't have much choice: it was often the only water for miles around. If a creek I stumbled upon had totally dried up, I would have

to continue on until I reached the next water source. On one scorching day, I arrived at a water trough only to discover it completely empty. I had two choices: backtrack or walk on. I could go back seven miles (11 kilometers) to a place where I had last filled up my bottles or continue five miles (8 kilometers) to the next creek, which could have dried up. I sat in the dust for a moment, considering my options. I was exhausted and only had half a liter left. This was no time to make the wrong decision. Determined, I took a chance and continued on. I was in no mood to backtrack. Two hours later I arrived at a spring, burbling with a slow trickle from the ground.

Giardia is a contagious, waterborne parasite that can make you extremely ill. It is found in stagnant water or where animal corpses are floating in the water upstream. Purification and filtration became essential, a kind of ritual before drinking. I didn't want to spend a week recovering in a hostel. So with a small filtration system, I sterilized each bottle, destroying bacteria or viruses with ultraviolet light. I only had to recharge the device once a week, although it wasn't the lightest option at six ounces and about the size of a Snickers. At first it felt crazy to put my life in the hands of technology, but it proved to be pretty efficient. While the water filtered, I simply waited, while other hikers used the Sawyer Squeeze to manually squeeze the water through a filter into their clean bottles. Other options were chlorine dioxide drops, or simply chlorine, which apparently kills everything. It felt a bit crazy to be putting toilet chlorine in your drinking water every day. But it was cheap and fast, and there were enough youngsters who were just fine with this option. Still, when I came across a spring straight out of the mountainside, it felt like a luxury.

One of the fears I wanted to confront during this journey was of sleeping alone in the wilderness. I had done a lot of camping in my life, but only once was I totally by myself. As an experiment during my student years, I went to a remote Dutch island and set up my tent for a weekend. But it was a disaster, as it rained continuously, and I felt overcome with boredom and the lack of entertainment. But I wanted to give it another try out here, far away from another living soul. Anxiety mingled with anticipation. I wanted to see how I would cope. Would I panic at the first ambiguous sound, pack up halfway through the night, and hike on in search of the next tent along the trail?

The moment had arrived: the comforts of society were far away as I set my camp alone in the middle of nowhere. I couldn't postpone it any longer. I hadn't seen a soul all day, so I wasn't expecting anyone to join me. I'd found a suitable flat spot just off the trail in a narrow gorge. After throwing some rocks into the bushes to scare away any hiding snakes, I set my tent up and whistled loudly to warn off any predators nearby. But glancing down into the valley below me, I realized what a stunning place this was, high on a mountain ridge, completely isolated. There were no city lights in the far distance. It was a full moon that night, without a cloud in the sky. The moonlight was so bright I could have read a newspaper at midnight.

Would I panic at the first ambiguous sound, pack up halfway through the night, and hike on in search of the next tent along the trail?

The shadows of the rocks formed magical figures in the sand. I began to feel that this deserted mountain top could be my home for the night.

I swiftly prepared some food and crept into my tent to eat it. It somehow felt safer inside,

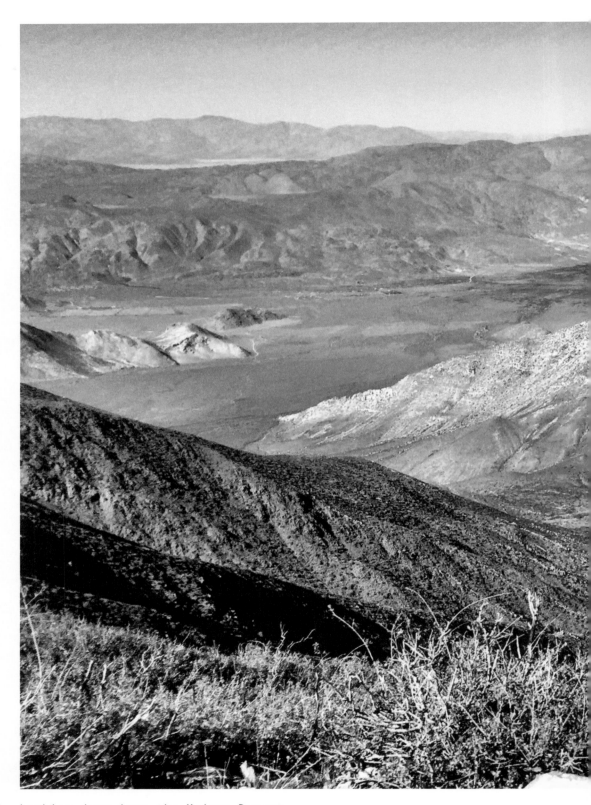

Looking down into the Mojave Desert.
Los Angeles sits beyond the horizon.

The trail winds through the high desert.

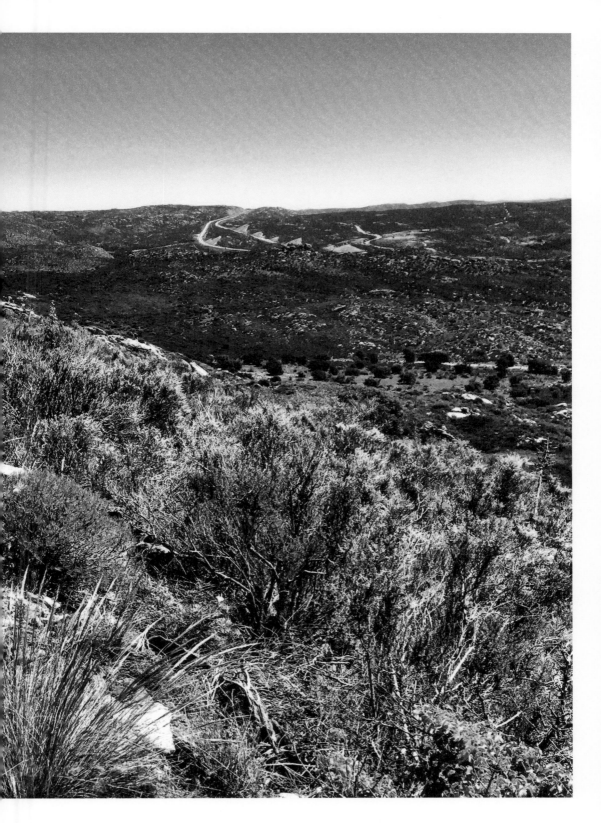

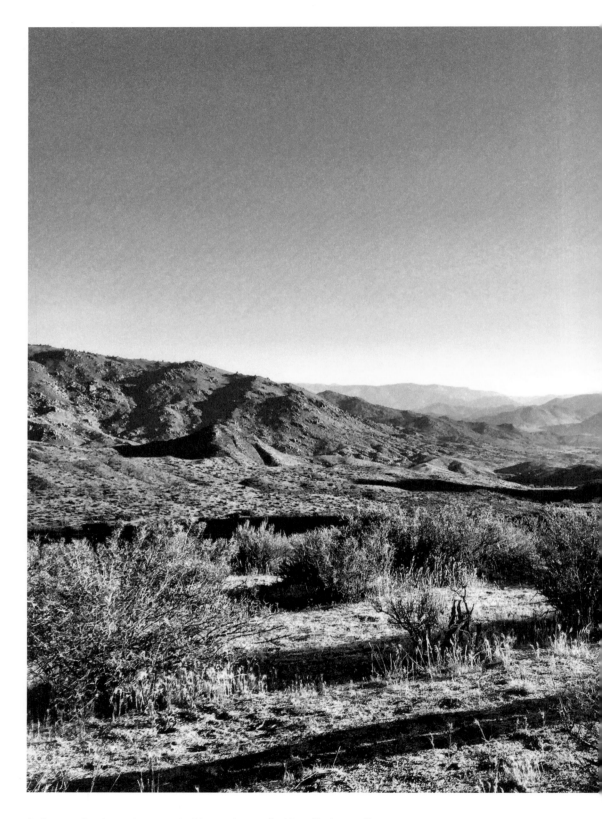

A lone Joshua tree at the edge of the Mojave Desert.

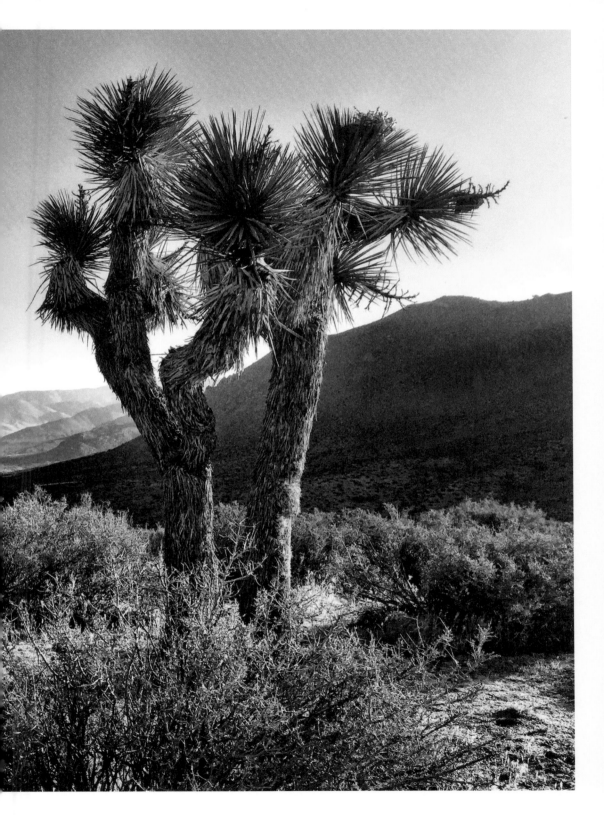

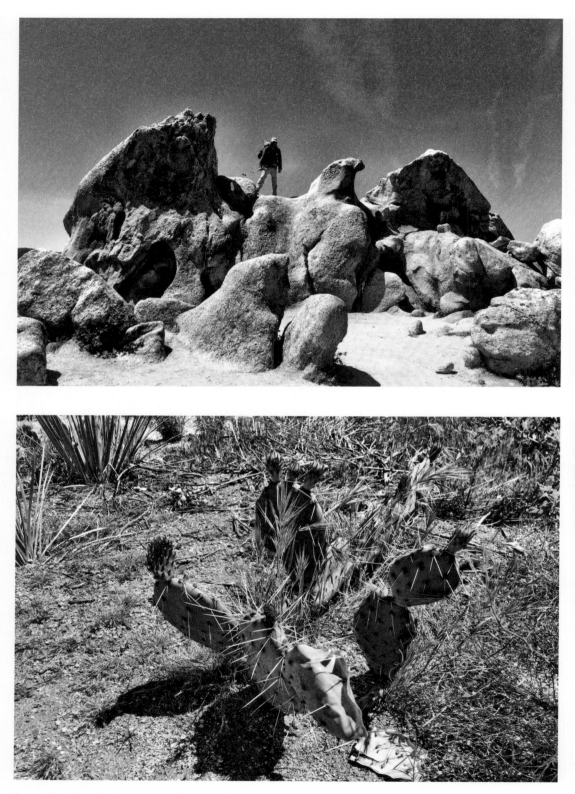

Top: Eagle Rock, near Warner Springs. Bottom: Opuntia "prickly pear"
cacti are widespread throughout Southern California.

even though the fabric was thinner than paper. I lay motionless in my sleeping bag for a while, acutely listening out for any sounds. In time, the animal nightlife awoke, and it seemed as if there was a party going on in the night. Are snakes actually nocturnal? I occasionally stuck my head outside, but nothing moved. I took an ibuprofen—which I'd come to think of as "vitamin-I"—to ease my restless legs. I was almost asleep when I shot upright, startled by a rustling sound beneath my head. I unzipped my tent and shone my headlamp

I lost so much salt that after days without a shower I could practically stand my shirt upright, stiff with crystals.

under the groundsheet. There, to my surprise, I saw thousands of termites frantically evacuating their larvae in long, coordinated columns. I had unknowingly put my tent up right on top of their underground colony. Some were actually quite large, so I quickly decided to move my tent. The only other flattish spot around, however, was the trail itself, so I took a chance and hoped that no early bird hiker would fall over me in the morning. And of course, as Murphy's Law would have it, I was woken before dawn by someone who tripped on my guylines. I heard a growling voice curse something incomprehensible in French as the hiker disappeared into the blue light of morning.

The following nights I continued to sleep alone, and slowly but surely my self-confidence grew. In the daytime the air grew hotter and hotter, and I sweated like a pig. I was fascinated by how much salt I lost each day, how after days without a shower I could practically stand my shirt upright, totally stiff with crystals. Because of sweat and constant friction, the skin between my thighs and backside were rubbed raw. It felt as

if I was poised atop a cheese grater, chafing with every step. I tried some anti-chafing powder, but the stinging sensation didn't subside. I was on fire. The inner seams in my boxer shorts added to the friction and discomfort, so I chucked them into the campfire. I never wore another pair of underpants during the remaining months of the trail.

After one and a half weeks on the trail, I entered the Mojave Desert, and the heat climbed even higher. The Mojave is one of the driest and hottest areas in the United States, with temperatures soaring to intolerable heights. I found no shade in this dusty, yellow landscape—just a few lonesome Joshua trees. To protect myself from the relentless sun, I wore long sleeves and a cap with a flap to cover my neck. At times it was nearly unbearable, and I knew I needed to make some drastic changes. That evening, upon stumbling across a small piece of a broken mirror in the bushes, I decided to cut my hair off. All of it. I cut it as short as I could with my tiny Swiss Army scissors, hoping for relief in the following days. I hadn't seen a cloud all week, but now found myself approaching what appeared to be a perfect, dark ellipse in the sky. It offered the first real shade of the journey, as the cloud blocked the heat of the sun. What a difference that made! Nature was finally giving back, instead of breaking me down. But it didn't stop there: it suddenly started to rain, very gently at first, but then increasingly larger drops fell from the sky. I shouted, threw down my pack, and started running in circles to celebrate. While I ran with my arms stretched out, I raised my head, opened my mouth, and stuck out my tongue in the hope of catching as many drops of water as I could. But within a few minutes, the party was over, and the rain stopped. The earth around me dried up again.

I've read that it rains so rarely in the Mojave that seeds in the ground can stay dormant for several years. In the days after the rain came, thousands of tiny buds and flowers

began to emerge. Spring was in the air. Where once I had seen only dry soil, a carpet of small white and pink flowers surrounded me. I felt delighted—and incredibly lucky—to be witnessing this rare sight.

A Trail Name

Mile 179

My body was struggling as it adapted to the long days and new lifestyle without the comforts of society. I missed soft, clean sheets at night, the instant warmth of a long shower, and the feel-good entertainment of watching a series on the sofa, warm under a blanket. Healthy, green food was also something that I really began to crave. I was burning calories at an alarming rate and I became increasingly hungry. No matter how much I ate throughout the day, it never seemed to be enough. I knew the trail would soon cross a road that led to the legendary Paradise Café, only a mile out of the way. A comment in my app claimed it served the "Best Burger in the World." It had been hyped up so much by the hikers I had met that the small wooden cabin was like a shrine to me. For days I fantasized about what I was going to order: a double hamburger with cheese, pickles, and ketchup, and hopefully they also had mayonnaise with the fries. Just the thought of a big vanilla milkshake made my mouth drool. After days in the wilderness, the moment finally came. I woke up extra early and couldn't wait to have that burger in my hands. My pace was faster than normal, and after a while, I nearly started running. I almost tripped a few times as the trail became a little uneven and was strewn with protruding rocks,

but that was of no concern to me now. When I finally stepped into Paradise Café at ten past nine, it was with a sigh of relief. I put my dusty backpack against the bar.

"Welcome to Paradise. What will it be? Oh, and packs outside, please, thank you."

Before me stood a voluptuous woman, totally covered in old-school tattoos. She had probably been the prettiest girl in her class back in the day. "A burger, please." I had been practicing the sentence for days.

"Sorry honey, kitchen opens at 11:00. Want some breakfast?" she said with a typical waitress smile, as if nothing was wrong. But of course, everything was wrong. No burger? I looked wide-eyed in disbelief. It couldn't be true. Would I have to wait another two hours for my beloved burger? I thought this was the US of A, with its 24-hour economy! I hadn't eaten a decent meal for days and heard my stomach churn. For the time being, I would have to settle for the "Best Breakfast in the World."

Somewhat disillusioned, I put my backpack out on the porch and returned to take a seat on a wooden bench next to the window. I opened the café's guestbook, which also doubled as the trail register. Trail registers acted like an analog trail Facebook, listing all the names of hikers who had passed through before me. I read countless comments about how great the burger had been: "Divine—worth every step." "Three Michelin Stars." "Never seen such a big burger." "I'm going to open a franchise in London." But no burgers for breakfast! Couldn't someone have warned me? I felt petulant: life is so unfair. This didn't feel like a first-world problem to me at that moment. Someone needed to fix it. I turned to an empty page and started painting. Before leaving, my sister had given me two small blocks of watercolor paint in indigo blue and cadmium yellow. Back home, I never made enough time to paint regularly, so I was now thoroughly enjoying the

opportunity to render my small impressions of the landscape each day. The paint was still drying when a young, long-haired guy wearing a pair of ski goggles joined me at the table. Reflected in his glasses, I saw that I looked just as haggard as he did.

"Hi. I'm Savage. What's your name?" he uttered from behind his mirrored glasses. He looked a bit like a crazy heavy-metal fan, but his voice was friendly, and I immediately took a liking to the guy.

"Tim, from Amsterdam."

"No dude, I meant your trail name!" He slammed his hands on the wooden table, almost spilling my Coke. I didn't have a trail name yet. You don't give yourself a name. It's always given to you by someone else. Perhaps this was the moment, so I leaned forward and asked Savage if he would give me a name, right then and there. He slowly took off his glasses, looked at me from head to toe, turned the trail register towards himself and then declared: "Tim van Gogh. No wait, Van Go!" he shouted through the tiny café.

And that was that. I accepted my new name immediately. We raised our Cokes to make it official.

Silently, I repeated my new name to myself. I had become Van Go.

Alone with Myself

Mile 184

The trail led deeper and deeper into the wilderness, and as far as I could see, there wasn't a soul in sight. The winding track was the only trace that anyone had ever been here before me. My life had become extremely simple. I knew exactly what I had to do: walk, eat, sleep, not go insane, and follow the trail north.

In the beginning it took quite some getting used to being alone. Solitude was something

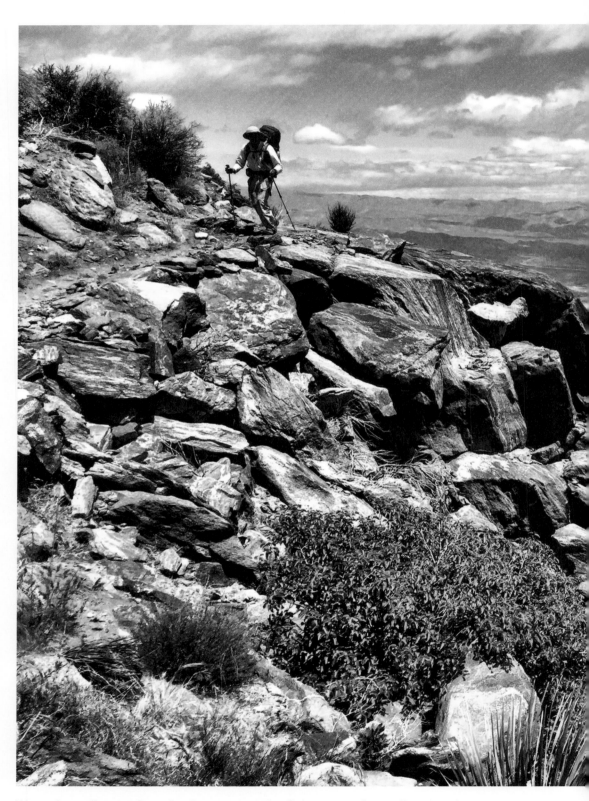

View from Mount San Jacinto towards Cabazon, where I stayed
the night with Trail Angels Ziggy and the Bear.

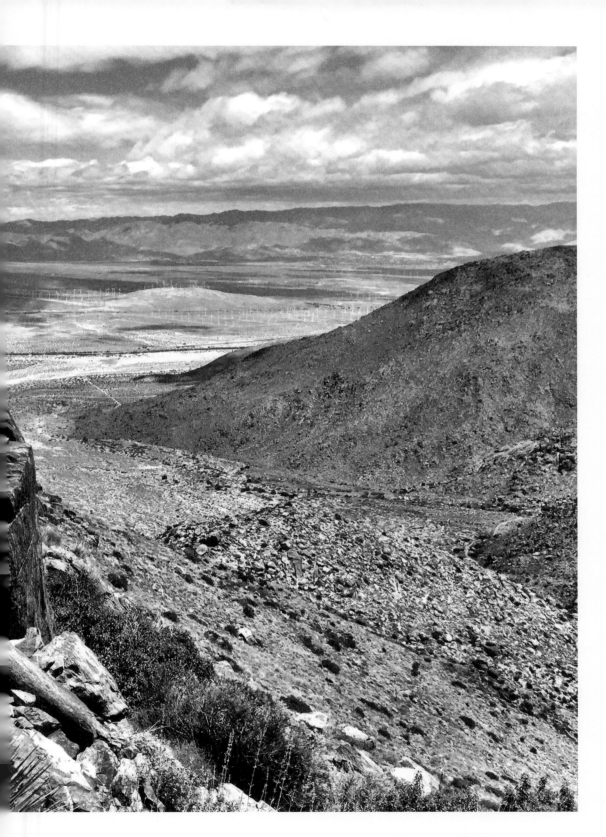

I didn't have much experience with. Being totally alone turned out to be a lot harder than I had anticipated. Walking through the California desert, I felt isolated and vulnerable, in a landscape that looked like another planet. I worried I'd become lonely or restless without human contact. Perhaps I would become bored with only my thoughts for entertainment. Or would I finally find myself? I didn't even know what that really meant. I was used to the constant stimuli of internet, Netflix, friends, and family around me. But as I walked, I discovered that I didn't feel lonely at all, that I wasn't bored, and that there were more than enough daily adventures to keep me entertained.

I'd been comfortably numb perhaps. Now alone, I felt I had woken up. On the trail, I was empowered and autonomous. I was completely isolated in my own bubble, in my own reality, and as long as I didn't go mad, I thought my new state of mind was pretty good. In fact, I was really enjoying it.

I was constantly talking to myself, not aloud, but in my mind. I asked myself what the best decisions would be: how much water to carry and what to do if I got lost, but also conscientious questions about whether or not I'd gone too far by leaving my family for so long. Occasionally, I confronted and scolded myself when I had made a wrong decision. In this way, several people walked along with me, each voice with its own desire: motivated by ego, by reason, or simply pure fear. It turned out that I wasn't that alone after all.

For the first time in my life I began to understand what was meant by "standing on your own two feet." Reasons to complain about anything evaporated. After all, there was no one to listen to my moaning. It dawned on me that it is mostly in groups that we complain, where we share responsibilities and have unspoken expectations of one another. At home, there was the bickering about the right route on family vacations or the quality of the food during a shared weekend trip with friends. Now that I was completely alone, it made no sense to complain. I moved through the days pleasantly, at my own pace.

But in moments of danger—during thunderstorms or sketchy mountain passes—I instinctively tried to find people. I did not want to face these obstacles alone. It was as if my pace automatically slowed in light of an unexpected challenge and even brought me to a standstill, sometimes waiting for hours until someone came along. I knew that together, we are always stronger than we are alone, even if I was only waiting for a 18-year-old stranger who had even less experience in the mountains than I.

Coming from densely populated Europe, where practically every part of nature is cultivated and regulated, these wide, raw, open lands felt like the wilderness I had dreamed of. A land of the free, with no rules, no one around for days, and the possibility to set up your tent practically anywhere you wanted. Everywhere I walked, I could turn 360 degrees and not see a single man-made structure. Only the lonesome, ocher trail stretched out in front of me.

Homesick

Mile 218

My thoughts often drifted to my three children, at school on the other side of the world. I tried to imagine what they would be doing at each moment: with their noses buried in books or chatting with their friends. We were living in completely different worlds, and I sometimes

felt so far away. God, I would have given the world to be able to hold them in my arms for a moment. If I had just stayed home, I could have seen them every day. Wouldn't it have been better to postpone my trip for another decade, until they'd left home? What effect would my lengthy absence have on my young teenagers? In my worst moments, I thought that my being away for so long might cause anxiety, attention disorders, or a chronic sense of abandonment in my children. The wildest scenarios flew through my mind as I considered all of the possible outcomes. A coin could fall just one of two ways, with either a negative or a positive effect. I hoped for and trusted in the latter.

God, I would have given the world to be able to hold my children in my arms for a moment. If I had just stayed home, I could have seen them every day.

I joked to my wife, Herminia, that as soon as our oldest daughter derailed and started doing crack cocaine, I would come home immediately. My oldest daughter always protested: "Why does it always have to be me? My sister can also get into trouble you know!" But as long as everyone remained happy and healthy on both sides of the ocean, I felt I could walk on with peace of mind.

When I asked my 11-year-old son what he thought of my plan to be away from home for so long, he replied, "How do I know? I'll only know when you're actually gone." But he really didn't get why I wanted to go on such a long walk. "What's the point? You're not achieving or earning anything with it, are you?" The tables had turned. He was parenting me, showing me the priorities in life. My 14-year-old daughter reacted similarly to my wife, pragmatically and straightforward. "I wouldn't dream of doing something like that myself. But it's your life, and if it makes you happy, go for it." It was my 13-year-old who was somewhat more subdued on the matter. She was less outspoken and kept her thoughts to herself. It was difficult to gauge what she really thought of it all and how she would react to me being away for six months.

Children, just like adults, are creatures of habit. Mine had slowly become accustomed to the fact that both my wife and I were occasionally gone for a while. It had started five years earlier when Herminia walked to Santiago de Compostela for a month by herself. After 10 years of raising young children, it was a great opportunity for her to do something totally alone. But half a year from home would be something else. In the run-up to my trek on the PCT, I talked about it with my children quite frequently, hoping they would gradually get used to the idea.

Here in the sprawling California desert, there was little to no internet, but as soon as I reached a high mountain pass, I always checked to see if there was any coverage, a connection to a town in the distance. If this was the case, the messages from home poured in. I would huddle out of the wind on the mountain crest as I tried to FaceTime my family. With the time difference I often called before dawn and joined my family for dinner as they ended their days. Via the screen of a laptop, I would sit between their plates of spaghetti and I could see the faces of my children. Everyone would shout across the table at once; nothing had changed in my absence. They asked if they could walk with me for a bit to give them an impression of the landscape. They asked about what I ate, if I'd seen any more snakes, and whether I'd gotten totally sick of all that walking yet. The mood was always cheerful and upbeat, but soon, everyone would leave the

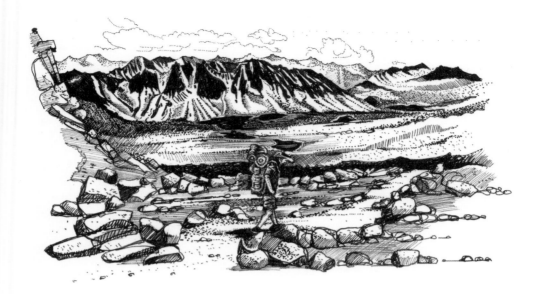

table to go about their lives, do homework, and to call *more important* people about the latest dramas at school. Who knows? Perhaps my journey might inspire them to explore the world themselves one day. Hopefully they won't postpone it until retirement.

During the first few weeks on the trail, I often asked myself whether hiking alone was too egotistical. Some friends felt that my timing was off, and others thought it was selfish. A few people responded very fiercely with disapproval. Surprisingly, it was mainly the strong personalities who accused me of being selfish and egotistical. It wasn't always easy to hear, and it gave me food for thought as I walked. Apart from the fact that there was certainly some truth in their reactions, I was particularly taken aback by the tone of their disapproval. I wondered if my adventure might be some kind of threat to them. Attack is sometimes the best form of defense. So alpha! They reacted as if I'd suddenly put a third goalpost in the field halfway through the match. Hold on! That's not what we had agreed upon in life. Stick to the game plan. Don't create your own rules.

But once I hit the trail, it was extremely touching to receive several personal messages of support from those who had been so fierce and critical beforehand. Perhaps the stories I shared each week on my blog had offered a different perspective. Life moves in mysterious ways.

Who knows? Perhaps my journey might inspire them to explore the world themselves one day. Hopefully they won't postpone it until retirement.

I'm lucky with my wife, Herminia. Yes, she is a saint, and yes, a trip like this was selfish in some ways, but some selfishness within our relationship allowed us both to rediscover and grow. But still, she had to look after the family, run our bed-and-breakfast, and solve all the unforeseen obstacles that life throws at us alone. And I believe that, just once in a while, it is also good to take some distance and create space for myself. How else can I face my fears? The trail

was a way to experience independence and build confidence outside the company of others.

"What does your wife think about you going away for so long?" Both before and after the trail, I was frequently asked this totally logical question. But from the very start, she was my biggest supporter. Though she enjoyed hiking, she didn't have any desire to join me in the remote wilderness, going days without a shower; she preferred to enjoy the journey vicariously. During the year before my departure, we often watched documentaries about the trail together. In the end, she told me, "It's your life. If it makes you happy, go for it. We'll be just fine."

"Didn't you miss each other terribly?" others asked. It may sound harsh or weird, but I didn't. After all, there'd been no loss, divorce, or death, and we both knew that we'd see each other again in a few months' time. By taking time to be alone, the time I could spend with her and our children became even more valuable. I got a clearer sense of what was important to me.

It was special to know, both consciously and subconsciously, that I had her support. No matter how alone I was on the other side of the world, I knew she was always there.

Joining the Group

Mile 306

I was walking through the woods in Morongo Valley, just days after scaling Mount San Jacinto, when I came across a small creek to refill my water. In the ferns on the banks lay four guys taking what appeared to be a post-lunch nap. Around them lay the wreckage of everything they owned, scattered as though a bomb had exploded. Wet socks and shirts hung on branches; it had clearly been time to do the laundry. One guy was awake and stood up to introduce himself as Pogue Mahone, "kiss my ass" in Gaelic, I later found out. He was a striking, big figure, with a gigantic red beard as wide as it was long, and a melodious Southern accent from Tennessee. Pogue was a tough-looking, hard-working forester, but his relaxed attitude and charisma made it seem as though "The Dude" from *The Big Lebowski* had been based on him. He wore a faded green bandana over his long hair, and I noticed that he was one of the very few who had high leather mountain boots, probably to protect his weak ankles. He'd previously hiked the Appalachian Trail, 2,200 miles (3,540 kilometers) along the East Coast of the States. He seemed to have a permanent smile under his long, bushy mustache and was clearly at home out here in the wilderness.

He lit up a small hash pipe and passed it to me as a token of friendship.

"I'm good thanks. I'm heading on," I replied. This wasn't the moment to explain that the Dutch guy didn't smoke weed. After having filtered a few liters, I put on my backpack and continued along the trail with a big grin on my face.

It had been another long, hot day, and I didn't stop until I got to a small pool of stagnant, green water deep inside a narrow gorge. A storm of mosquitoes surrounded me and, together, they produced a piercing high-pitched buzz that was hard to bear. I squinted my eyes shut and threw my arms around me furiously to try and keep them at bay. But nothing I did seemed to help, and before I knew it, my legs and neck were covered with bites. When I got to the pool, an even thicker swarm of bugs circled above the water's surface. This was clearly their territory, and there was no space for intruders. The pool was inundated, so I quickly scooped out the cleanest water I could see and rushed up the bank to filter it out of harm's way. But the mosquitoes soon followed, so I went looking for a safer spot even higher on the ridge.

"Van Goooooooo!" Pogue's Tennessee voice echoed through the rocky walls. "Is there water down there?"

I nodded and gestured to the green pool far beneath me. The guys were clearly hiking at a far faster pace than I and had caught up with me. Pogue disappeared into the gorge, emerging shortly to join me with the others. He threw down his backpack and sat beside me. Quietly, he lit up his hash pipe, looking at my water with a sigh of disgust. "Do you call that water? Looks more like slime to me, dude!"

Pogue introduced me to his friend Barbie, an eccentric fellow in his 30s, also from the South. Barbie was extremely loud and very opinionated. Each sentence was riddled with street slang, and everything he said always seemed to make everyone laugh, oozing rock n' roll with his Memphis accent. But he often challenged us to think, asking outspoken questions about religion, politics, and sex. There was no filter where he came from. Barbie was a born entertainer. At the same time, he was a man full of contradictions: I have rarely met someone so caring and compassionate when a fellow hiker was in need of help. If one of us got hurt, he would stick by their side to the end. He was as loyal as a Labrador.

"How did you get your name?" I asked. He showed me a plastic Barbie doll he carried on his backpack everywhere he went. It was his 10-year-old daughter's doll. He took pictures of the Barbie every day and sent them to her whenever he had cell reception in town. He tossed the doll my way, snapping a photograph of her as she dangled in my beard. "Barbie Goes on Adventure" was his slogan, and he meant it very literally. He wanted to keep his daughter actively involved in his journey on the trail.

This wasn't the moment to explain that the Dutch guy didn't smoke weed. After having filtered a few liters, I put on my backpack and continued along the trail with a big grin on my face.

I thought it was a great idea. He had found a form that really resonated with his daughter, and it was something I could learn from. I pondered how best to find a fitting way to reach out to my kids. Barbie and I discussed how it felt to miss our kids for so long, and we agreed that it gave the whole experience an extra layer to deal with. It was especially hard as I lay on my air mattress at night, just before I fell asleep. It was then that I missed my family most.

Hiking up Mount Baden-Powell with Pogue, Goldie,
Corkscrew, Barbie, and others.

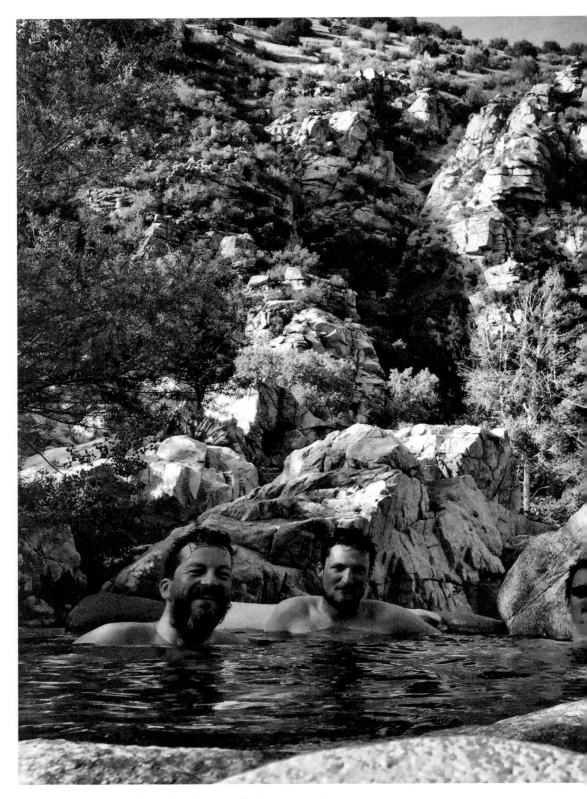

With Corkscrew, Barbie, Pogue Mahone, and
Goldie at Deep Creek Hot Springs.

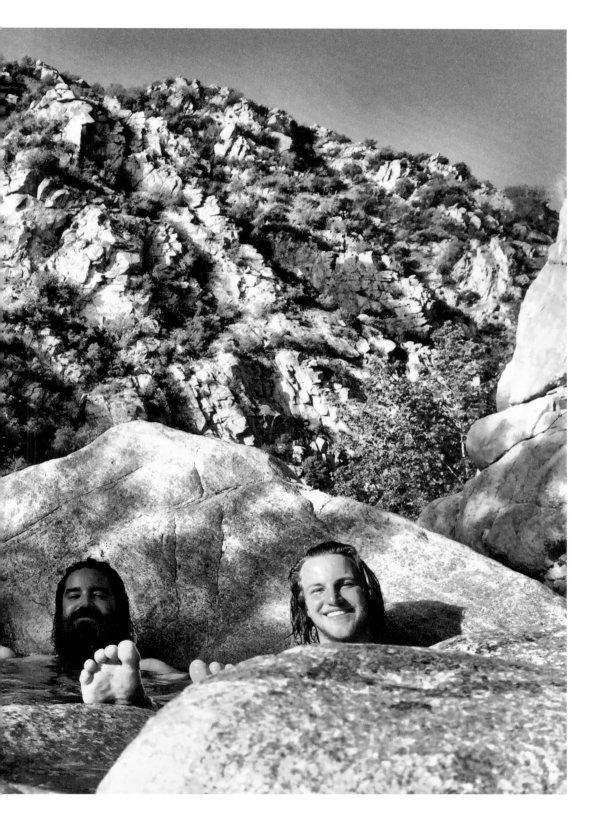

"Yeehaw!" An abrupt call resounded above us. In a cloud of dust, a young guy in a kilt came running down the hillside and jumped onto Pogue's shoulders. It was 18-year-old Goldie from Austria, a free spirit with a remarkably loud voice. He gave me a high five and disappeared into the gorge for water.

While we cooked, everyone was constantly joking around, as if we'd known each other for years. Barbie was ridiculed for only eating "ramen bombs" for three weeks straight, consisting of noodles and mashed potatoes. Goldie couldn't contain himself at the sight of Pogue smoking his pipe, taking long drags between each bite of his dinner. And I was repeatedly bashed for the quality of the water, which, to be fair, did taste pretty awful.

Pogue peacefully whistled an old country tune, and Goldie devoured yet another pan of pasta while continuously talking and sharing the adventures of his day. He was a funny fellow, and there was something very familiar about him, although I couldn't quite put my finger on what it was. I could even recognize a few traits from my own younger years. There was also a quiet, young guy in their group, who didn't have a trail

It turned out that the boys had been cowboy camping for weeks, sleeping in the open air. I hesitated for a moment—but why not? I had to try this.

name yet. I looked at this strange bunch, taking in their disheveled hair and scrappy clothes, and felt pretty at home in their company.

I was about to put my tent up when Barbie shouted in amazement. "Dude! What the hell are you doing? It's much nicer without a tent. We be Ultra Lazy." It turned out that the boys had been

cowboy camping for weeks, sleeping in the open air. Roughing it seemed to be the thing to do out here. I hesitated for a moment—after all, I had seen numerous mosquitoes, spiders, and snakes that day—but what the heck, why not? I had to try this. I lay my sleeping pad on the groundsheet, crawled into my sleeping bag, and looked up at the stars in the sky above me. Never before had I seen the Milky Way so clearly. It was a breathtaking sight, and in the following months I frequently opted to cowboy camp under the stars.

I hadn't seen so much water in the desert for weeks. A refreshing dip all to myself, and, to my delight, I discovered a small, natural hot spring.

The following morning it was quite a surprise to wake up without the familiarity of my tent around me. As dawn broke, birds plunged into the gorge, crickets sang in the dry grass, and the ants busied themselves around me, looking for scraps. The moon and stars were still slightly visible as the sun rose behind the mountain ahead. The motionless sleeping bags next to me gave no signs of life, so I quietly packed my things and hit the trail. I walked down into a narrow gorge, following the thin trickle of water until it finally joined a fairly wide river, perhaps 12 feet (3.5 meters) across. I hadn't seen so much water in the desert for weeks. A refreshing dip all to myself, and, to my delight, I discovered a small, natural hot spring that was pleasantly warm. I jumped in, moving in the flow from hot to cold. It felt great to be so clean and to relax my tired body.

"Yeehaw!" With a huge splash, Goldie jumped into the hot spring, nearly emptying it in the process. Goldie and Barbie had caught

up with me within half an hour. The others also joined us shortly after. For the entire morning, we swam and lazed on the banks in the shade. Pogue lit his pipe and read a thick book under a tree. If this wasn't paradise, what was? The only thing missing was a cold beer.

But as idyllic as it may have been, within a few hours I became restless again. Goldie looked up in amazement as I put on my backpack. "What's the rush?" he asked. I didn't really know myself, but I wanted to move on. I left without a word.

Shortly after, I began to curse my decision to head on. The trail offered no shade or water, and the day became searingly hot. Young Goldie was absolutely right. What was the rush? Why couldn't I just relax and enjoy the moment? Where did all that restlessness come from? I trudged on in the dust. Now and then I could see the river wind far below me in the gorge.

Surviving on a Snickers

Mile 341

Before leaving, I had created a food list based on Hummingbird's list. Hummingbird was a young English woman who had hiked the PCT a year before me and had meticulously described every detail of her preparation on her blog. I'd been able to see exactly how she had arranged her American visa, which cell phone provider was the best, and what gear she had bought. But I was especially happy with her food list and resupply plan. I found two screenshots of her food list on her blog and copied them into

a spreadsheet of my own. That way, I knew exactly what to buy for breakfast, lunch, and dinner, as well as how many snack bars I would need for each section of the trail. I had never heard of most of the products, which were typically American. I had no idea what *Pop-Tarts* (an extremely sweet breakfast biscuit) were or that beef jerky turned out to be dried beef. Thus, with a shopping list in my hand from a woman I had never met, I had entered a gigantic supermarket in San Diego, planning to buy enough food for the first seven weeks on the trail.

I had divided all the food into seven different packages and sent them ahead, addressed to myself. The trail endlessly winds through the wilderness, only rarely crossing a small town, and because of this, food prices can be very high in the remote resorts. This complicated, crazy logistical planning was called "resupply." To be honest, it was a nightmare to organize and get my head around. I had found several postal addresses of secluded farms, hostels, and mailboxes that were accessible a few miles from the trail. There were food and snacks in every box, but also paper maps for the next sections, toilet paper, and a pair of new shoes every 500 miles (800 kilometers). Others chose to just wing it and buy along the way, but I preferred to have my foods of choice waiting for me in boxes. This way I could fully enjoy my day off in town instead of shopping all day. On the trail, my fellow hikers called these days off a "zero:" a day where you don't walk a single mile.

The first few weeks I was pretty happy with my food but hadn't taken into account that I wasn't a woman and that I would need a lot more calories than the much smaller Hummingbird. I started to get more and more hungry every day. It soon became clear that I had far too little food with me, and that I would have to ration my meals until I arrived at Cajon Pass, where my next resupply box was waiting for me. The first three days I stopped eating breakfast, and reduced my evening dinners to a minimum in order to make it last.

But somewhere my rationing had gone terribly wrong. I was constantly hungry and couldn't help myself. I managed to cut all the meals in half, but the bars were too hard to re-sist on an empty stomach. I still had 24 miles (39 kilometers) to walk before reaching Cajon Pass, and all I had left to eat was a Snickers. I hadn't done that kind of distance in one day yet, so I started early on an empty stomach. After days of eating less than I needed, I could feel a constant nagging in my stomach. I had never ex-perienced extreme hunger before, and although I was in no real danger, I began to feel the fear that accompanies a total lack of food. It effects your

Somewhere my rationing had gone terribly wrong. I was constantly hungry and couldn't help myself. I still had 24 miles (39 kilometers) to walk all I had left to eat was a Snickers.

mind as much as it does your body; you start to hallucinate or panic about whether you'll reach food in time. Around 11 o'clock I took a short break, carefully opened the Snickers wrapper, and took one small bite. I chewed as slowly as I could, letting the nougat, peanuts, caramel, and

chocolate melt in my mouth. Every subsequent three hours, I allowed myself another small bite of this holier-than-holy candy bar. It was only the thought of reaching the McDonald's at Cajon Pass that kept me going. It was, therefore, surreal to suddenly see a yellow "M" poke up over the desert horizon at the end of the day. It was even

I had never experienced extreme hunger before, and although I was in no real danger, I began to feel the fear that accompanies a total lack of food.

more surreal to stand in front of an eight-lane freeway after all that peace and quiet. Cajon Pass was no more than a truck stop along Interstate 15, just north of San Bernardino. A run-down Best Western and a McDonald's stood on either side of the busy road. A little dazed by the noise and speed of the heavy trucks flashing by, I followed the freeway towards the "M" and then literally ran across a parking lot, scared it may close be-fore I reached it. I was flooded with happiness as I joined the back of the line to order. There was a mother in front of me furiously shouting at her son, a couple arguing about what to order, and a heavily tattooed man barking down his phone to a client. I was clearly back in civilization.

"How can I help you sir?" said a cheerful young lady who didn't quite fit into her uniform.

"Three Big Mac Menus and a salad please," I replied, my mouth watering. I found an empty table, put my backpack in the corner, and went straight to the bathroom to wash my hands for the first time in five days. I could slowly feel my-self becoming human again as the warm water and soap cleansed my face. I was nicely refreshed when the waitress came to bring my order. The three orders took up the entire table. I attacked

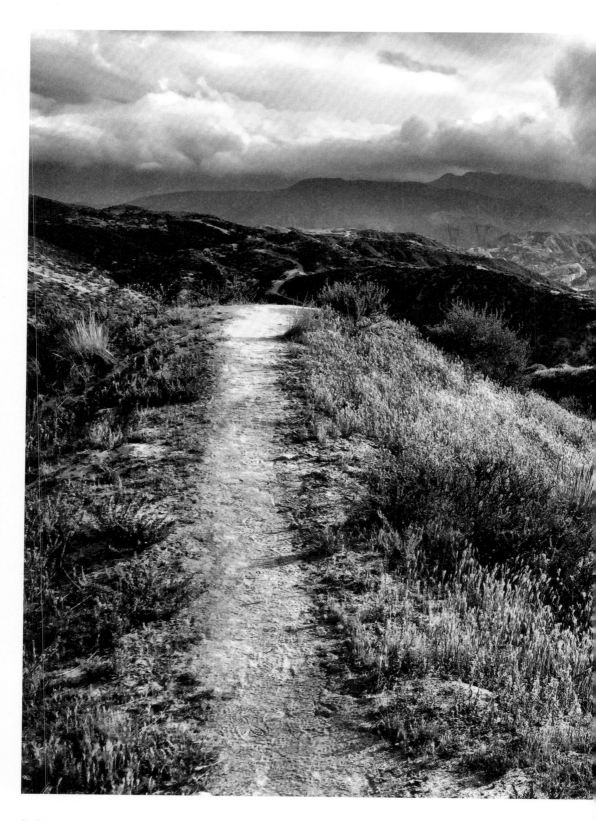

Following the trail down toward Cajon Pass.

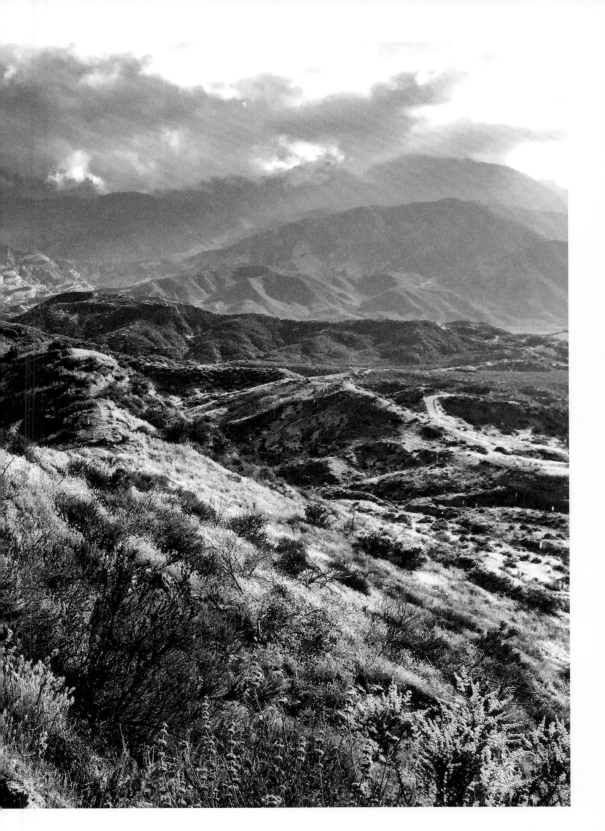

my meal messily, taking big bites. I found, though, that after only two Big Macs I was totally full. It seemed my stomach couldn't process all that greasy food anymore. In something of a trance, I stared at the wall in front of me while the sugars, fats, and salts entered my bloodstream. It was as if I had taken a hit of heroin! I took the remainder of my food to go, crossing the highway to check into a room in the motel.

My resupply box was waiting for me at the reception. I hobbled to my room, glad to have it, though I made a mess of it in no time. I fell asleep on the king-sized bed while running a bath, and by the time I awoke, the entire floor was soaking wet. The carpet was drenched, and water gently flowed out the front door. Even after endless mopping, everything remained damp, and as it became hotter, the odor of the rancid carpet rose around me, a mixture of age and cigarette smoke. I tried in vain to get a new room at reception, but the motel was fully booked that weekend. Tough luck buddy. I returned to the damp room, now a swampy ashtray.

Shots in the Desert Night

Mile 356

The following morning, I was relieved to close the door behind me and walk into the fresh air. My backpack was heavily laden with extra food for the coming six days. As I hit the trail, the terrain became increasingly mountainous, the going treacherous. I'd walked for a couple of hours when I had to stop and wait for what seemed to be a never-ending freight train winding slowly through the desert valley. Even in this wide-open American wilderness, one couldn't escape the influences of civilization. At the beginning of the evening, I reached a windy plateau, far above the clouds. As the sun set, I looked down over the cloudy blanket that stretched to the horizon. As usual, I set up camp as soon as I stopped for the day. I found a protected spot under some bushes that gave sufficient shelter from the growing wind. By now I could practically set my tent up blindfolded. After months of research, I had opted to buy a two-person tent. I'd weighed up the pros and cons of all the available tents on the market: cost, durability, weight, space, double-walled, single-skinned, free-standing, camouflage, Cuben Fiber, and nylon. Although it was pretty pricey, at 1 pound 11 ounces (790 grams) the tent was simply the lightest, most spacious tent out there. The Cuben Fiber fabric—adapted from the sailing industry—was light and strong. It gave me enough space to lay my backpack next to me, and I could make a clothing line inside to dry my socks at night. I rarely closed the side flaps, which kept it fresh inside. That way, I could see beyond the mosquito netting to the stars in the night sky.

When I pushed the last peg into the hard ground, I suddenly noticed Goldie some distance away, relaxing under some trees. He lay on his sleeping mat, gently stirring his cooking pot, which was simmering over a gas burner. I threw a few small rocks his way. He immediately sat up, spun his head around like a gerbil,

and when he finally spotted me, came running over, kicking dust all over me. "I haven't seen you since the hot springs!" He sat down and told me all about the events I'd missed that day. He had met a group of beautiful girls—they'd made a campfire and had swum all night. His enthusiastic story went on and on, and I listened with excitement. Someone had brought along a guitar, and they had sung and danced for hours. That was probably the worst part of hearing about the night I had missed. I love music and singing around the flames of a fire. I'm a real sucker for corny campfire tunes.

The wind began to pick up, blowing sand in my food. It was time to call it a day, so I headed in. Unfortunately, the night didn't bring the peace and quiet I longed for. I was woken by the sound of gunshots in the distance. Ta–ta–ta–ta! Loud, consecutive shots rang out again and again. It felt as if they were getting closer every second. Some kind of semi-automatic weapon was being fired, certainly no more than a mile away. I sat upright and listened carefully for where the sound was coming from. It was quiet for a few minutes, but then the shooting started again, this time accompanied by loud screams. They really were getting closer!

> **The wind began to pick up, blowing sand in my food. It was time to call it a day, so I headed in. Unfortunately, the night didn't bring the peace and quiet I longed for.**

This was another side of America I was experiencing, and I was shocked at the contrast from my home country. My mind started racing as to what I should do. I yelled to Goldie but didn't get any response. He was too far away to hear

me through the howling wind! But what could I do, other than sit and hope it would soon pass? It seemed to go on for hours. What was happening out there? It was only when I heard a police siren in the distance, followed by barking dogs, that the shooting finally stopped. I sighed with relief and my body relaxed.

The Plumber Cowboy

Mile 381

A day later, walking through a wide canyon, I saw a plume of white smoke curling up in the distance. I was surprised to find two horses grazing near a campfire and puzzled not to see anyone else around. There were a lot of flies circling around the horses, so I moved away some distance before putting up my tent. Shortly after, a stocky fellow walked up the trail with large buckets of water in each hand. With a raw voice, he told me that his horses needed to drink up to 50 liters a day in this heat. "Damn, these two have quite a temper, just like my girl, really!" He gave the gray horse a slap on the nose, as she tried to bite the man's glove. "Easy, Misty." The man sat by the fire and lit a cigarette, just like the Marlboro Man. The only thing missing was a cowboy hat. According to him, the idea of doing the PCT on horseback had been his girlfriend's, but she had packed her bags and left him stranded three days ago.

"I think it's over between us now," he sighed. "I didn't know anything about horses, so I watched a bunch of YouTube videos about them before heading out on the trail. I'm actually

a plumber and sold my tools and van to pay for these two, which cost me $2,500 (ca. €2,200) each. Now I understand why the previous owner wanted to get rid of them! They really don't listen, super stubborn. More like donkeys to be honest. But I'm slowly getting the hang of it after a month. It's damn hard work, horses, especially with all that extra food that we have to carry. And can you believe it, they're not welcome in most trail towns or hostels either," he scowled.

I was curious how he'd found the trail the past days. "The whole trail was originally laid out to be suitable for horses," he told me. "It's never too steep, perfect really. The trail rarely goes straight up the mountain slope, and there are always endless switchbacks that zigzag up and down the mountain. But the past few days have been pretty tough with all those fallen trees across the trail. It's hard, but these horses can handle obstacles surprisingly well. I usually just leave it to them to figure out the best route. Sometimes they jump over the trees and sometimes we have to go way back to find a detour." And with that, he stopped talking and rolled another cigarette.

I wished him good luck, retired to my tent, and lay awake thinking for some time about his astonishing tale. I couldn't imagine doing the trail with two horses. The thought of having to care for them all the time was exhausting. It was crazy, really, and it all seemed pretty irresponsible. Only a week later I heard that he'd quit.

Apparently, it had become too much. It didn't surprise me one bit. It seemed the horses were better off this way too.

The Rat Pack

Mile 400

A few days later I bumped into Pogue and the rest of the crew at a bar in Wrightwood, a tiny mountain town. We'd all had a few tough days, and I was glad to see familiar faces again. We ordered some pizzas and drank to each other's good health with the local IPAs, basking in the bar's atmosphere until last call. Luckily Pogue had booked a room, and we all crashed on the floor. I woke up to the stale smell of sweaty feet, unwashed clothes, and empty pizza boxes. It also soon became clear that after all that drinking, I needed to rest. I decided to take a zero.

"Damn, you snore, Van Go!" Goldie belted through the room, waking everyone in the process.

"No, I don't," I replied with a grin on my face. I clambered over the other sleeping bodies and stepped outside to go online and book a place for the five of us for the following night. I found a charming log cabin not too far away in the woods. Finally, we could cook a healthy meal! We were allowed in to the cabin at noon. When we got there, it looked as if time had stood still for over 50 years. There was no TV or internet. It was exactly what we needed to recharge.

At the cabin, Barbie and I retreated to the kitchen to prepare a wholesome feast. He concentrated on creating an array of tacos, while I made a spinach salad, full of nuts, goat cheese, and chicken. I'd also bought some artichokes and

a few bottles of white wine for our little family dinner. While we chopped and cooked, Barbie told me all about his work as a hotel manager in Tennessee, and how tough it had been to get up so early every day for so many years, plus having to work weekends and on holidays. He had saved for years to do the PCT and—even though he missed his daughter—nothing could stop him from reaching Canada now. For months he had scoured the web for discounts on ultra-light gear to get the best deals. He prided himself that he'd bought everything for less than $1,500 (ca. €1,300).

That evening, one of the guys got his trail name. I had asked him to open the bottle of wine for dinner. He twisted the corkscrew into the top but was subsequently drenched as wine spurted all over him. The bottle, as it turned out, didn't have a cork, but a screw cap. From that point on, he was *Corkscrew*. The table was beautifully set with lots of dishes. We raised our glasses, and Goldie cheerfully proclaimed, "The trail provides!" A bunch of starved vultures, everyone devoured the food. Life was good. I felt totally at home within my new trail family, or "tramily" as they say. The Rat Pack was born.

Hiker Heaven & Hippie Day Care

Mile 453

During the pilgrimages I'd walked in the past—the Buddhist 88 Temples trail in Japan and the Catholic Camino de Santiago through Spain—the local religion had always played an important role in my hike. The PCT has no spiritual roots beyond love and respect for nature. It was striking to discover that all these trails do have one thing in common: Trail Angels. I have found that wherever you hike in the world, there are always locals who welcome tired hikers into their homes for a cup of hot tea or a bed for the night. This was my American pilgrimage.

> I couldn't believe what I saw. The entire garden had been transformed into a big festival site, with more than 50 tents set up within an inch of one another.

In Agua Dulce, a quiet desert town 453 miles (729 kilometers) from the Mexican border, I left the trail to stay in the Saufleys' garden for three nights. A warm, generous family who had been Trail Angels for 20 years, they opened their home and garden to PCT hikers all summer long. When entering this hiker heaven, I couldn't believe what I saw. The entire garden had been transformed into a big festival site, with more than 50 tents set up within an inch of one another. The Saufleys had converted their garage into a post office, storing hundreds of resupply boxes filled with food, waiting for hikers to collect them. The lady of the house, Donna Saufley, even offered to do my laundry. This really was heaven! She showed me to a large trailer in the yard where I could take a shower. She advised me to quickly put my name on the shower list because there were already 25 people waiting, and it would take quite a while. In the living room, I saw a number of people sprawled out, binge-watching *Game of Thrones*.

I found a small spot between three tents where there was just enough space for me to set up mine, after which I joined the crowd sitting around the campfire. All the faces lit

The stunning rock formations at Vasquez Rocks just before Agua Dulce.
They were also used as a filming location for *Star Trek*.

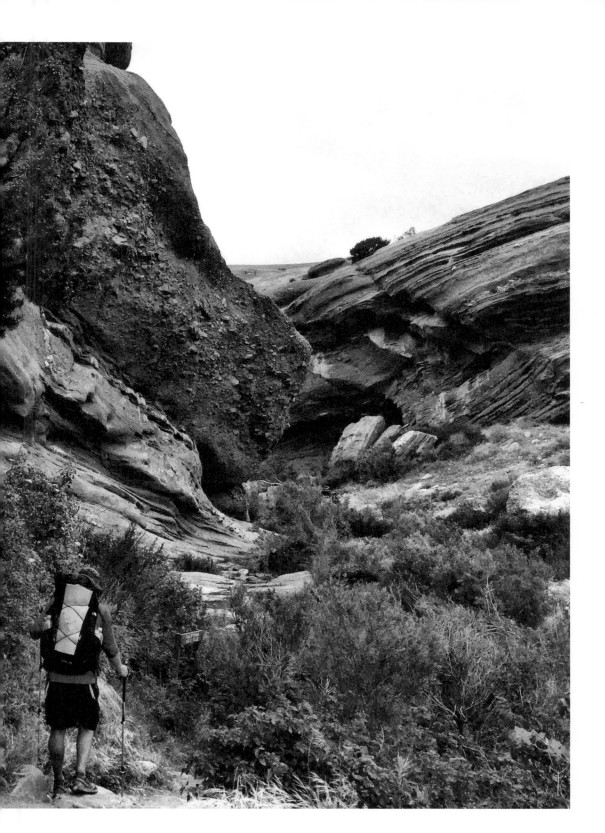

by the flames were new to me. I wondered how long they'd all been here; it seemed as if they had camped for weeks. Someone offered me a beer, another played his guitar, and some goofed around with a drinking game. Others simply stared into the flames. It was good to have a drink and meet new people.

There were only three rules at Hippie Daycare: everyone had to wear a Hawaiian shirt, you could join the daily Mexican dinner for a small donation, and everyone had to be quiet after 10 o'clock.

I stayed in this heavenly garden for three nights, enjoying back-to-back movies and sharing stories with the other hikers. I met an interesting couple from Taiwan, who were doing the trail dressed from head to toe in silver, reflective outfits to protect themselves from the sun. They didn't speak a word of English, but managed to communicate just fine with hands and feet. There was also a charming family from England who totally stole my heart when their youngest daughter insisted on playing Hula-Hoop with me. After a lot of hassle, the parents had managed to take their children, aged 10 and 12, out of school for half a year to hike the entire PCT from border to border. Their kids had more than enough buddies to play with—there were so many hippies around—and seemed to be fully enjoying their adventure. The family was a wonderful example of the just-do-it philosophy and had shown a healthy dose of perseverance. There could always be hundreds of reasons why something like this would seem totally impossible and inconvenient with a young family, but this ordinary family from Yorkshire proved that it could be done. I couldn't imagine a better education for children.

Only days after having left the garden, another temptation crossed my path. I came across a handwritten sign on the trail. "There are two kinds of hikers: those who have been to Casa de Luna and those who wish they'd been to Casa de Luna." The words spoke volumes. Apparently, I couldn't skip this place, so I left the trail once more and stuck out my thumb, hoping to get a ride. Within 15 minutes an old Toyota with a lady behind the wheel stopped, asking where I needed to go.

"To Casa de Luna," I answered hopefully.

"Oh, those folks. I wouldn't go there. They're nasty people," she snarled. Then she drove off. I was somewhat taken aback by her aggressive tone and was actually quite glad that the car had driven off. But only seconds later, the same car screeched to a halt and drove back in my direction.

"Get in. I'm Terrie Anderson from Casa de Luna. Gotcha!" Laughter filled the car as I squeezed into the back seat next to an enormous, drooling dog. Terrie was the owner of Casa de Luna. She loved the hiker season—when countless smelly hikers stayed in her backyard—more than anything in the world. It was her way of being part of the hiker community, who were like a family to her. There were only three rules at Hippie Daycare, as she called her home: everyone had to wear a Hawaiian shirt while staying at her place, you could join the daily Mexican dinner for a small donation, and everyone had to be quiet after 10 o'clock so as not to disturb the neighbors. "Other than that," she told me, "anything goes."

On arrival, I explored the garden. It looked like a scene from *The Hobbit*. There were countless tents tucked away, hidden under the low-hanging trees. There were lots of familiar faces, and I was especially happy to see Savage, the guy who had given me my trail name. He threw me a Coors and introduced me to his friends.

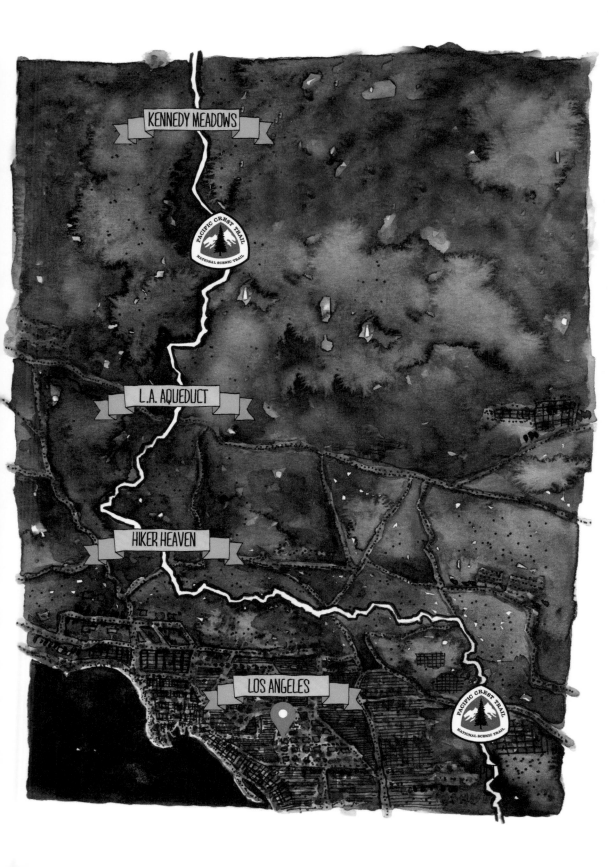

I pulled up a plastic garden chair and didn't get out of my seat for the rest of the day. That night the rest of the Rat Pack stumbled into Hippie Daycare. It was good to feel complete again.

I often fantasized about what it would be like to live during a different time in history. I think I would have enjoyed living in the sixties, experiencing the free spirit of the flower power movement. Now, over 50 years later, there are still millions of people who want to experience that lifestyle, visiting music festivals as urban hippies. Burning Man in Nevada is probably the closest many will get. But after a week in the dusty desert, people generally find themselves back at the office, $5,000 (ca. €4,400) lighter, in a meeting to review the quarterly targets.

> There was always a joint going around, and the occasional philosophical discussion around the campfire gave it an echo of how I imagine the sixties might have been.

On the trail, I finally experienced what it could be like to live that dream, living in nature within a community of free spirits from diverse backgrounds, colorful and dusty. No one shaved their chins or armpits, bras clearly didn't work under heavy backpacks, and there was a healthy amount of free love amongst the youngsters. There was always a joint going around, and the occasional philosophical discussion around the campfire gave it an echo of how I imagine the sixties might have been. Often, someone brought out a guitar, and although it wasn't always great, they generally managed to get by with the basic chords for Bob's "Blowing in the Wind." Dreamers, pursuing their dreams.

But this wasn't some kind of utopian paradise. There were frustrations on the trail too.

I occasionally came across people who were either rude, arrogant, or spoiled. I did my best to keep my distance. If I got a bad vibe from someone, I hiked on another few hours to find a place on my own.

L. A. Aqueduct

`Mile 521`

After Casa de Luna, the Rat Pack moved on with a few new faces. As there was a heat wave predicted, we discussed how best to deal with the expected 110-degree temperatures in the coming days. To avoid the heat, we decided to night hike. Goldie and Barbie saw this as one great adventure, but I was a bit uncomfortable with the idea at first. Thanks to the low temperatures during the night we were able to cover a lot of miles without carrying too much extra water. My headlamp lit the trail in front of me and exposed a whole different part of the animal kingdom: countless small scorpions, centipedes, and desert rats scattered away under the glare. Moths and bats darted into the beam of the light. All pretty exciting really, walking in the dark on a narrow trail along the steep slope.

At the end of the first night we stopped at around 1 a.m. to sleep under a derelict bridge. We spent most of the following day sheltered from the sun in the shade of the bridge, but the sun quickly rose in the sky, and we had to keep shifting our sleeping bags to stay in the shade.

Around six in the evening, we packed up and hit the trail again, embarking on the only truly flat stretch of the Mojave Desert that lay in front of us, across the LA Aqueduct. It was a full moon that night, and there were no clouds in

the sky. Although we were literally walking over water, the next water source would be 19 miles (31 kilometers) away. For ages, the trail took us straight over the aqueduct, a long, 12-foot-wide (3.5-meter-wide) tube that supplied Los Angeles with fresh water from the mountains year-round.

Although I hadn't taken any mushrooms, I also felt as high as a kite, mesmerized by the beauty around me. The moon and stars, the city lights, the cactuses and Joshua trees.

A 22-year-old girl from Michigan who we called So It Goes had joined us a few days earlier. She'd gotten her trail name due to her love of Kurt Vonnegut's *Slaughterhouse Five*. Along the way, a few of the guys had taken mushrooms, hoping to make the moonlit night even more magical. Their psychedelic trip added colors and strange new dimensions to the hike. One of them, however, was having a bad trip and started talking gibberish. At one point, he began to walk in the wrong direction. So It Goes guided him in the right direction again, taking care of him for the rest of the night. It was good to have a woman in the group, and I thought I could clearly notice a difference. The jokes and slang continued to be as foul as ever, but with her presence, everyone seemed to be a little more respectful and caring toward one another. The group moved slowly, so at my faster pace, I soon found myself far ahead, completely alone in the vast desert.

Hours passed, and although I hadn't taken any mushrooms, I also felt as high as a kite, mesmerized by the beauty around me. The moon and stars, the twinkling city lights in the distance, and the enchanting silhouettes of the cactuses and Joshua trees, which looked like spiky scarecrows

swaying gently in the wind. Childhood memories of scary children's books, of monsters in the night, flashed back. The wind picked up and grew steadily stronger, blowing dust in my eyes, it was unpleasant to continue. At four in the morning, Barbie and So It Goes joined me as we sought shelter under a cluster of the otherworldly trees.

And Now for Something Completely Different: Why Do the Mountains Call?

1985 – 1991

Where does this fascination with hiking actually come from? Is it a curiosity about what lies beyond the horizon? Is it escapism, soul searching, or the need to prove myself? Probably a little bit of each. The mountains have always called to me.

Every summer of my childhood, we trekked through the Alps with four other families. A group of eight parents (who were dubbed "the Old Trees") together with their 10 children. Each year we gathered high in the Alps and set out on foot, with one parent taking a boxy Renault station wagon to drive from camp to camp with all our supplies. We packed gear for 18 people into the one tiny vehicle—tents, pots, mats, sleeping bags, and countless other heavy camping accessories. As the group moved into the mountains, the jam-packed Renault and that day's driver would wind around the mountain to buy food,

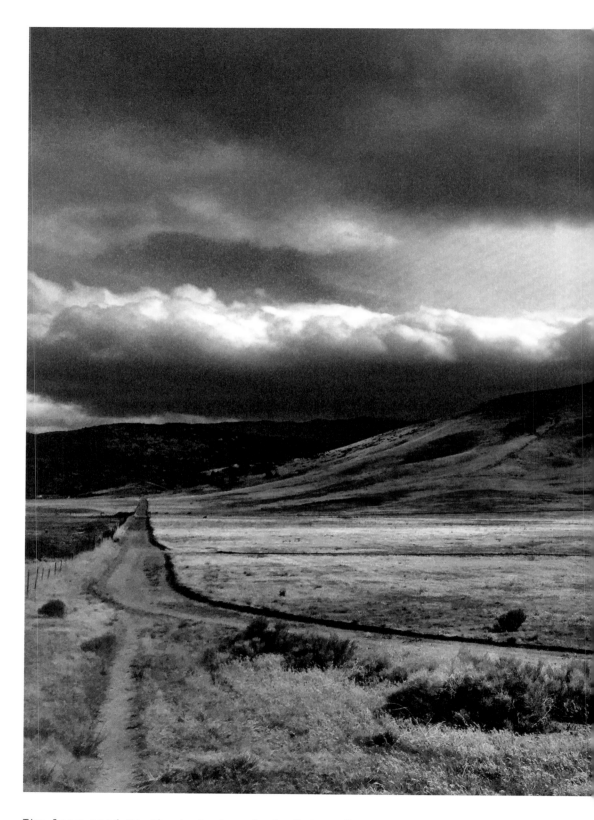

The long road to the L.A. Aqueduct, Mojave Desert.

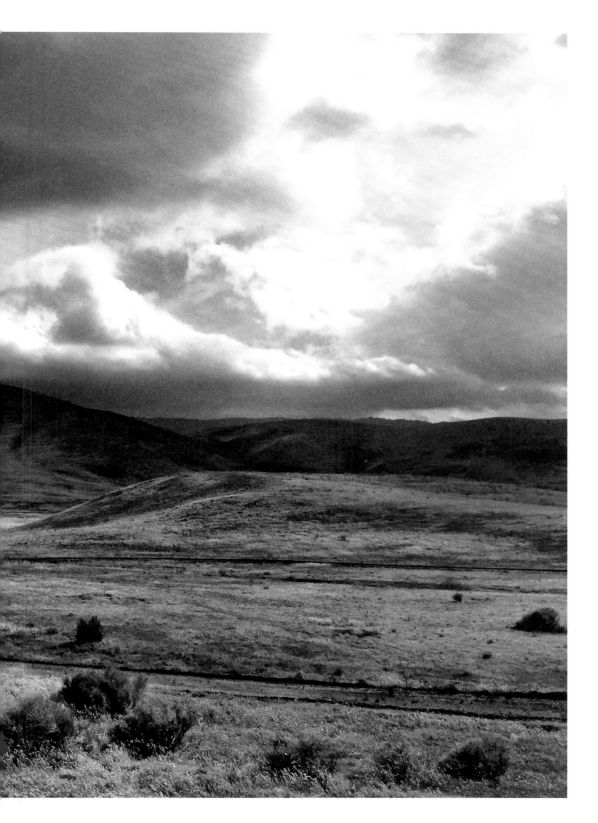

waiting for us in the evening at the next valley. This ritual repeated itself over the following 10 days. We camped in the wild along river banks and rarely saw another living soul. There were never any hot showers or swimming pools during our summer vacations. Life was simple and spartan while we enjoyed everything nature had to offer. There weren't any tables or chairs; we sat on the ground to eat dinner. Each and every one of us had our own daily chores, and mine was washing up. The dishwater would be heated on the campfire while we ate, and each evening we would sing as we scrubbed away at the burned pasta pans. There seemed to be no end to the pile of dishes to clean, but it was always fun to sing and discuss the day's adventures. The others gathered wood, set up tents, and fetched water.

At sunrise everyone was busy packing everything up again. The heavy tents were dismantled, mats and sleeping bags rolled up, and all the clothes were crammed into back of the van. The porridge simmered over the flames of the campfire, while others prepared sandwiches for lunch. After everything was skillfully repacked in the van, we formed a long line and walked over the campsite to "vacuum" it, picking up any trash so as to leave no trace.

Each evening, one of the fathers would set out a route for the next day. Often we didn't follow the marked mountain trails; we choose instead to create our own paths through the mountains to the next valley. We called this "wandering," a mountaineering philosophy that was popular in the 1970s and 80s. This way it was always an adventure, because you never knew exactly where you were going or how long the day was going to be. During these wonderful trips, we lived in a bubble, secluded from society, constantly in motion, nomadically moving from valley to valley. And because we didn't follow the fixed trails, we sometimes had to be tied to a long rope in order to traverse snowfields safely, since the slopes could have deep crevasses. I've always had a fear of heights, and during these sketchy parts, it would be my younger sister who guided me step-by-step along the steep cliffs, gently talking me through it.

One night as we all sat around the campfire, my mother told a story about her own mother, who in 1930 had climbed with ropes and crampons to the summit of the Matterhorn in Switzerland. Together with a number of fellow students, my grandmother had spent two weeks with a local mountain guide climbing several peaks in the Alps. I was mesmerized by these tales. I hoped to one day embark on such adventures myself.

Tehachapi Resupply

Mile 565

The first five and a half weeks on the trail had taken a toll on my body. My shoulders were sore, my feet a little bruised. I was tired and felt it was time for a short break. The next town was Tehachapi, where I checked into a large room in the nearest hotel. Within two hours, seven other hikers had joined me and were lying on the floor. Completely dressed, I stepped into a full, hot bath and poured shampoo all over myself. As the water turned brown, my clothes slowly became clean. After rinsing fully, I wrung everything out and hung my dripping shirt, socks, and pants out on the balcony. Freshly washed, I looked at myself in the mirror and was shocked to discovered how much weight I had lost.

I found a pink rental bicycle at the hotel reception, which I happily rode to the nearby shopping center. With my food supply list for the coming month at the ready, I threw myself at the endless grocery shelves and, within an hour, was pushing two full shopping carts out of the supermarket towards the post office. There I bought five priority mail boxes and distributed my newly purchased products evenly among them. I put the food in ziplock bags and threw away all the unnecessary bulky packaging. Each box contained bars, nuts, raisins, wraps, and noodles, as well as toilet paper, vitamins, and fish oil. To keep things fun, I also added some surprise items to each box: a Frisbee, marshmallows, and a jump rope. When all was packed and ready to go, I addressed the boxes to myself and sent them to different locations along the trail. I must have been quite a sight, sitting on the floor of the post office, apologizing to the clerk for all the mess I'd made.

Tremendously relieved that the excruciating task of resupplying was finally done, I cycled back to my hotel to relax in bed. But before I got there, I was stopped by a friend who insisted that I join her for a drink in the bar. How could I resist? It appeared that the entire hiker community had gathered at the local brewery. The bar was already lined with shots, and the atmosphere was enthusiastic. To my delight, Pogue was there too. He gathered me into a bear hug, then put a quarter in the jukebox. He started dancing and encouraged everyone to join. In no time, we had completely taken over the sleepy bar and turned it into a party. As the liquor flowed, new, intimate couples began to form at the bar, and one of the boys even left with the waitress. As the night continued, the bar began to spin in front of my eyes. It was time I left. Luckily, I remembered my pink bicycle and carefully rode back to the hotel.

I woke with a splitting headache and decided to stay in Tehachapi for another day. After all, I had heard that there was still a lot of snow in the Sierras ahead of me, so there was no use in rushing. I pulled my beanie over my eyes to block the light and fell asleep again. That afternoon I aimlessly wandered through the old town, where I came across an arts and crafts store.

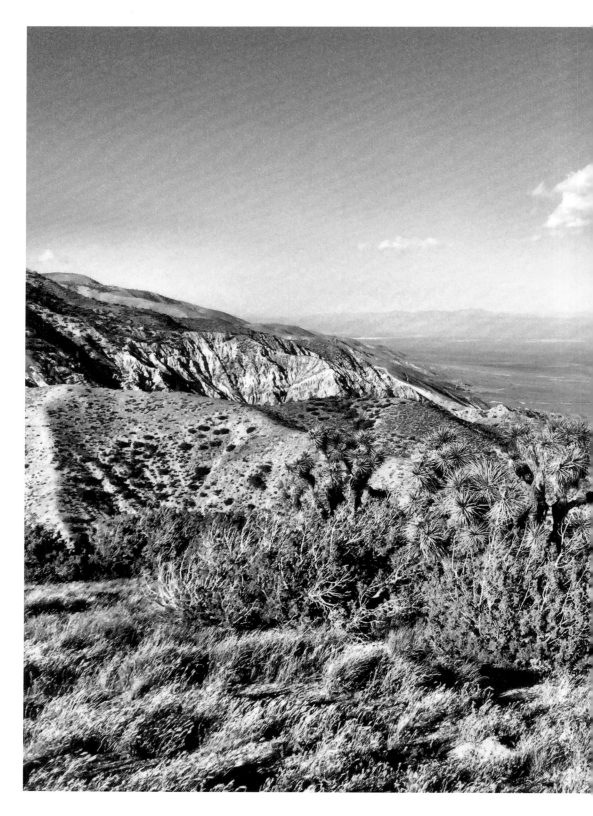

Wind farms near Tehachapi.

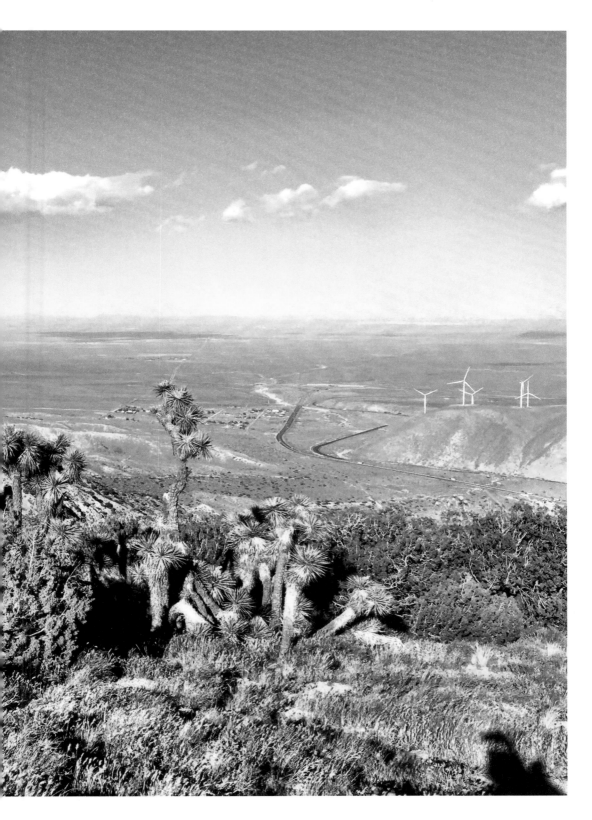

I stepped inside to check out the exhibition of some local artists and discovered a group of elderly ladies painting together at a long table.

"We're the Wednesday Painting Club. Wanna join in?" asked one of the ladies. She didn't have to ask twice, as I jumped at the opportunity. Before I knew it, they had strapped an apron around me. The four women were between 70 and 80 years old, and they asked me all sorts of questions about the trail. The funny thing was, they had lived in Tehachapi all their lives but had never heard of the Pacific Crest Trail.

The ladies told me about their horses and joked playfully. This painting club was clearly not just for painting; it was also for discussing the latest town news. I closed my eyes for a moment, visualizing the landscape I'd just passed through and selected a dark blue and ocher yellow to capture it on paper. I splashed a lot of water on the page first and only then gently started adding the pigment. Very slowly the horizon, hills, and spiky trees came to life. I'm not a man of detail, and I enjoy letting the water do most of the work, as it creates unexpected combinations of color and unforeseen little mistakes, just as in life. The painting didn't measure up to what I'd seen out

> **What a gift it had been to have spent time with these energetic ladies. This never would have happened if I was hurrying through the trail.**

on the ridge, but it felt good to work on a large piece of paper and use some different colors for a change. When it was time to part ways, the ladies pinned it to the wall, there were warm hugs, and I was given two special paintbrushes. They were hollow and could be filled with water so that I could do more painting on the trail.

"Very handy," they declared. "That way you won't have to waste your precious drinking water when you paint out there."

What a gift it had been to have spent time with these energetic ladies. This never would have happened if I was hurrying through the trail, and it probably helped that I was alone. It was a short class, but these ladies made an impression on me. I hoped to experience these kinds of encounters more often in life but had no idea how to create opportunities like this back home.

Wildfires

Mile 651

As there was still so much snow in the mountains ahead of me, I slowed my pace and didn't feel any need to rush. I began to notice small changes. My fingernails had become longer than ever because I was no longer biting them due to stress. My breathing was slower, and I didn't feel the desire to achieve or push on. There was no need to get in the miles, and I often stopped to take in the beauty of the landscape around me or wandered off-trail just to enjoy the views.

At the bar in Tehachapi, I'd had an interesting conversation about isolation with an Australian guy. He'd asked me a question that continued to haunt me as I walked: "What's the longest time that you've ever been completely alone?" Being so isolated, I wondered how long I could go. Even here on the trail, I hadn't been totally alone for more than 40 hours. He told me that at the age of 15, he had once been dropped in the Australian outback for five days, completely secluded in a remote area with no more than a

tarp, some food and water, and a Bible. It had been an awareness-survival exercise for the teenagers of his parents' church and had made quite an impression on him. He told me that he hadn't gone mad in those five days. Instead, he'd read the Bible front to back twice—and he still didn't believe in God. Five days totally alone—could I do that? It was something I looked forward to trying one day. On the trail however, it would be quite difficult to achieve, because even though I often didn't see a soul for days, in the end I would bump into someone somewhere, mostly at a water source. Perhaps one day, I thought, I could try to find a remote place to retreat to and be totally alone for a week. Back in Holland, this would prove pretty difficult in my overpopulated, small country. In any case, it was high on my list, and I was curious to see what effect it would have on me.

I grappled with thoughts of solitude for a while, but after days on the trail, it was great to reach civilization again. A town lay far beneath me in the valley. It was dusk and the lights of the houses twinkled in the distance. I could make out a string of tiny cars winding their way along the shore of a huge black lake, probably on their way back home. A miniature world full of life, love,

dramas, dreams, and work. I ran down the hill and soon stumbled into a pleasant family campground close to Lake Isabella. I was delighted to see they had a pool. I checked in, took a shower, put my weary feet into the clear-blue water, and opened a cold Budweiser. I couldn't have been happier. But as I opened my second beer, I saw a plume of black smoke and an orange glow rising over the horizon.

A stream of fire trucks sped past the campground. Everyone around the pool began to speculate.

"Do you think it was started by a hiker?" one wondered.

"Can we get to Kennedy Meadows?"

"Is there an alternative route?" There was quite a commotion. The legendary community of Kennedy Meadows, a small settlement at the foot of the High Sierras, was only four days' walk ahead of me.

It wasn't the first encounter I had had with wildfires. Some weeks back, just after Mount San Jacinto, I'd had to skip a small section of the trail due to a fire closure. To protect the fragile ecosystem and allow it to recover, the park authorities had issued a $2,500 (ca. €2,200) fine to anyone who crossed the 30-mile (48-kilometer)

Kern Falls on our way to Kennedy Meadows.

Jesus takes a moment to read in the
morning light of Sequoia National Park.

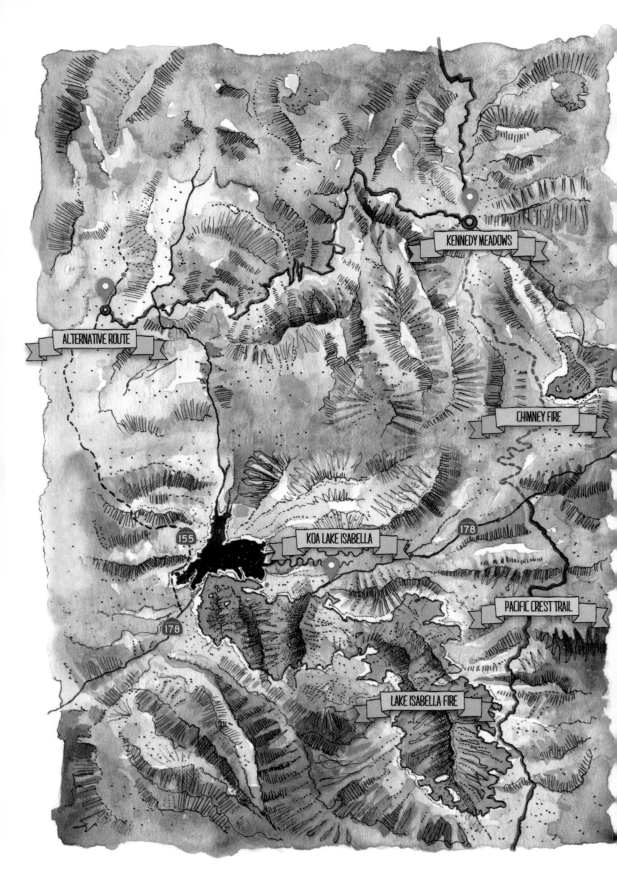

KENNEDY MEADOWS

ALTERNATIVE ROUTE

CHIMNEY FIRE

155

178

KOA LAKE ISABELLA

PACIFIC CREST TRAIL

178

LAKE ISABELLA FIRE

burned stretch. I could have taken a chance, but the fine was a bit too steep for my liking. I had done a few extra detours since then to compensate for the lost miles, but I dearly wanted to walk into Kennedy Meadows without having to take another hitch.

Not only did the wildfire threaten the landscape and communities around Lake Isabella, it also threatened my plan to walk the entire length of the PCT on foot. We soon heard that the section of trail ahead of us had been closed, so in order to reach Kennedy Meadows by foot, alternative routes had to be found. Multiple maps of the surrounding area were unfolded on picnic tables as groups of hikers began to explore the possibilities. At the end of the night, two new routes were established.

I had serious doubts about both routes and could not make up my mind about which to take. The people who had come up with Plan A were sensible and calm, while the gang who had concocted Plan B were loud and chaotic. What was wise? Goldie had already joined Plan A. Not being a thrill seeker, bushwhacking through an unknown mule trail with eight cooks in the kitchen didn't seem the most sensible thing to do. But I finally decided to join Plan B. After all, it was Barbie's plan. I felt I could use a little adventure.

As it happened, I'd had a chat at the swimming pool that day with a friendly Swiss gentleman, Wale, who was touring with his family through California in a stretch RV. Once I'd made the decision to hike with Barbie, I arranged a ride with Wale to take us to the start of our alternative route. He thought it was a great idea but told me that first we'd have to join them at the Giant Sequoia National Monument to see the thousand-year-old sequoia trees. We were going on a real tourist trip with his family.

The following morning, So It Goes and a bunch of hairy hobos stepped into the Swiss family's motorhome. Jesus—a hiker with long hair, a thin beard, sandals, and a white outfit—came along too. He was an odd-looking character, and the contrast between us hikers and the Swiss family couldn't have been bigger. They were neatly dressed and clean cut, whereas we were in tattered rags. After a short stroll through the sequoias, we settled for lunch in the parking lot. Our brief detour completed, they dropped us off at the trailhead, and we said our goodbyes.

It took some time to actually find the trailhead as the mule trail hadn't been used in years. Gnarly shrubs formed a thicket, which called for some serious bushwhacking with our trekking poles. We followed a small river down the valley to avoid the nasty thorns. In stark contrast to the trail, the ground was wet and boggy, thick with plants of all shades of green. The water teemed with life: frogs, fish, and insects darting through the current. Around us huge trees towered on either side of the water, forming a wonderful arch. My feet were soaked, and I had mud up to my thighs, but I didn't care. When Pogue fell face down into the sludge, I nearly pissed my pants.

The wildfire threatened not only the landscape and communities but also my plan to walk the entire length of the PCT on foot. So in order to reach Kennedy Meadows, alternative routes had to be found.

Suddenly a scream of a more serious tone pierced the air, and one of our guys emerged from the bushes with a rattlesnake in his hands. Apparently, the thing had attacked him, and he had hit it with stick. My eyes couldn't quite believe

it at first. It was huge! He held it as nonchalantly as a hunter, as if it was nothing new to him.

He was renamed Rattlesnake on the spot. When I'd recovered from the initial excitement, I asked if I could hold the snake for a minute. I had never touched a snake in my life and carefully took the lifeless creature from him. It was more than four feet (1.2 meters) long and suddenly began to move in my hands. I nearly let it go and then quickly gave it back. Snakes have reflex movements long after they die.

We threw our gear on the ground at the next open patch of grass along the river. We hadn't walked far, but we decided to call it a day. I wanted to try my luck at catching a fish, hoping to grill it over the campfire. Full of high hopes, I pulled out my homemade fishing rod (a hook and a line at the end of my trekking pole) and sat at the bank of the river. The water was about a foot (30 centimeters) deep and 10 feet (3 meters) wide. It was so clear that I could see the smallest creatures crawl over the pebbles at the bottom. The rounded rocks that formed the riverbed shone brightly, a rhythmic mosaic of yellow, red, and black. A bird perched on a branch nearby and flew to the other side of the bank to see if there was any action. My fishing endeavor was probably going to be the highlight of her evening, and she wanted to get a front-row seat. I sat and sat, staring at the fish swimming around my hook, dreaming of my dinner. But nothing happened. Unfortunately, life doesn't work out so easily, and I've never been a very patient man. I moved to a different spot along the river to try improve my luck. Again, the small bird followed me, and again, there were loads of fish, but not one took a bite. I looked for another spot. Disillusioned, I finally gave up, rolling in my fishing line and securing the hook. The bird flew off.

"Any fish?" Jesus asked when I rejoined the crew. I shook my head, showing my empty hands.

"No worries dude, we're eating snake tonight!" He pointed in the direction of the fire to where a skinned snake lay smoking over the flames. The young snake catcher sat silently tending to the flames. There were some crazy stories about this kid, who was apparently doing the whole trail without any money, without a permit, and ate as much wild food as he could find along the way. Whether the tales were true or not remained unclear, as he rarely spoke.

He cut the snake into chunks with a long dagger and gave each of us a piece. I thanked him and carefully took a bite to see what it tasted like. The black, charred skin revealed some beautifully soft, white meat. It was good, but it took me a minute before I could put my finger on the flavor. It was like a mixture between chicken, fish, and chewing gum. With every bite I had to remove at least three tiny bones from my mouth. Silently, everyone sat chewing away at their pieces of snake, as people had done for thousands of years before us. Our most basic instincts were warmed by the fire.

There were some crazy stories about this kid, who was apparently doing the whole trail without any money, without a permit, and ate as much wild food as he could find along the way.

On the third day, we came across an abandoned trackers' cabin nestled along the banks of the raging Kern River and decided to take a zero. We played cards, cooked over the fire, read, swam, and painted. That evening, we all climbed to Kern Falls, an enormous waterfall about an hour from the cabin. Rattlesnake climbed down into the deep gorge to bathe under the waterfall.

Dwarfed under a thousand-year-old redwood
tree in Sequoia National Park.

So It Goes and Jesus hike through Sequoia National Park.

It was extremely steep and slippery, and my palms broke out in a sweat. This was seriously dangerous. I nearly called out to stop him going any farther, but he probably wouldn't have listened to me anyway. I didn't want to play Dad out here either. These were grown men who could look after themselves. I could clearly see the difference in generations though: the young guns always wanted to try everything, to push boundaries, the more dangerous the better.

I was shocked to see the meager collection of food that lay on the ground. A lot of bars and mash remained, but not enough for more than a day or two. We decided to ration and share the food.

In the coming days, we continued to follow the river upstream, deeper and deeper into the mountains. It was hard to estimate how long we would still be out here, so one night everyone laid out the remainder of their food to see how much we had left. I was shocked to see the meager collection of food that lay on the ground. A lot of bars and mash remained, but not enough for more than a day or two. From then on, we decided to ration and share the food.

So It Goes wasn't feeling great and struggled to keep up with the pace of the group. We often had to wait more than an hour at a junction. It was important to stick together. Barbie looked after her and remained at her side, while the others walked ahead to explore the route. But after a while, the lack of food and the endless waiting put noticeable pressure on the mood. Everyone was tired, hungry, and longing for a cold beer. In the last stretch, we had to make our way through nasty, tall grass, and finally managed to find the

official trail once more. It was great to see the sign at last: "Welcome to Kennedy Meadows."

We walked shoulder to shoulder, like brothers—and sister—in arms, up the wooden staircase to the only store in town. It also served as the central hangout for hikers. We were welcomed with applause as we joined the familiar faces. It seemed as if the entire hiker community had gathered for what looked like a crazy festival. A freak show of scantily dressed hikers. Three sat on the ground playing guitars, while others twirled circles in Hula-Hoops. Tables were covered with empty beer cans. Someone juggled, others played cards. I was happy but also somewhat overwhelmed by the sudden crowd.

Kennedy Meadows

`Mile 702`

What a journey! Having walked for seven weeks, I hadn't even done a quarter of the trail. Still, I was overjoyed to have put the hot desert behind me at last. Kennedy Meadows was a small community of no more than ten houses, with a general store where you could practically anything you needed.

I went in and bought two bags of chips, a six-pack of beer, and a bear canister, which was mandatory in the mountains, as I would be walking through bear country from now on. The bear canister was a transparent bucket with a black screw cap; I could put my food inside so that the bears couldn't smell or open it. The park rangers strongly recommended putting the canister 50 feet (15 meters) away from your tent at

night. This way, the bears won't associate people with food. Time would tell if it would work. It was weird to think that this plastic contraption could be a lifesaver, while at the moment I was more worried about the immense extra weight and how on earth I was going to squeeze it into my backpack.

I ordered two burgers at a burger stand and opened a can of beer. The rest of the guys were out on the store's porch, and we enjoyed the beers while relaxing in the sun. I was exhausted, but mostly I was just relieved that I'd made it. Kennedy Meadows was a kind of oasis that could swallow you up like a vortex of pleasure. You could linger for days. Everyone was drinking and celebrating the fact that the desert was finally over. A number of people were waiting for their resupply boxes, which had been delayed due to the wildfires around Lake Isabella. Fortunately, my box was already waiting for me, as I'd sent it from San Diego more than seven weeks ago. I tore it open with my greasy burger fingers. It

was packed full of gear that I had bought online back home: clothes to protect me in the cold temperatures of the mountains. I was excited to see the ice axe and my microspikes, which I would wear under my shoes for the coming snowfields. There were gloves, merino-wool long johns,

What a journey! Having walked for seven weeks, I hadn't even done a quarter of the trail. Still, I was overjoyed to have put the hot desert behind me at last. I had finally reached Kennedy Meadows.

snow glasses, and a whole load of vitamin pills. But the highlight of the day was my new pair of shoes. After having walked more than 700 miles (1,126 kilometers), my first pair of shoes were worn through the treads. To my surprise, there

The High Sierras rise up ahead, as I set up
camp for the night.

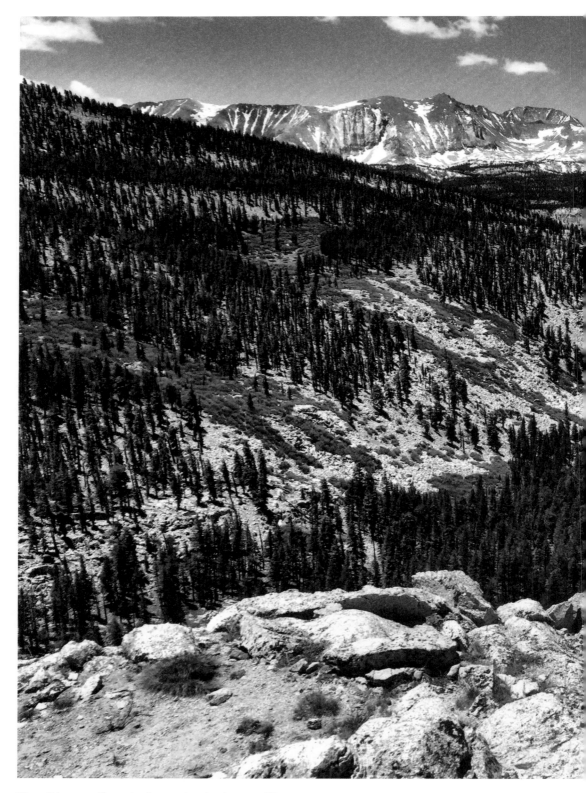

The Sierra Mountains, just days after
leaving Kennedy Meadows.

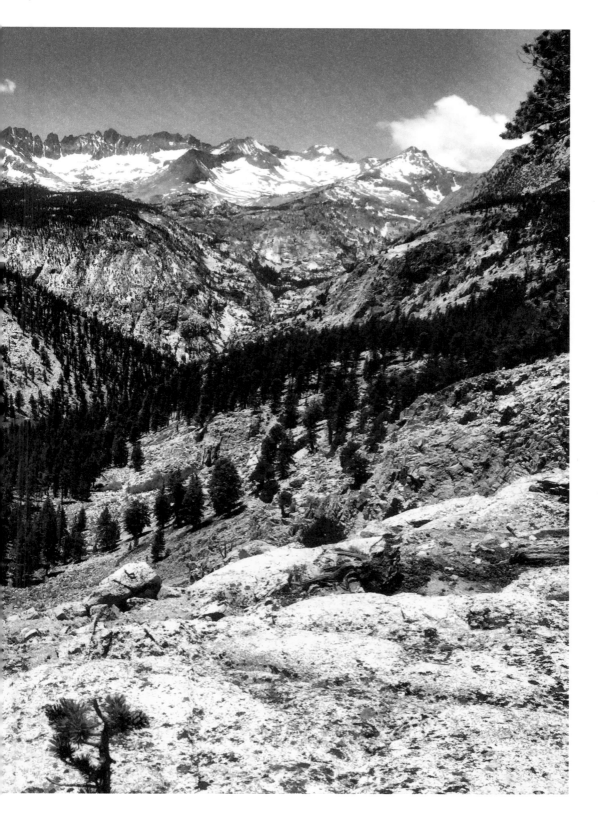

was also another package. My backpack had been slowly falling apart due to the sun and all the extra water I had been carrying, but the manufacturer had sent me one totally free of charge as a replacement. Real American customer service, if ever I saw it.

"Does anyone want to go to Grumpy Bear Resort?" An old man yelled from a pickup truck in the parking lot in front of the store. I collected my stuff and jumped into the back of his truck. Less than half an hour later, I was sitting at a shabby bar in the only café in the wide vicinity. The resort was a musty roadhouse with some antlers on the wall. I was welcomed by a mounted bear head at the entrance, giving me a taste of what the mountains had in store for me. I ordered pancakes, which promptly arrived drenched in butter and maple syrup. But I hadn't come for the food: I'd come for the Wi-Fi, since Grumpy Bear Resort had the only connection in the entire mountain valley. It was my daughter's 15th birthday, and I hoped to get hold of her on FaceTime. A few weeks earlier, I had sent her some gifts, but it felt strange not to be with her today. Nostalgia and guilt caused an unpleasant knot in my stomach. When I asked the barman what the Wi-Fi code was, he mumbled that the internet hadn't been working for a week. Just my luck. There I was, more than three hours from the nearest village with internet, without much I could do. My knuckles turned white as I clenched my fingers in frustration. I had to speak to my daughter. I asked the man whether I could perhaps use his landline because it was my daughter's birthday. He could put the international calling costs on my bill. He nodded, but said I had to be quick because he had already been screwed over by some hiker from Italy last year. The woman had secretly called home for more than an hour on his phone, giving him a bill of more than $150 (ca. €130) the next month. He didn't want to make that mistake again. I thanked him and retreated to the bathroom, the only quiet space where the telephone still had reach, and called my daughter in Holland. It was still early in the morning there, but luckily she quickly picked up the phone. "Happy birthday to you, happy birthday to you, happy b—" I sang cheerfully through the line, but soon I heard "Hello? Hello—I can't hear anything, Mom." I called again, but the line was still pretty bad, and half of my words vanished into thin air. I tried again, and this time we could hear one another. I congratulated her and told her how much I loved her. She asked me how things were on the trail and had just begun to tell me what gifts she'd received when the line disconnected.

> There I was, more than three hours from the nearest village with internet, without much I could do. My knuckles turned white as I clenched my fingers in frustration.

"No!" I shouted out with frustration. I redialed, but there was no answer.

I felt alone, a million miles away from her. My daughter's self-assured voice had made me the proudest father in the world at that moment, but would she be proud of me? I doubted it. No matter how you spun it, her Dad wasn't there for her on her 15th birthday. Did she feel the same void that I now felt? I returned the phone to the barman, paid the bill, and left the rest of my pancakes. I'd lost my appetite. I hitchhiked back to Kennedy Meadows.

On arrival it seemed like I had entered some kind of wild party: there were too many people, too much alcohol, and too much drama. I had been playing with the idea of walking alone again and felt this was perhaps the right moment to continue without the group. During the past

weeks, the Rat Pack had grown in size considerably, with the inevitable dramas and tensions that always occur if too many people begin to depend on one another. There were little things that began to bug me, and I found myself becoming less patient. The pot smoking was beginning to attract a number of dodgy characters, and I noticed that there were different camps emerging within our family. I couldn't quite put my finger on it, but I didn't feel at ease anymore. It was time to move on alone. But it was difficult to finally make the decision to actually leave the Pack. I'd enjoyed the fun and the conversations I had with Barbie, Pogue, Goldie, and Corkscrew. And my timing couldn't have been worse, with the High Sierra mountains just ahead of me. This was exactly the section where I shouldn't be alone. But the desire for solitude had grown too strong. That night, I took Pogue and Goldie aside to say goodbye. Early the following morning, I left the circus behind and walked into the wilderness again.

Mount Whitney
to South Lake Tahoe

Mile 766–1,091

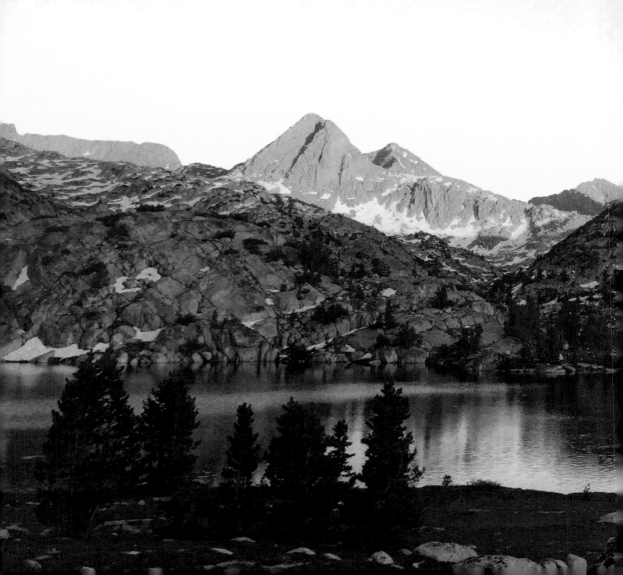

"The mental journey was perhaps the hardest challenge of all, as my motivation and sanity were tested each day in the High Sierras."

Walking in
a State of Shock

Mile 766

The abrupt transition from the desert to the High Sierras hit unexpectedly hard. Three days after leaving Kennedy Meadows, I climbed up Mount Whitney and spent the night in a thunderstorm on the summit. The storm had traumatized me a little, and the snowstorm that followed meant that I had to create a new trail down the mountain. It was more luck than skill that I didn't slide to my death down the side of the trail. The storm left quite a stain and affected my self-confidence. I felt insecure, no longer trusting the weather. I was apprehensive about the long section of mountains that lay ahead.

Alone again, I no longer had my trusted hiking family around me to put things into perspective. In the coming month, the trail would go 440 miles (708 kilometers) across the Sierras, with daily overpasses that were 13,000 feet (3,962 meters) high. In my current state of mind, this was the last thing I needed. Something had snapped in me. I hardly recognized myself, I had become paranoid when walking through the dense woods.

The trail kept getting more beautiful; it was such a shame that I wasn't feeling well. This section, also known as the John Muir Trail, had recently been voted the most beautiful hike in the world by the readers of *National Geographic*. I was walking through Bob Ross landscapes with white mountains, lush green valleys, meandering rivers, and crystal-clear lakes. I could clearly see how amazing it all was, but I wasn't enjoying

a second of it because of the shock. I no longer trusted the trail. In my imagination there was a bear waiting behind every tree. I felt vulnerable rarely seeing anyone else. As a way to stay sane and keep the bears at bay, I sang show tunes and campfire songs to myself all day. I tried anything that would break the silence, hitting my trekking poles against each other and shouting incomprehensible, rhythmic gibberish. My eyes were constantly fixed on the path ahead, frantically scanning for any movement. I felt especially unsafe amongst the tall pines. My preference for the wide desert probably had something to do with the fact that I come from a very flat country and was accustomed to open landscapes. These dense forests obscured any kind of view. I felt claustrophobic, breathing heavily, as much from anxiety as the high altitude.

> I was walking through Bob Ross landscapes with white mountains, lush green valleys, meandering rivers, and crystal-clear lakes. I could clearly see how amazing it all was, but I wasn't enjoying a second of it.

As my insecurity intensified, my instincts drove me towards one primeval desire: run. Escape. Get the f*** out. Get away from these mountains as fast as possible. I felt trapped, surrounded by towering peaks with no sign of civilization for miles. But there was little I could do about it other than continue walking to the nearest town to rest and recover, over two to three days' walk away. I wanted nothing more than the safety of a hotel room, where I could close the curtains and hibernate for a few days.

Although I had heard that the trail would be a lot tougher mentally than physically, I found

it hard to imagine beforehand. It was beginning to dawn on me what this meant. The mountains were steep, but that wasn't the hard part. It was the constant thought of quitting. I had sacrificed quite a bit to be out here, and I knew it was a once in a lifetime opportunity, but the thought kept nagging at me. I thought of hitchhiking ahead and skipping the Sierras altogether, continuing my journey in Northern California, which was a lot less challenging. I was almost ashamed to admit it, but I longed for those predictable, open plains, a section that was often described as boring. The big snowfields I was currently walking through were a lot more serious than I'd expected. There was no faking or bluffing it up here; the mountains meant business, commanding respect. I was filled with humility.

But then again, quitting wasn't my style. I wanted to hike the whole thing from start to finish. I hoped a few days' rest in town would help me see things from a more positive perspective.

Suddenly something moved in the bushes. A small bear cub ran behind the leaves. That could only mean one thing. The mother bear would not be far away. I felt a shock of adrenaline rush through my body and stopped dead in my tracks. My thoughts flashed back to the YouTube videos I'd watched months ago about what to do during a bear encounter. Stand still. Whatever you do, don't run away. Don't run! Bears are a lot faster than people. But it was easier

said than done. I scanned the scene again. To my relief, I discovered that it wasn't a young bear after all, but a big coyote. I had never seen one in my life. It was almost a cross between a wolf and a fox. Our eyes met, and we stood motionless, looking curiously at one another. Inquisitively, the coyote sniffed my scent with its long nose and took a few steps in my direction. There was something absolutely calm about the animal. I didn't feel threatened at all. I slowly brought out my phone and carefully took a few photos. And then, just as quietly as the coyote had arrived, it disappeared back into the forest. It was an extraordinary encounter between two ordinary creatures in the woods.

The Infamous Forester Pass

Mile 779

In order to get to the next town, I had to cross a final obstacle: the infamous Forester Pass. I had heard many scary stories about Forester, which—at 13,152 feet (4,009 meters)—is the highest point on the trail (Mount Whitney isn't officially part of the PCT). Even in high summer, the pass can still be covered in icy snow, making some of the steep parts dangerous to cross. One icy path in particular was so sketchy that I needed an ice axe in case I slipped. One misstep could be fatal, since I could plunge 2,500 feet (762 meters) down a vertical wall of ice.

It didn't seem like a good idea to do this pass alone, especially in my current state. I quickened my pace, hoping to catch some other hikers and join them for the crossing. At one point,

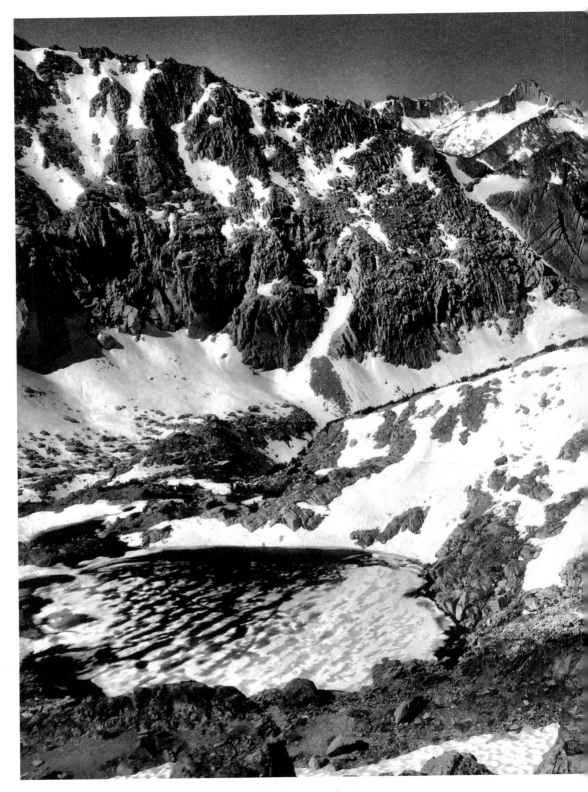

Forester Pass is officially the highest point
on the trail, at 13,152 feet (4,009 meters).

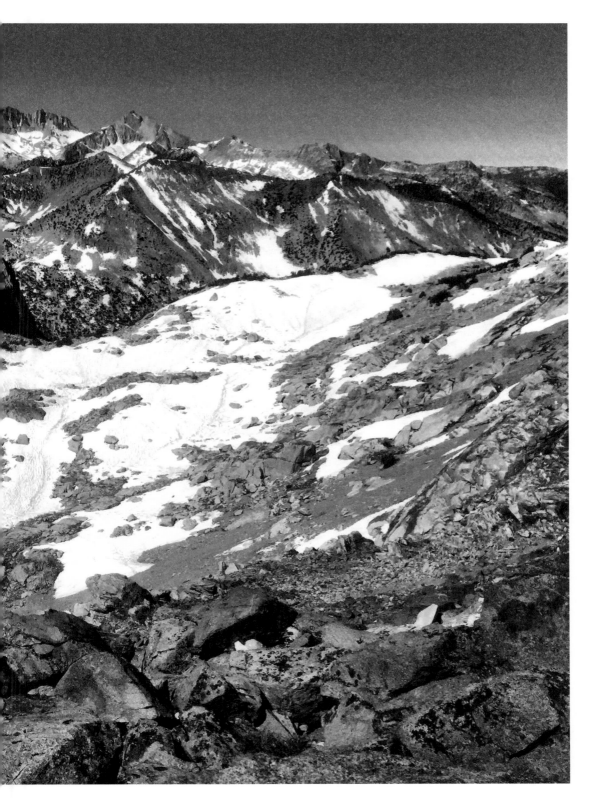

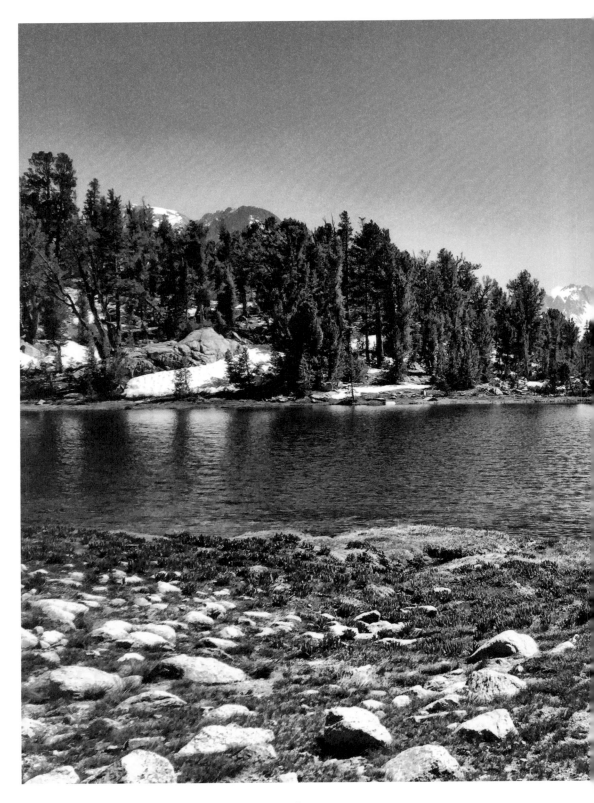

Bullfrog Lake, just before Kearsarge Pass.

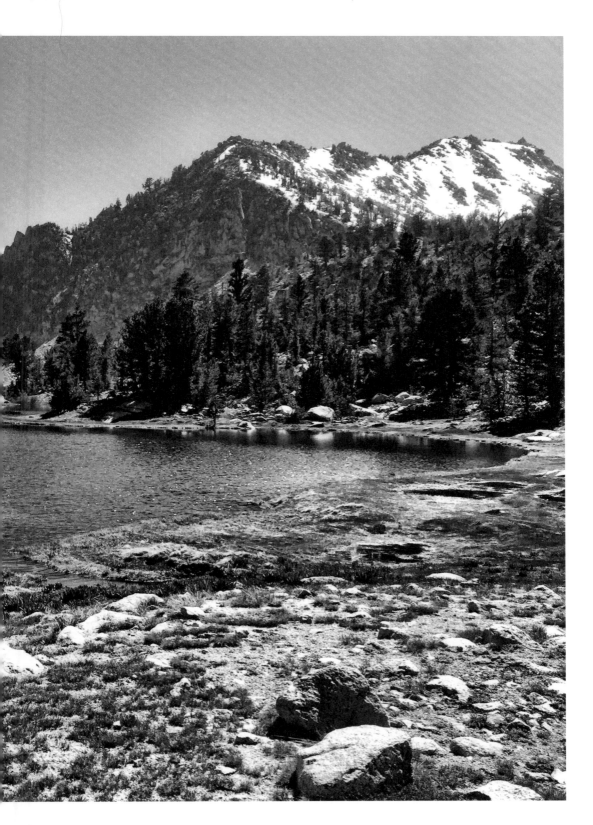

I thought I was pretty close to the pass, only to discover that Forester was far behind it in the distance. There always seemed to be a mountain behind the mountain. It was disappointing that the pass was so far away, but at the same time I was relieved to see three colorful backpacks moving in the distance, so I pressed on as fast as I could. It was four in the afternoon and the sun was shining down mercilessly. The snow became slushy, and my legs sunk deep into the fields of snow. Even my microspikes couldn't help me now. It was slow going, and I was worried about the quality of the snow on the pass. I didn't know what to do. On the one hand, I wanted to cross the pass as quickly as possible, but on the other hand, it would be much safer the next morning, with the snow frozen in the early day's cold.

I struggled to catch the hikers in front of me. The slushy snow was getting even more difficult. Clouds as thick as cauliflower gathered. Was there another storm brewing? I was tired, still in shock, and could feel the high altitude. Was I going to push on stubbornly and make the same mistake as I did on Whitney? Maybe it was wiser to turn around, get a good night's rest, and do the pass early in the morning? But the prospect of sleeping alone, high on the mountain again, was unnerving. I yelled loudly, waving my arms, hoping to stop the people far ahead of me, but they couldn't hear me. This was crazy. Exhausted, I collapsed on my knees. Turning around, I started walking in the opposite direction in search of shelter and safety. All sorts of thoughts shot through my head: wasn't this even more dangerous, being totally alone without shelter high in the mountains? Had I made a mistake by leaving the people in front of me? I was backtracking through a barren plateau with mountains towering on either side. The tree line was more than two hours below me. Should I stop and put up my tent or continue on to the safety of the trees? Or should I head the other way

around? I couldn't think straight anymore. It felt unsafe spending the night up here by myself. Dark clouds gathered around the peaks. I cursed myself for having gotten into such a stupid situation again and hobbled down the path that I had climbed only an hour ago.

All sorts of thoughts shot through my head: wasn't this even more dangerous, being totally alone without shelter high in the mountains? Had I made a mistake by leaving the people in front of me?

All of a sudden, I saw a black dot slowly moving towards me in the distance. Could it be? Yes, it was a hiker. This was my chance to not have to spend the night on this deserted plateau alone. Whoever it was, I had to convince them not to continue on today, to camp here, and do Forester Pass together with me tomorrow morning. When the hiker eventually reached me, I walked towards him with a big smile and open arms, blocking the trail so that he couldn't pass. He was a tall, thin man in his forties and, unlike most other hikers, he was clean shaven and looked healthy. I acted as if we were best friends who hadn't seen each other for years. I asked him what his plans were, whether he also thought the snow was too dangerous at this hour. He didn't seem to see the problem and was about to continue on when I switched to a different tactic. I was totally honest and told him I no longer had the strength to cross the pass today and that I would really like to scale it together with him the following morning. My voice trembled. I almost begged. He took a long look at me and said in friendly tone, "Why not?" He introduced himself as Claude and began setting up

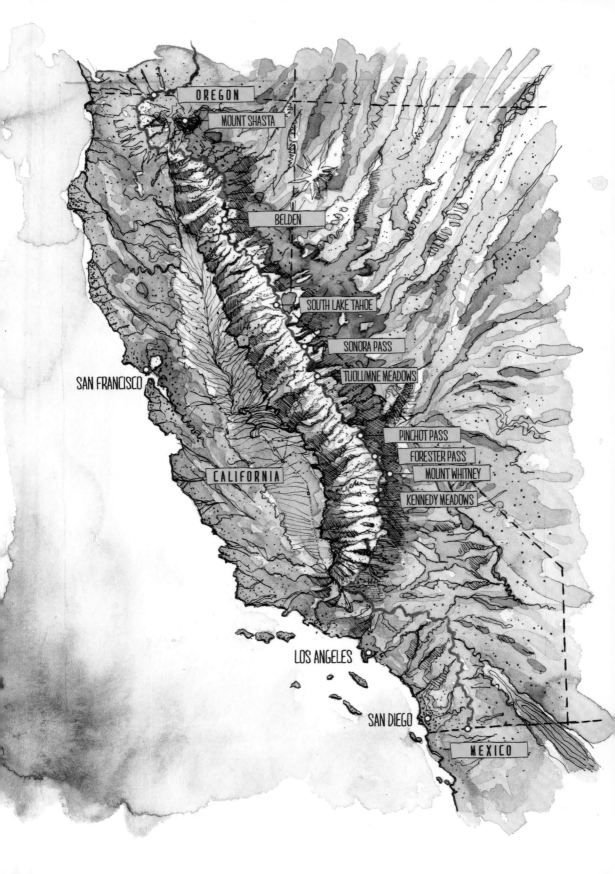

OREGON

MOUNT SHASTA

BELDEN

SOUTH LAKE TAHOE

SONORA PASS

TUOLUMNE MEADOWS

SAN FRANCISCO

PINCHOT PASS

FORESTER PASS

MOUNT WHITNEY

CALIFORNIA

KENNEDY MEADOWS

LOS ANGELES

SAN DIEGO

MEXICO

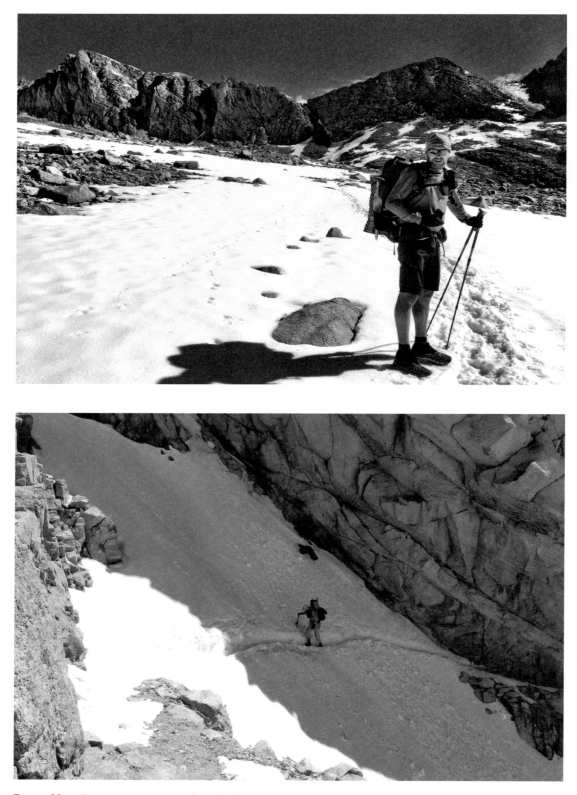

Top: Claude prepares to lead the way over Forester Pass.
Bottom: I cross Forester Pass, at 13,000 feet (3,962 meters).

his tent. From that moment on, he was my hero. My savior. I set my tent near his and noticed I was still breathing heavily due to the altitude. I asked him if he was also having trouble breathing, but he hadn't noticed a thing. While we ate, I learned that he was from Luxembourg and that he could even speak a little Dutch, but we quickly switched back to English. He ran a successful business and needed some time to reflect after having worked non-stop for 20 years. He'd recently lost his trusted dog, who had been at his side day and night, and had decided to spend some time alone by hiking the PCT. The conversation was comforting, but I kept a constant eye on the clouds as they grew over the nearby mountains. I asked Claude if he thought there was going to be another storm that night.

A cold wind battered the tents. I peeked outside every few minutes to see if the clouds were getting closer. The combination of the high altitude and my lingering fears were a nasty mix.

"A storm? Tonight? No, don't worry." He answered calmly, but I wasn't convinced. But what could I do? As it grew dark, we retired for the night. A cold wind battered the tents. I peeked outside every few minutes to see if the clouds were getting closer. The combination of the high altitude and my lingering fears were a nasty mix, which made it hard to fall asleep. My tent flapped violently as the temperatures plummeted to freezing. I put my raincoat over my down jacket but was still trembling inside my sleeping bag. This called for more drastic measures, and, in an attempt to keep the wind at bay, I grabbed the groundsheet from under my tent and wrapped it around my sleeping bag a

few times. I could hardly move, wrapped like a caterpillar, but it did help. To block out the noise, I put some earplugs in, swallowed two ibuprofens, and lay there, cocooned deep in my sleeping bag. Hopefully I would wake up feeling better and could fly over the mountain like a butterfly.

Just before sunrise, I unzipped my tent and saw two unfamiliar figures walking up Forester Pass far in the distance. Next to me, I heard the rustle of plastic bags and the sound of air being squeezed out of an airbed. I jumped into action and stuffed all my belongings into my backpack. I felt so much better than the night before. In less than five minutes, I was ready to rumble. I even looked forward to scaling the pass. What a difference a good night of sleep can make.

Without exchanging a single word, Claude and I saddled up and headed toward the pass. I put my microspikes on to cover the initial snowfields, which were still coated in a hard layer of ice. Upon reaching the final, rather steep ascent, we followed innumerable switchbacks up the cliffside. It was a 2,300-foot (701-meter) climb, and the higher we got, the closer we had to walk to the rock face. The drop fell vertically right next to the trail. At 13,000 feet (3,962 meters) we approached the notorious ice chute that we would have to cross one at a time. There were deep footprints across the chute, a 45-degree slope that plummeted thousands of feet straight down.

"Don't look down. Whatever you do, don't look down," I mumbled.

"I'll go first." Claude carefully proceeded in the footsteps of previous hikers. I grabbed hold of the cliff face and held my breath as I followed his progress. Halfway across, he suddenly stopped, looked back at me with a cheeky grin, got out his camera, and took some pictures of the abyss below him. He then continued to the safety of the rocks 65 feet (20 meters) away.

Now it was my turn. I threw a fleeting glance into the depths, thrust the handle of my ice axe deep into the snow, and carefully placed my shoe in the first footprint. Systematically, I repeated every movement: ice axe, step, ice axe, step. My fear of heights didn't help, and I felt my body tense up. It was painstakingly slow going, and after ten steps I stopped to take a deep breath to relax my nerves. That helped and I was able to get across in one piece.

When I reached the other side, I grabbed Claude's hand as he pulled me onto the rocks. Safety! It was only a few more yards until we reached the saddle of Forester Pass. The view that awaited us on the other side of the mountain was picture perfect. The ancient glacier valley, flanked by gray-blue mountains, stretched out for miles in front of us. I could see countless Mediterranean-blue lakes dotted in the distance. It looked like the promised land. But there was much more snow here on the north face of the mountain, and we would have to descend through it for a while. Despite its fairy-tale beauty, I couldn't fully appreciate it. I still felt uncomfortable and wanted to get out of there. The nearest road was more than 20 miles (32 kilometers) away, and we would first have to cross Kearsarge Pass. It was going to be a long day.

During the long descent into Kings Canyon, I lost sight of Claude and steadily continued alone. The last climb up and over Kearsarge Pass was followed by an endlessly steep descent of more than 2,500 feet (762 meters) into the desert valley. By the end of the day, I was in a daze, moving on autopilot. I hadn't stopped to eat. But I couldn't wait to get to the safety of a town, and there was nothing that could stop me until I found a bed. It was almost dark when I finally reached the road to hitchhike. But there weren't any cars, so I started the extra 12 miles (19 kilometers) along the road, which led to the town of Independence. I couldn't give a damn

anymore—I simply had to get off this mountain. Eventually, a police car pulled over and kindly offered me a ride to town. I was too tired to talk and only politely answered the questions the friendly officer asked. He dropped me off at a motel in Independence, where I checked into the last available room they had. When I closed the door behind me, I collapsed on the bed and fell asleep with my clothes still on.

Rehab in Bishop

Mile 788

After a long sleep, I still felt shaky and clearly needed more time to recover properly. For the first two days, I stayed in bed with the curtains closed and only ventured outside to eat. There was a fantastic little French restaurant called Still Life Café, which served healthy salads and delicious steaks. It took forever for my order to finally arrive, but I wasn't in a hurry. It was such a treat to have a real meal after all those noodles and burgers. Two days passed, and still I didn't feel ready to go back into the mountains. I decided to hitchhike to Bishop, a small desert town 37 miles (59 kilometers) away, where I hoped to see some familiar faces at the famous Hostel California. Before departure, I called the hostel to reserve a bed and then stuck my thumb out to get a ride along the busy road. It was hot, and it took surprisingly long before a car finally pulled over.

On arriving at Hostel California, the man behind the reception told me it was fully booked and that there was no room for me, though I had

The vast pine forests spanning
the valleys of Kings Canyon.

made a reservation only two hours earlier. "Look here, sir," I spoke slowly. "I've just survived a storm on top of a mountain and booked a room with you just two hours ago, so we are going to work this out together, one way or another. I need a bed!" I clearly wasn't myself.

"I'm really sorry, but—" He tried one last time, but I cut him short. "I need a bed, now!" And with that he leaned forward and whispered. "OK, you can sleep in my apartment up here in the hostel's attic. I'll be staying at my girl-friend's place tonight." He grudgingly pointed to the room.

"Thank you," I said and shook his hand as if we had just made an illegal deal. I paid for an additional two nights in a bunk bed in their dorm. I took a shower and rested for an hour, but I felt the need to see some friends. There weren't any familiar faces in the communal room, so I walked across the street to the local brewery,

where there was always a better chance of bump-ing into friends. And sure enough, my dear friend Tater Tot, who I'd met in Tehachapi, was sitting at a long table with a bunch of young guys. She had told me about her life on a small tropical island in Malaysia, where she made a living as a self-taught artist. After having lived in the hec-tic hustle of England for most of her life, she had decided to travel the world and ended up on the remote island. There she lived a simple life, living in a single-room cabin near the beach, where the sound of the waves sang her to sleep each night. She helped out in the local resort from time to time to make ends meet, but concentrated most-ly on teaching herself to paint her surroundings, from the tall palm trees to the dense, wet bushes teeming with insects to the continuously chang-ing light over the sea. In her 30s, Tater Tot was a beautiful woman with a thick Cockney accent. She had shaved her head at the start of her hike

to combat the heat. She clearly loved extremes, as she was very independent but also loved to look after people. She had a youthful spirit and mostly hung out with guys no older than 20 on the trail. But more than anything, she always seemed to be the queen bee, initiating the fun and games wherever she went. It was impossible not to love Tater Tot. I gave her a big hug and joined her table as she introduced me to Necktie, a young chap from England she'd been hiking with the past few days. The other noisy hikers at her table seemed like a bunch of goofy high school dropouts.

Before I knew it, I had ten different kinds of IPA in small glasses in front of me. We knocked back the shots of beer and ordered some more to go around. Tater Tot was totally in her element: she had secretly arranged that Necktie could play his guitar along with the local bluegrass band that was currently playing in the brewery. Everywhere he went, Necktie always carried his thin Martin guitar with him, so this was a perfect occasion to show what he had to offer.

Necktie was a lanky, modest boy with a perfect, British boarding-school accent. He was a touch shy. But once he stepped on stage, he turned into a true entertainer and played an amazing solo. The whole bar lit up during his performance, our little Mark Knopfler. What a transformation! With each drink I felt more at ease, singing along with the band's songs that I knew.

The following day I awoke to find that my whole body was as stiff as a plank. I could hardly walk. My back and shoulders really hurt, and my legs and feet were starting to cramp. The stress and tension of the past week had taken hold of my body. I clearly needed some real treatment if I was to get myself back into the mountains. There was no other option but to find the cheapest local physiotherapist to sort me out. I was not looking forward to hearing what it would cost. I'd have to cut back on the beers for a while.

After a few calls, I hobbled into a white room and lay face down on the treatment bench. After a lengthy silence, the man in the white coat asked: "Why are you hiking?"

"Well, 'why not?' you could also ask," I said with a cheeky smile, which he obviously could not see as my face was buried in a towel. "After having spent years of 60 hours a week behind a computer screen and a pretty jam-packed schedule, I felt I needed something else," I mused aloud. "More nature and adventure. To experience a humble, simple life alone in the woods. Something completely new. To see the world and rediscover myself perhaps. Who knows?"

Nobody could answer the question "Why are you hiking the PCT?" more beautifully than my dear friend Pogue Mahone: "It's probably the only place where I can truly be myself. I feel at home out here."

I told him that I had asked the very same question to others I had met in recent weeks, to find out what motivated them to hike the PCT.

A 20-year-old guy from Texas had told me he'd become utterly bored with life after having taken up two jobs to pay the bills. He had read an article about the PCT, quit both his jobs, and had impulsively decided to hike the trail three weeks before departing. A woman from Kansas confided in me that she'd left her abusive husband and felt a lot safer out on the trail. She was slowly regaining her confidence in people and faith in humanity. What a story! There was also a young guy from Seattle who saw the trail as a ritual passage of a boy coming of age. According to a French hiker I spoke to, her life was too short to sit in an office for another 15 years. But nobody could put it more

beautifully than my dear friend Pogue Mahone: "It's probably the only place where I can truly be myself. I feel at home out here."

"Okay," I heard behind me in an obligatory tone. The poor physiotherapist had asked me one simple question more than an hour ago, and consequently had to listen to all my endless stories. Perhaps I should've gone to a psychologist instead.

Back in the Saddle

Mile 836

After having spent five days in town, it was time to get back on the trail again. But was I ready? I was still anxious about thunderstorms in the mountains. Fear had taken control of my head, heart, and body, and I worried it would return at any time. But I needed to plough on.

Back at the hostel, I had hung out quite a bit with an Englishman my age and decided to return to the mountains with him. He was an experienced climber and had a lot of mountaineering knowledge. I felt a lot safer with him around. He was a funny chap, always up for a discussion, challenging people's opinions with his outspoken attitude. And of course, his trail name was England.

We got a ride to the trailhead where I had been picked up by the police car five days earlier. Without saying a word, we trudged up to Kearsarge Pass, which seemed to go up forever. After five days of rest, my legs had to acclimatize to the heavy walking again. I could clearly feel the beers with every step I took. I had the weight of nine days' food in my backpack. The sun was relentless. In minutes, my clean, washed shirt was soaking wet.

Walking down into Kings Canyon, we started talking. It was fascinating to hear how England had arranged his life. He didn't have a conventional lifestyle and hadn't had a regular job for years. He was a modern vagabond, constantly on the move, focused on living in the present. He was a minimalist who spent very little money. His fixed annual living costs were less than $1,000 (ca. €850), and he did a bit of construction work to make ends meet. I was pretty astonished to hear this. My monthly costs were nearly four times what he spent in a year. For England, it had become something of a sport to live as economically as possible. He lived in a camper van he had converted himself, with a tiny Smart car hooked on a trailer at the back.

This way he could visit his friends, park the van in front of their house for a short while, and drive around town in his tiny Smart. During the summer he generally took to the Alps and walked from hut to hut, but in recent years he had increasingly done long hikes across America, where he felt he could fully experience the freedom of untouched nature. In comparison, just a handful of countries in Europe allow wild camping, but in the vast American national parks you can pitch your tent practically anywhere you want.

Wherever England hiked, he always tried to spend as little as possible. He was witty and vividly described how he'd been heavily involved in the underground acid house scene in London 20 years ago, where raves in abandoned warehouses sometimes went on for three days. Now he had completely surrendered himself to the mountains, which he found just as intense as the acid parties all those years ago.

At the end of the day, we stopped at a flat spot between the trees to set up camp. I made

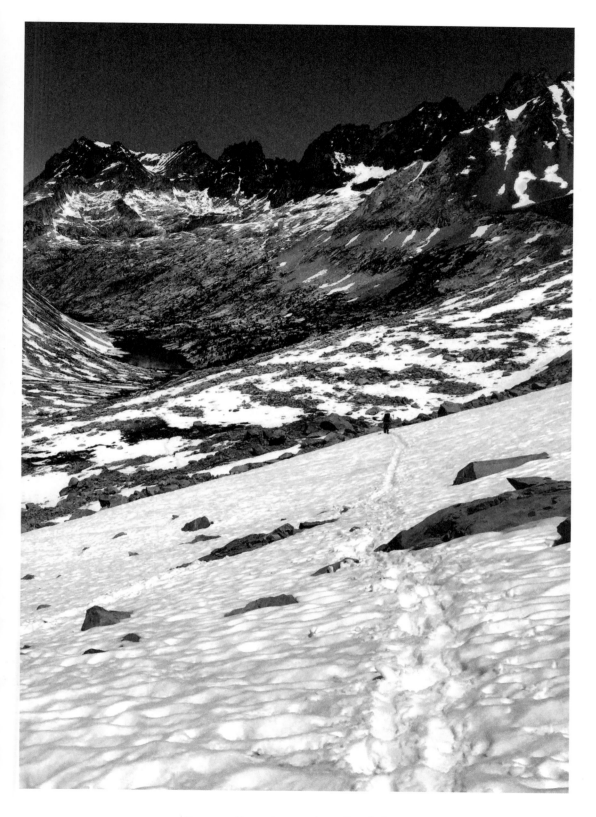

Descending into the glacial valley of Kings Canyon.

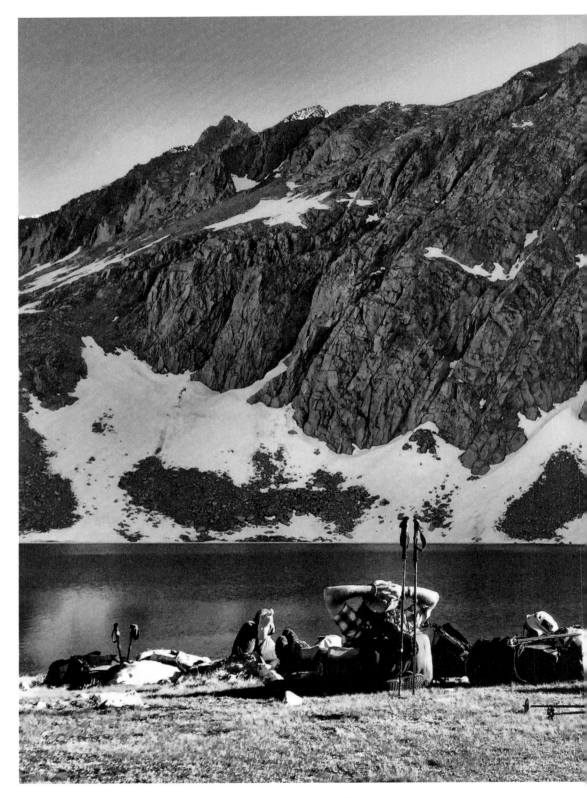

Pogue Mahone and the guys take a lunch break at
Rae Lakes, having just crossed Glen Pass.

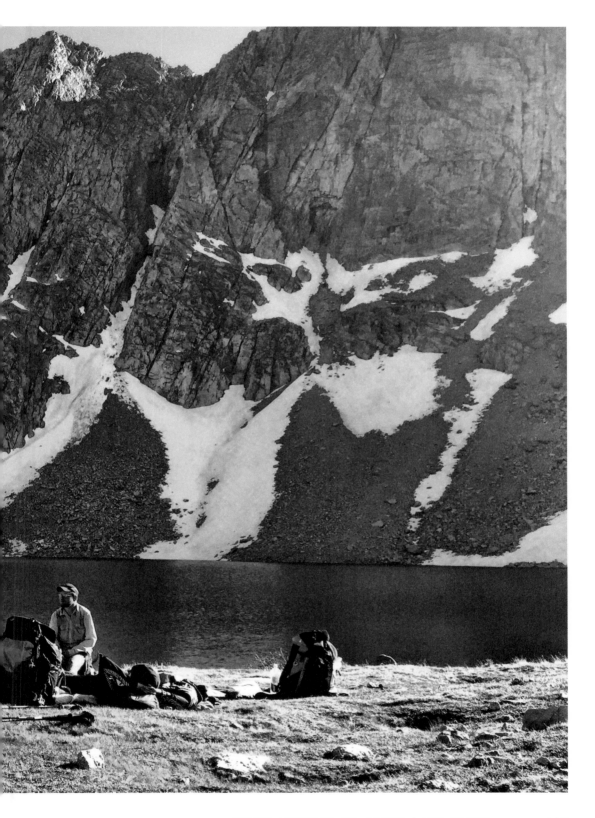

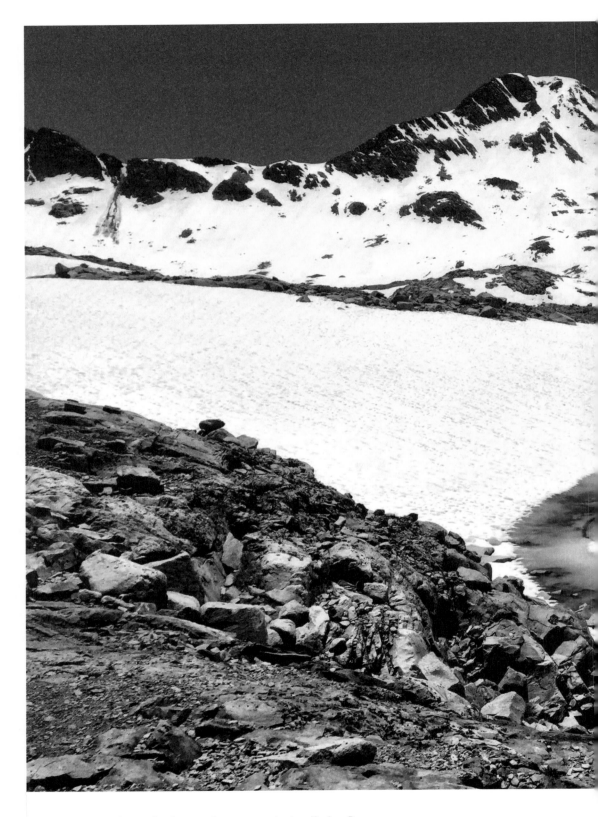

Helen Lake, just before the ascent to Muir Pass.

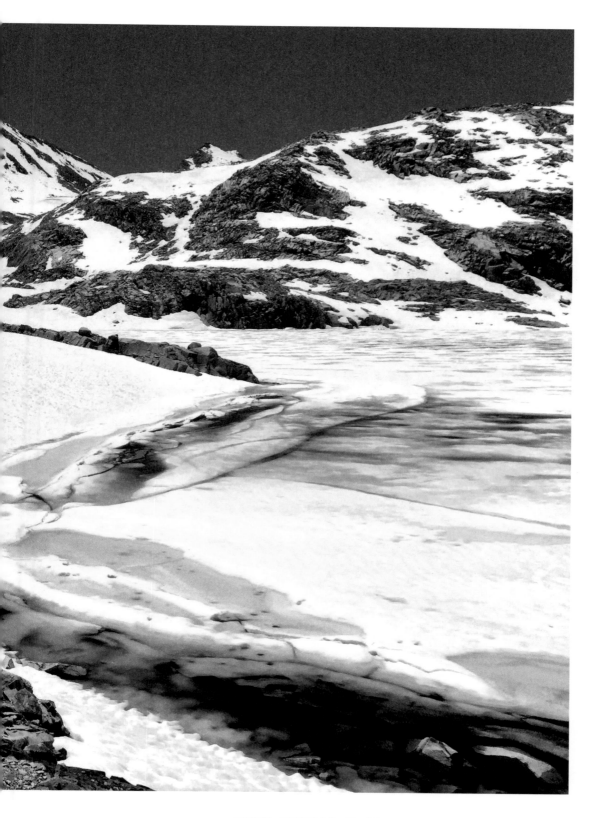

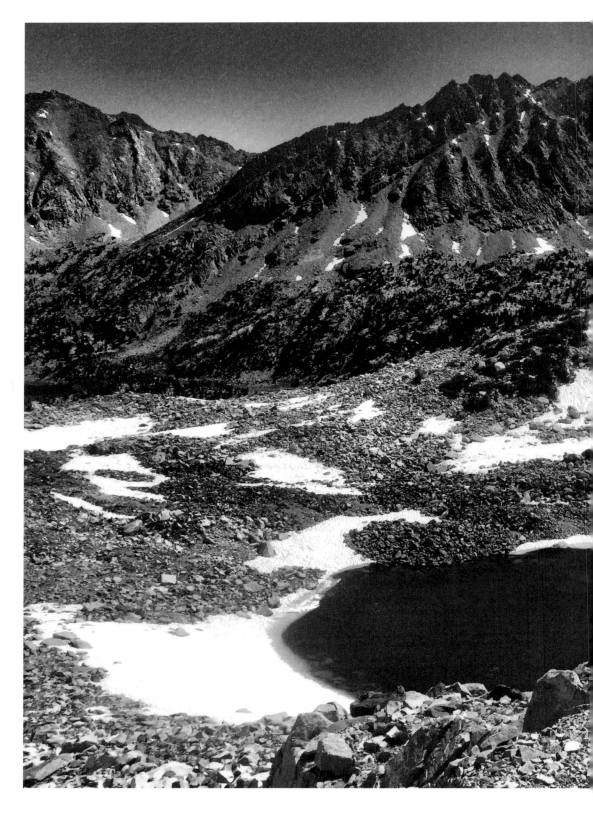

One of the many hundreds of lakes in Kings Canyon.

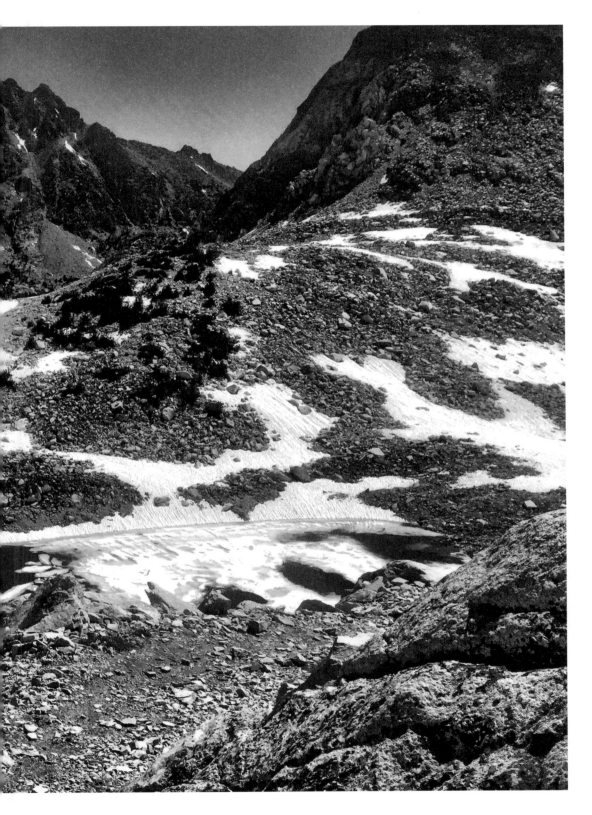

a small fire down by the river and put wet leaves over the hot ashes to create smoke. This allowed us to cook dinner and keep the teeming mosquitoes away. We'd both taken a beer with us, which tasted a lot better on the trail after the long hot day than any I'd drunk in the bar.

Before going to bed, England insisted we hang our food high up in the trees because we had entered bear territory. I hadn't seen one yet, but according to him, they were everywhere, especially close to the rivers. We had become guests in their backyard. Although bears don't like hikers, they absolutely love hiker food, and, with their sharply developed noses, they could smell everything we had with us, right through the plastic packaging. England didn't trust the mandatory bear canister that you had to leave on the ground a few yards from your tent.

But it was a lot harder than I thought to hang my food. I took a careful look at how England swung his rope over a high branch, which he succeeded at his first attempt. Now it was my turn. I tied a small stone to a long piece of rope, wheeled it like a lasso, and threw it up with all my might. Not high enough. I collected the tangled rope and made another attempt. This time it went high enough but straight up, almost landing on my head on the way down. I kept trying, but even after fifteen minutes I had no success. There really was an art to this David and Goliath business. I nearly got it right, only to discover that the stone at the end of the rope had gotten stuck in the branches. England couldn't stop laughing and finally took over. He hurled my rope over the high branch in one go, fastened my food bag to it, hoisted it 12 feet (4 meters) into the air, and tied the rope to the base of the tree. That's how you do it. In the days that followed, we had our work cut out for us with challenging 12,000-foot (3,657-meter) obstacles: Glen Pass, Pinchot Pass, Mather Pass, and Muir Pass. England was an experienced mountaineer and taught me how to safely cross dangerous snow

bridges. By keeping my trekking poles horizontal I could brace myself in case the snow collapsed, so we wouldn't end up in the icy river that gushed in a tunnel beneath the snow. He taught me how to decipher all the different types of clouds, and, in the process, my confidence slowly returned. As my trust in nature rose, I began to appreciate the beauty around me again. So there I was, jumping into every lake I came across.

However, after a week things took a turn for the worse for England. His foot began to swell up drastically because he had switched to another brand of shoes. As a result, he had to leave the trail at the first possible exit in order to rest and allow it to heal. We agreed to rendezvous the following week some 100 miles (160 kilometers) farther on the trail, but unfortunately his injury lasted longer than expected. I continued alone but felt a lot stronger thanks to England's support.

Yosemite

Mile 929

After having reached Donahue Pass, 929 miles (1,495 kilometers) from the start of the trail, I walked into Yosemite National Park. It was paradise on earth. As dusk fell, I descended into a valley along the river, and it was as if all the animals emerged from the forest to drink its waters. I secretly hoped to see my first bear bathing in the river, but was more than content with the deer, squirrels, marmots, and a bald eagle. Spring was in the air. Again! After having experienced my first spring some months ago in the desert, it had only now started in the Sierras. The seasons slowed at this altitude, spring coming late in the cold mountain air, but because

of the recent heat wave, the mountain flowers were all coming out. It was like walking through *The Sound of Music* crossed with *Groundhog Day*.

After almost three months of walking, I still wasn't even halfway along the trail. I was beginning to wonder if I would ever make it to Canada. Something had to change. After giving my progress some thought, I decided to get up earlier and hike for longer days. I joined a young Israeli guy who walked extremely fast, as he was trying to catch up with some friends a few days ahead of him. He went by the name of Animal Style and had just completed his three-year military service. He had a remarkably loud voice, and it was never hard to find him in town as there would always be a small circle of hikers gathered around him, listening and laughing at his jokes. He seemed to continuously speak in corny movie one-liners by Arnold Schwarzenegger. His heavy Israeli accent was very distinctive, his language full of foul slang he had picked up not on the streets but from playing computer games like *Grand Theft Auto*. It somewhat amazed me that he planned to become a doctor one day. But for now, he hoped to see the world, and what better way

to do that than as a smelly hiker, a "chillax to the max!", "let your ego go" dude. The combination of his loud Israeli accent and cheesy one-liners cracked me up every time. We did back-to-back marathons for several days while we talked.

> After almost three months of walking, I still wasn't even halfway along the trail. I was beginning to wonder if I would ever make it to Canada. Something had to change.

I had a great time with Animal Style, but once he had caught up with his friends, the pace slowed dramatically. Rushing things clearly wasn't his style. "Chillax," he shouted as I headed on at my own pace, and soon I found myself walking alone again. The last high pass of the Sierras, Sonora Pass, was not far ahead of me. I decided to set up my tent just before the summit.

My meals had become increasingly bland as time progressed. I had already eaten most of

the good stuff and was now left with noodles and mash for days. It was mostly salt that I craved at the end of a long day, and the spices that came in the pack of noodles seemed to hit the right spot. Another thing I had picked up recently was miso soup. It was super light and very salty, and I slurped two cups of the tasty Japanese soup each evening to start my meal with a bit of flavor. For the rest, I tried to give my noodles or mash some bite by adding Sriracha hot sauce. This generally burnt my tongue but made any bland food taste better. For dessert, I had a handful of raisins, since all of my sweet bars were finished off. Dinner wasn't great, and I had eaten the same thing for more than a week, but I didn't care. It was calories and salt and didn't add too much weight to my pack; that's all that interested me at this point.

I took in the beauty around me. The horizon glowed a brilliant orange. The colors sank behind the white peaks and morphed into a darker, starry night.

That evening, while I sat to eat my noodles, the sky transformed into a colorful blaze. Nourished, I settled in to watch it. The dusty ground around me was red-brown, as the gray, granite mountains of the Sierras had given way to the volcanic lava peaks. I'm a sucker for sunsets, but why had I chosen to sleep high up on the mountain ridge once more? I was again exposed to the unpredictability of the elements. The contradictions bounced through my mind, but for now I just took in the beauty around me. I tried to distinguish all the different shades, as the dark blue flowed into purple, itself flowing to a thin layer of deep red. The horizon glowed a brilliant orange. The colors sank behind the white peaks and morphed into a darker, starry night.

It was still cold when I got up and left the following morning. The descent down from Sonora Pass was difficult, with lots of loose grit, and I had to be careful not to slide down off the steep volcano slope. There were still quite a few snowfields that I had to cross, and it was on one of the last of these that I suddenly saw two girls fall and slide down the mountain. I was shocked. They came to a halt at some boulders, 250 feet (76 meters) below. I called down, hoping they were alright, but the wind was too strong, and I wasn't able to hear what they yelled back at me. But I saw two thumbs-up to indicate that everything was okay.

I had to cross the exact same section of snow where the girls had slipped and fallen, but I no longer had my microspikes with me. Naively, I had sent them home a week earlier because I thought I wouldn't be needing them anymore. The footsteps across the sketchy part of the snow had also been swept away by their fall, making it practically impossible to take the same route.

Turning back wasn't an option because I didn't have enough food for the trek back. The trail ahead was the only way to reach the valley. I was stuck. I looked back, hoping to see someone else behind me, but there was no one. I carefully took three steps onto the snow to see if it was possible to create some new tracks, but with the fourth step my foot slipped away. As I fell, I just managed to thrust my trekking poles into the snow to self-arrest my fall. I clung on without twitching a muscle, for fear that the smallest movement would make me slip down the slope. As I glanced down into the abyss, my fear of heights grabbed me by the throat. I could feel my body cramp up. But I had to do something. I took a few deep breaths, then slowly pulled myself back up again, awkwardly crawling to the safety of solid ground. I heard some distant shouting from the bottom of the slope and waved down to indicate that everything was okay. I had

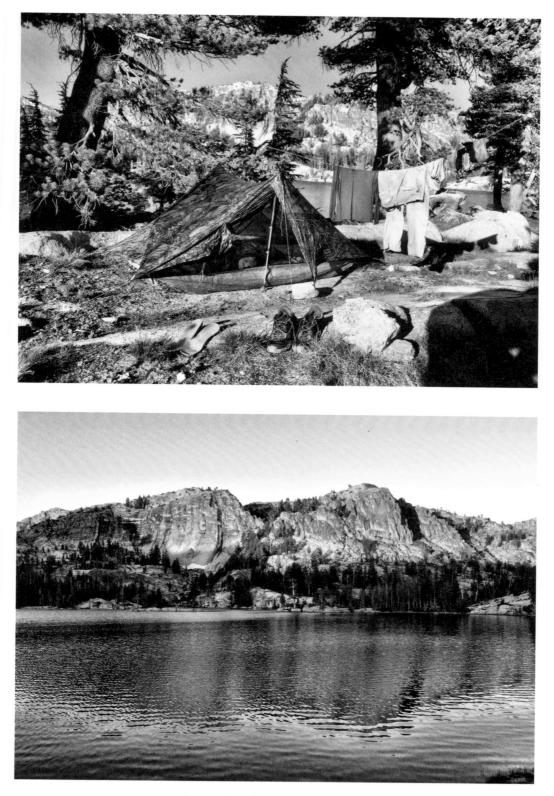

Top: Hanging my laundry out to dry in Yosemite.
Bottom: Sunset on the mountains of Yosemite.

Animal Style climbs toward Sonora Pass.

Leaving Ansel Adams Wilderness behind and getting
a first glimpse of Yosemite National Park.

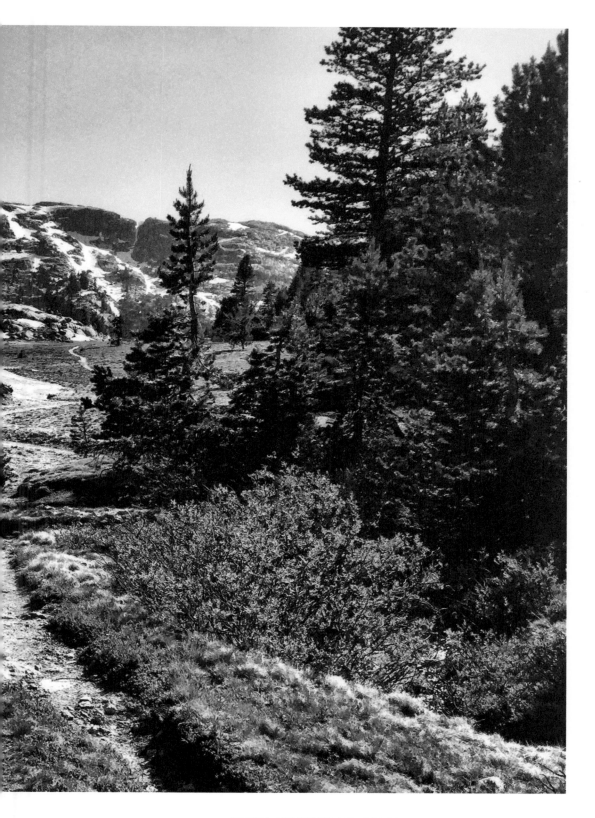

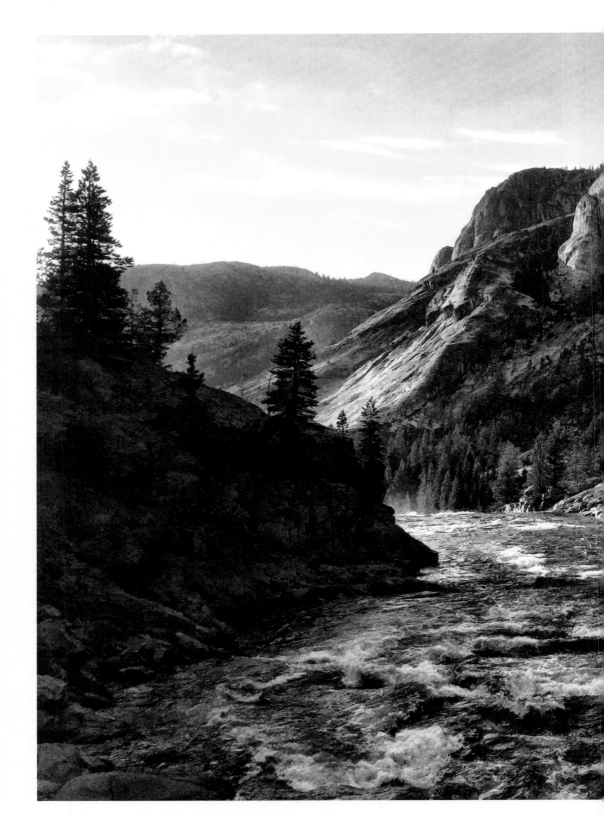

A stunning waterfall plunging into
one of Yosemite's grand valleys.

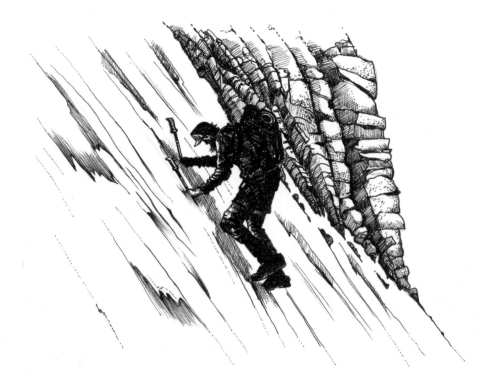

lost a lot of energy but hadn't moved an inch. This was serious stuff. I took my backpack off and walked back to see if I could scale the over-hanging rock face, which stretched above the icy slope. I figured that there could be an alternative route if I walked back a few yards and followed a long, stone ledge, which was no wider than my foot. Since the rock face was vertical, it wasn't covered with snow, and there appeared to be a few deep cracks I could put my fingers in for sup-port. My palms started sweating just looking at it, but there was no other option. I had to give it a try. I would have to climb using my hands for a while, especially to get around the large, over-hanging boulder. I returned to my backpack, put it on, and carefully started the detour, far above the original trail. It was painstakingly slow, and I didn't dare look down for a second. I almost lost my balance when my shoulder strap got caught behind a sharp rock and I had to hold onto the rock face, clinging to its cold surface. Time and

again, I had to wipe my sweaty hands dry. I could feel my legs shaking as I edged forward. Every few yards, I paused with my cheek pressed to the rock wall to take a deep breath and settle my nerves. I was living my biggest nightmare. All in all, the whole stretch spanned no more than 150 feet (46 meters), but once the steep rock wall was finally behind me, I could still feel my heart furiously throbbing in my throat. I was safe! I col-lapsed flat on the ground, regaining my strength. I was more than relieved to finally rejoin the trail. The slope was a lot less steep down there, and it was relatively easy to kick new steps in the snow with my heels.

With Sonora Pass behind me now, the Sierras were finally over. I had done 500 miles (800 kilometers) over the course of a month. The going had been slow over the high snowy passes, but it had been great to have so much water around me. I rarely carried more than a liter, since there was always an ice-cold stream

to drink from. Although I hadn't had a shower in 12 days, I had frequently stripped and washed in the numerous lakes I passed every day. The water was so cold that it felt as if it burned my skin as I jumped in. I often tried my luck at catching a fish

> My confidence had returned, and apart from the few sketchy river and snow crossings, I was enjoying my surroundings again. The smallest little things made me smile as I walked through the forest.

before dinner, but they always outsmarted me and managed to eat the precious salami from my hook without getting caught. I hadn't seen a single sign of civilization for days and could see how the high mountain ridge managed to keep the tourists and day hikers at bay. I had never experienced such a long stretch of time without internet, cell coverage, or a convenience store in my life. But I could see it had done me good. My confidence had returned, and apart from the few sketchy river and snow crossings, I was enjoying my surroundings again. The smallest little things made me smile: the warmth and flicker of the flames when I made a fire at night, the strong smell of young pinecones as I walked under the tall pines, and the soft, bouncy ground that the pine needles created as I walked through the forest.

But don't get me wrong, I was equally happy to reach a road again and stick out my thumb to hitchhike into South Lake Tahoe. As it was the biggest city I had seen in months, it was a bit of a culture shock. There were cars everywhere, loud groups of people celebrating bachelor parties, and lots of tourists in bright colors. It was a popular holiday resort for water-sports enthusiasts in summer and skiers in winter.

Even more important than a shower was my burning desire for food. I was hungry as hell and desperately craved fresh vegetables and meat. As soon as I was in town, I stopped at the famous casino buffet at the luxury Harrah's Hotel. It was an all-you-can-eat buffet, and I kept going back for more. The feast went on and on: salmon salad, pasta, vegetables, sushi, steak, soup, chocolate cake, crème brulée, fresh fruit with cream, beer, coffee, and whiskey. While I ate in silence, I looked out of the window, high over the white mountains I had just left behind me. It had been beautiful and overwhelming in the Sierras, but I longed for the simplicity of Northern California's wide desert hills. A predictable terrain stretched out in front of me.

Quitting

Mile 942

In South Lake Tahoe, I finally saw England again. Unfortunately, he still hadn't recovered from his foot injury and, as a result, would ultimately have to quit the trail. But he was not the only one: a large number of hikers don't actually finish the PCT, mainly because of injuries like infected blisters, fractures, or simply exhaustion. Tendonitis was particularly painful when it took hold of your shins. Created by thousands of tiny tears in your shin tendons, it makes every step excruciatingly painful. But the worst thing about tendonitis is that it takes forever to get rid of, and there's no quick-fix pill you can take. Even after two weeks of rest and constant ice packs, it can return and haunt your trail until the end. Of course, there are also complications

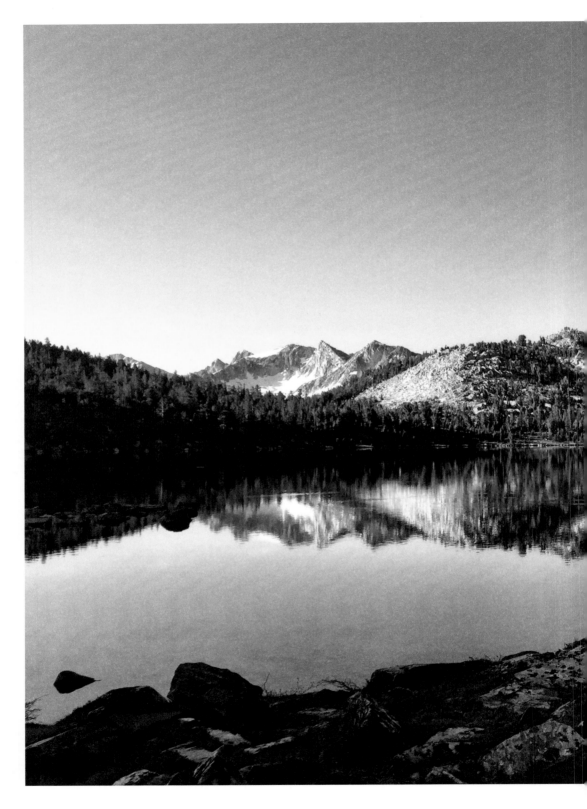

A crystal-clear lake not long after Tuolumne Meadows.

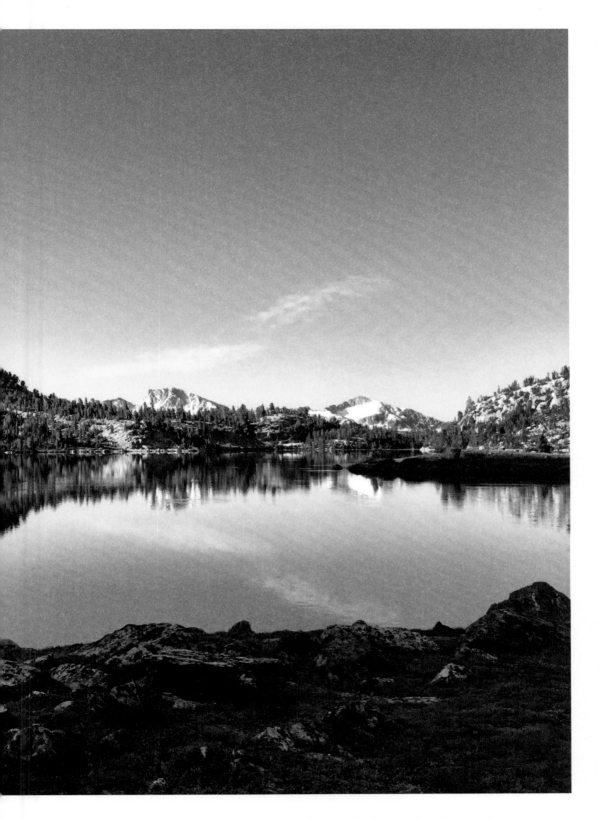

back home that cause a number of people to stop prematurely. But I also met a surprising number of youngsters who discovered that their cash had dried up halfway along, forcing them to leave the trail and head home.

Demotivation and inner demons were ultimately what drove most people off the trail. For some, the honeymoon was quickly over and the magic was gone; the wilderness wasn't romantic anymore—it was hard work. Or they simply lost the motivation to get up and hike every day. The pain never really goes away, the mountains never get any flatter, the hard, cold nights in the tent don't abate. For some, they find shattered illusions about the trail's power to change them. The trail provides, but doesn't magically solve all your problems, and it's hard to avoid your bad habits even when you are out on the trail. For some, the endless hours of being totally alone are simply too much.

Demotivation and inner demons were ultimately what drove most people off the trail. For some, the honeymoon was quickly over and the magic was gone; the wilderness wasn't romantic anymore—it was hard work.

I hadn't seen my dear friend Pogue for weeks and was shocked to hear that he had quit too. For me, Pogue was the embodiment of everything the trail stood for: a beautiful, big, strong American. He was very self-sufficient, loved freedom, and felt completely at home in nature. As a child he had often gone out into the woods alone and would spend nights on a hunting high seat. It seemed as if he never worried about anything—certainly not about what could happen tomorrow—and rarely dwelled on the past. He enjoyed the present as a true vagabond, with his beloved hash pipe in his mouth. Women were very fond of this charismatic energy. Through the grapevine, I heard that Pogue had left the trail in Mammoth Lakes to visit his girlfriend for a week, but supposedly he hadn't returned. Off-trail life—with all its comforts and temptations—can pull harder than you might think. He had left for good. It's easy to lose your flow and motivation if you step off the trail for too long.

Although I hadn't seen him for more than a month, it felt strange to know Pogue was no longer on the trail with us. We never sent messages—I didn't even know his real name—but it always felt good to know he was somewhere around, either ahead of or behind me. The trail felt a little less complete without the exuberant energy of Pogue Mahone. He had made a big impression on me. Though I knew I'd bump into him again sooner or later in life, his departure played through my mind as I walked up and over the endless hills.

I, too, had my bad days. The day after I heard about Pogue's decision to quit, I woke to find that my shoes and socks were still soaking wet from the river I had crossed the previous day. I didn't want to get up and couldn't find anything appealing about the prospect of walking up the mountain that lay ahead of me. Being alone rarely made me feel lonely, but my mood that day was darker than ever before, and I couldn't twist my thoughts in a positive direction. What was the point of all this? I still had such a long way to go, the scale of the trail just overwhelmed me to the point that I became a little depressed. I missed the sense of belonging that I'd felt with the Rat Pack and longed for the comfort of friends and family. But what could I do, sulk and take pity on myself all day? I had to get up and hike, grit my teeth, and hope the day wouldn't bring too many challenges.

As the trail continued and the days rolled into one another, it was harder to motivate myself. But they say you should never quit on a bad day. If you are thinking of stopping, postpone your decision for at least a week. Then, if you still want to quit, it's okay. Head on home.

But no one had told me that the pain never stops. Although my body was in pretty good shape after a thousand miles, there was always something that hurt and needed attention. I was constantly readjusting the straps of my backpack to change the height, to try to reduce the painful rubbing on my hips. The weight my hips had to bear always seemed to cause problems. I tried sponges and cut up an old sleeping pad to create more padding, but nothing really seemed to eliminate the pain altogether. There was always a muscle or tendon in my leg that was slightly injured after I had rolled my ankle over a rock I hadn't seen in time. But it was the pain in the balls of my feet that never totally seemed to go away and always flared up at the end of each day. I did my best to massage them with a tennis ball before going to sleep, smearing them with ibuprofen gel to ease the inflammation caused by the beating they received day in, day out. Poor feet. But however hard the trail was, it never drove me so mad that I would actually quit. I could only quit if there was trouble back home with my family or with a serious injury. I knew I would probably regret quitting and would deeply miss being in nature, which seemed to be getting more and more impressive.

As I walked through Yosemite, the sunset transformed the vertical rock formations into a golden cathedral. Yosemite had captured my mind since the day I had visited with my family when I was 14 years old, and it was great to be back amongst its round, monolithic rocks. The meltwater from the snow up high meandered through the cracks to form thin, white waterfalls, descending the cliffs into the valley. Amidst these large rock formations stretched a long, green valley with a wide, gently flowing river.

The evening light seemed to bring out all the animals. Everywhere I looked there was life. From the millions of mosquitoes, who luckily couldn't quite keep up with the pace of my stride, to the many deer that came out to drink. It was clear that hunting was prohibited in the national parks, as the animals were not scared of my presence. I would be entering tourist country within a few hours, so I decided to stop early and set up my tent on the banks of the river. It felt good to stretch out in the tall grass and look up at the circling eagles, ready to swoop down and catch an unsuspecting rodent or fish. As the night fell, millions of stars lit the blackness. I wished I had paid more attention during school when they taught us about the star constellations, but my favorite, Orion, with its three-starred belt, was always there for me.

The following day, I stumbled into the tiny hamlet of Tuolumne Meadows, which consisted of little more than a campground, a makeshift post office, and a café along a busy road that led to Half Dome in Yosemite Valley. I was having breakfast at a picnic table when a man named Josh asked if he could join me. He started eating a huge hamburger, opened a Bud Light, and announced that he was quitting the trail. After more than two months, he had decided it was enough. His PCT was over. He was waiting for the next bus to San Francisco, where he could catch a plane back home to Denver. He was eager to share his story and energetically began telling me why he had decided to quit.

Josh was 45, and had, like me, temporarily left his wife and three teenagers to hike the PCT, something he had been dreaming about since he was a student. Although he had intended to complete the entire trail in one go, he had discovered that this was too much for him.

"While I'm out here walking through the wilderness, my children are having to spend the whole summer without their father.

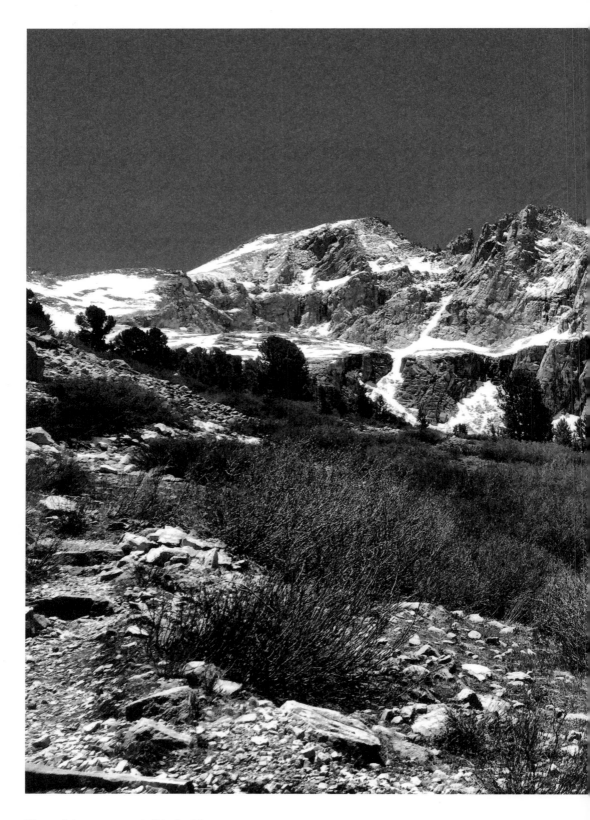

The white-capped High Sierras.

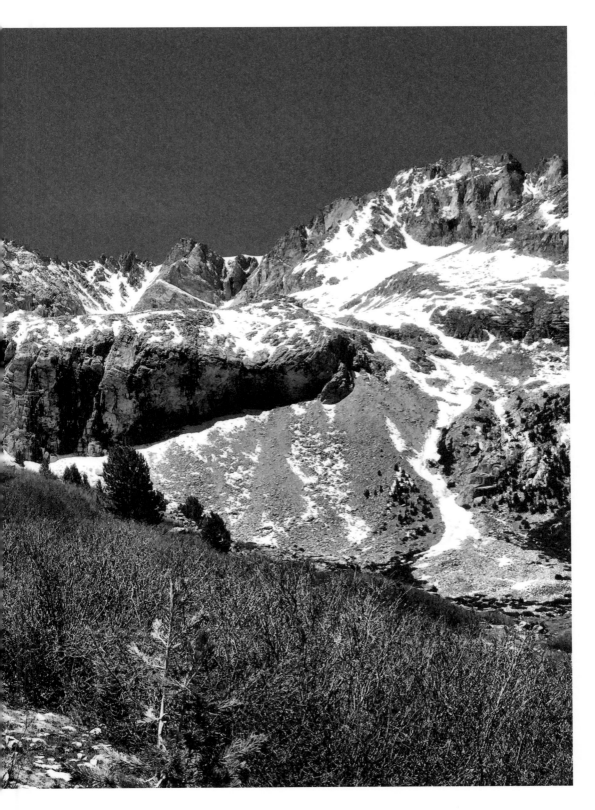

It just doesn't feel right. I've walked far enough to know that I can do it and have decided to finish it in a couple of years when the kids have left home. Some hikers look down on the fact that I'm not a real thru-hiker anymore."

Personally, it was the idea of walking from border to border that had captured my imagination. It was one of the driving forces behind my hike. Completing the entire trail in one calendar year was part of what had drawn me to thru-hiking. If I managed to do the PCT, just imagine how many trails I could try next?

Josh rambled on: "But I've found that this thru-hiking cult is not for everyone and can sometimes even be a bad choice. Section hiking is a much better way to hike for me. Thru-hiking is massively overrated, romanticized, and mostly for dreamers. It's about what suits you best. For me, it's about the experience. There are people who need me back home. I've decided to prioritize my family. I'm going home."

Josh slid his resupply box toward me, threw me a lukewarm can of beer, grabbed his backpack, and headed to the bus that had just arrived. After he had left, I thought about what he had said. Was he right? Was it selfish to leave your family for so long?

While I mulled it over, I took a look inside his box and pulled out some tuna, noodles, and peanut butter. I brought the rest of the food to the hiker box. I didn't need that much, as I had just picked up my own resupply with eight days of food in it. Hiker boxes appeared at every hostel or post office along the trail, with free food or useful items that other hikers had left behind. There were always a few youngsters short on cash who practically lived off the free food they found in them.

In the hiker box I found a book that someone had left behind. *Where the Mountain Casts Its Shadow* by Maria Coffey. For some reason the title triggered something in me, and I began reading it

in the morning sun at my picnic table. The book was about the consequences for the relatives of deceased climbers. I read how the author's boyfriend, Joe Tasker, had died in 1982 during an expedition to Mount Everest. She had interviewed a number of widows for the book, asking about the impact that the loss of their climbing partner had had on the rest of their lives. Now, I was not on Everest and intended on returning home in one piece, but I was well aware that each day there were real risks as I walked through the wilderness by myself. Each year, an average of three hikers tragically come to their deaths or are reported missing on the PCT.

I was mesmerized by what Coffey wrote. Especially about the irony of how climbers' funerals are always full of respect, that at least they died doing what they loved most. But the point she focused on was not the heroic, deceased climber with a new climbing route to his name. It was the effects on the widows and children, the devastation death brought for the family who remained. Time and again, the widows she interviewed pointed out that mountaineers overestimate themselves and underestimate the effects of their actions. It is the folks back home who pay the heavy price of the adventure, not the climber who is no more.

The tale of 45-year-old Andréa Cilento broke my heart. Her father, the American mountaineer John Harlin II, never finished his dream climb, a direct route on the north face of the Eiger. The route he took now bears his name: the John Harlin Direct. But what mattered to her was that he had been gone since she was eight. Although he passed away when she was only a child, she still felt angry and abandoned more than 30 years later. The trauma of this tragic event in her life enraged her to this day. Her story highlighted the responsibility climbers have towards those they leave behind, and it set me thinking about my responsibility back home.

Pffff, heavy stuff. And too true. I would not be paying the price for the risks I was taking, and I had far underestimated the long-lasting traumatic effects a fatal end to my journey could have. And dying was probably the best-case scenario, as the prospect of becoming a missing person on the back of a milk carton was too much to wrap my head around. I did what most people do in such a situation: I drank a beer and started hiking. Sticking my head in the sand and dodging the reality of the question was the easy option.

The Mental Game

Mile 970

A day later, while having lunch at a crystal-clear lake somewhere in Yosemite, I was joined by Genie, a medical student from Australia. She was polite, modest, thoughtful, and was able to articulate her thoughts with remarkable nuance. Our conversation soon moved to the issues of motivation and mental strength. We shared what had motivated us to do the trail in the first place and discussed why it was that so many people around us were suddenly quitting. Everyone seemed to be going through a rough patch, and it was clear that the trail was a lot tougher mentally than physically. I told her about an article that I had once read about mental strength, which had helped me through some of my tougher days. It was an article written by Amy Morin, an American psychotherapist and the author of *13 Things Mentally Strong People Don't Do*.

According to Morin, these are the 13 things mentally strong people avoid:

1. They don't waste time feeling sorry for themselves.

2. They don't give away their power.

3. They don't shy away from change.

4. They don't waste energy on things they can't control.

5. They don't worry about pleasing everyone.

6. They don't fear taking calculated risks.

7. They don't dwell on the past.

8. They don't make the same mistakes over and over.

9. They don't resent other people's success.

10. They don't give up after the first failure.

11. They don't fear alone time.

12. They don't feel the world owes them anything.

13. They don't expect immediate results.

I was especially inspired by number 11, as it spoke about the power of spending time alone, and it reminded me that you don't always have to be dependent on being with others to be happy and confident.

In the past weeks I had gradually recovered from my anxious state of mind. I felt more confident every day. The endorphins flowing through my body probably helped. After all, I was doing a daily, 11-hour workout. I enjoyed my simple life in the forest, sleeping on the ground under the stars, and drinking from the river. Life had taken on a new rhythm, where I no longer looked at my watch. Instead, I woke up when the sun came out and went to bed when it got dark. The sound of bugs and birds in the forest was my stereo, and my thoughts and imagination had become my entertainment. I learned to relax and let go, make fewer plans, set fewer goals, and surrender myself to the surprises the trail threw at me. It was the first time I truly felt that alone time was something I could manage.

Ultra-light or Ultra-cool

Mile 1,000

One evening, I saw a man sitting at a campfire and asked if I could join him. He introduced himself as Scrambler from Texas. He was a young fellow with scruffy dreadlocks, eating some noodles from a peanut butter jar. It struck me that he had remarkably little gear with him. Not everyone hiked across the mountains with heavy packs like I did. From time to time, hikers wearing tiny packs would pass me. I was baffled

and couldn't understand how they did it—surely they needed food, water, a tent, and clothing to survive just as I did. To save weight, these ultra-light guys often didn't carry a gas stove or pan to cook with. Scrambler told me he was doing the entire trail stoveless. In order to prepare

> He told me that he had been inspired by Grandma Gatewood, a pioneer within the ultra-light movement, who had hiked as a pure minimalist.

his food, he simply put his noodles or pasta in an empty peanut butter jar with some water. Within a couple of hours, the meal was fully hydrated and ready to be eaten—cold. He would add some tuna, olives, or tortilla chips to spice it up or give it some crunch. But apparently you can also eat the noodles uncooked. He tossed me a 20-cent pack of instant chicken noodles. I tore the pack open with my teeth, sprinkled the spices over the dry noodles and began to gnaw away at the brain-like cluster. I thanked him for his kind gesture, but this would take some getting used to. I definitely wasn't going to give up my stove any time soon.

Scrambler told me that he had been inspired by Grandma Gatewood, a pioneer within the ultra-light movement, who had hiked as a pure minimalist. In 1955, no more than six pounds (2.7 kilograms) of gear, Grandma Gatewood, whose real name was Emma Rowena Gatewood, had been the first woman ever to walk the entire Appalachian Trail on the East Coast. As a mother of 11 children, she had only discovered hiking at a later stage in life. When she walked the Appalachian Trail, she was already grandmother to 23 grandchildren. She carried an old shower curtain over her shoulder with all her

belongings in it. The shower curtain was multifunctional, as she used it as her tent and rain poncho. It was wonderful to hear how passionately Scrambler spoke of Grandma Gatewood, how he dreamed of hiking as minimalistically as her one day.

But not everyone was going light. In contrast to this ultra-lighter, I also met characters like Banjo, who didn't pay any attention to weight. Full of youthful strength, he carried his guitar and skateboard over every mountain pass. A true romantic if ever there was one. It was always great to bump into Banjo on the trail, since we could make music around the fire. On other occasions in town, I saw him fly past on his little skateboard with a big smile, his long hair waving in the wind. Some things are simply essential to have with you on the journey.

Necktie, the Englishman I had met in Bishop, also carried his guitar with him. Hiking the trail without music was inconceivable to him. I had bumped into him at South Lake Tahoe again, and he'd told me that he had just recorded an album. I couldn't believe it. How had he managed to pull that off in the middle of nowhere?

She carried an old shower curtain over her shoulder with all her belongings in it. The shower curtain was multifunctional, as she used it as her tent and rain poncho.

He told me that he had been busking on the streets of Bishop when someone had given him an offer he couldn't refuse. The stranger had a recording studio in his garage and offered for Necktie to come and record some tracks with him. Before he knew it, Necktie spent the following week in the man's studio writing and recording his first album, *California.* So it goes: the trail provides.

Just like Scrambler, Banjo, and Necktie, everyone I met carried their own personal luxury item. My luxury was a blue chequered scarf. It was multifunctional: I could use the scarf as my laundry bag, swimming towel or pillow, and I could wrap it around my head to protect against the sun and wind. In town I could wear it as the ultimate hiker-trash accessory. Never underestimate the value of trail fashion.

Hike Naked Day

June 21

All over the world, June 21 is commemorated in unique ways to celebrate the longest day of the year. In Sweden, they dance around the maypole during the summer solstice, and in other countries, huge fires are lit to burn the troubles of the past and welcome new life. Back home in the Netherlands, we also used to have a tradition of lighting big fires a few hundred years ago, but nowadays most people treat it as nothing special and just enjoy the extra minutes of sun. On the PCT, June 21 was celebrated naked. Hike Naked Day was probably born from a joke but was now a well-established tradition within the hiker community. And to think that you're not even allowed to be topless on beaches in the States! In California, you can get a $1,000 (ca. €850) or a 90-day jail sentence for public indecent exposure. Nevertheless, on the solstice, a surprising number of hikers walked nude through

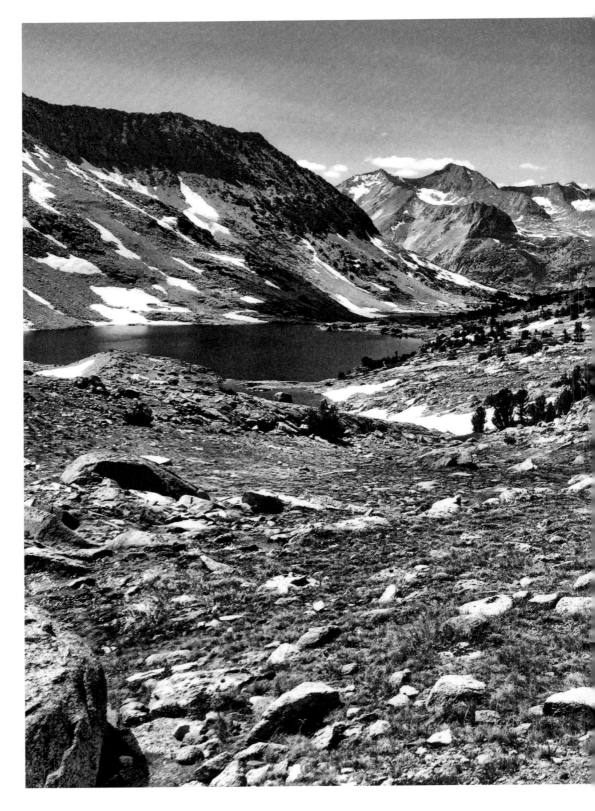

Goldie descends from Pinchot Pass into Kings Canyon.

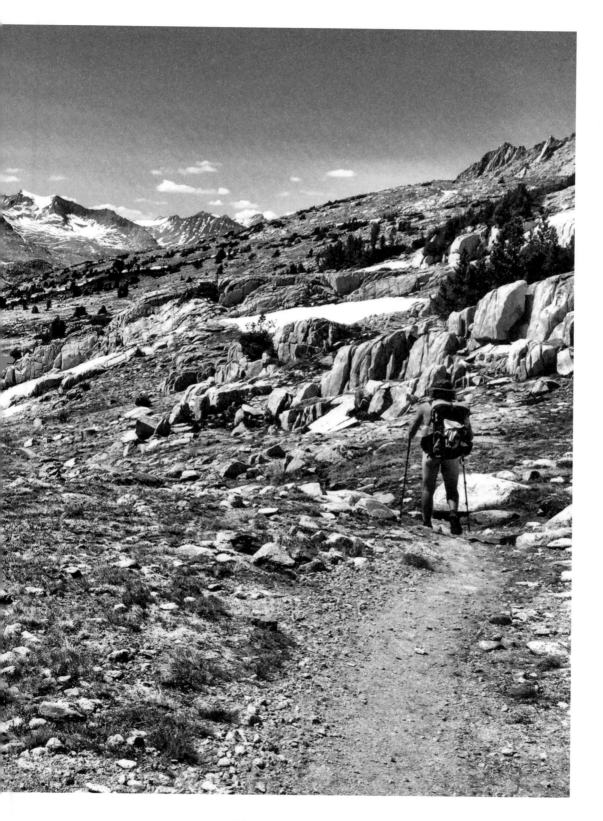

nature. But not everyone was eager to hit the trail in their birthday suit. Of the six people I camped with that night, only three left camp that morning butt-naked. It was obviously not the most sensible thing to do under the blistering sun at a height of 12,000 feet (3,658 meters), but I didn't want to miss out on my only chance to walk through paradise like Adam had. I covered myself from head to toe with SPF 50, hoisted my backpack on, and started the long trek up to Pinchot Pass. It was a little strange at first, but soon it felt quite liberating. Once I had reached the Pinchot, I saw Goldie relaxing in the sun without any clothes on. To commemorate the day, we took a few naked handstand pictures with the majestic Kings Canyon in the background. Just as Goldie, butt-naked, fell on his back after a failed handstand, two hikers came to the Pass from the opposite direction. They greeted us in Southern accents, but kept their eyes fixed to their feet and hurried on down the other side of the mountain without taking a moment to enjoy the view or have a quick chat. Perhaps it was all a bit too European for them.

I had never been to a nudist beach before and noticed how natural it actually felt to walk through nature this way. Out in this uninhabited environment, it didn't feel weird or rebellious at all. There weren't any tourists for hundreds of miles, giving a number of women the same confidence to try their walk without clothes too.

And Now for Something Completely Different: What Does It Cost to Hike the PCT?

Over the years, I had collected quite a large amount of camping gear, but during my research it soon became clear that I wouldn't be using any of it. As I would be carrying everything on my back for half a year, weight became the magic word. The trick was to keep my base weight (everything I carried minus food, water, and gas) as low as possible. In order to understand the pros and cons of each item, I delved into this new world of ultra-lightweight gear and devoured other hikers' gear lists online. I had to be self-sufficient, and it sometimes felt like I was buying a new house with a kitchen, bedroom, and a completely new wardrobe. I had to be prepared for anything, especially for unexpected bad weather.

So, what does it cost? New lightweight gear will quickly set you back between $1,000 (ca. €850) and $3,000 (ca. €2,600). The *big three* (shelter, pack, and sleep system) personally cost me around $1,100 (ca. €950). I spent an additional $800 (ca. €700) on my burner, electronics, and clothing, resulting in a base weight of around 23 pounds (10.5 kilograms).

In my case, the traveling costs were also quite expensive, since I had to fly to San Diego from the Netherlands (and back from Seattle), which cost me around $800 (ca. €700).

My extended six-month American visa took a lot of time to organize and set me back another 200 bucks (ca. €150). Fortunately, my health insurer covered my adventure, but to be safe, I also took out additional search and rescue insurance, should I get lost or injured and have to be evacuated by helicopter. And then there's all the food and lodging on and off the trail itself. This included the postage costs involved in sending yourself 21 resupply boxes of food. Altogether, this costs somewhere between $2,700 (ca. €2,400) and $5,000 (ca. €4,400). And don't underestimate the temptation of the local craft beers: they'll set you back more than you can predict.

On average, this amounts to something between $5,000 (ca. €4,400) and $10,000 (ca. €8,900). But the most expensive part of the hike is that you're not making any money while you walk. So, if you ever consider doing a thru-hike yourself, I advise you to live frugally for a year and put aside $700 (ca. €600) a month. Subsequently, you'll have to quit your job or take unpaid leave, and sublet your home before hitting the trail.

Most of the people I met had very modest reserves. They had each worked extremely hard all year, patiently saving up to hike the PCT. Each made their own sacrifices. In many cases, their entire savings were gone after the trail, with only a few dollars to their name.

What's the best way to get prepared? In four simple steps. Spend the first three months convincing your partner that this is a great idea for the both of you. It then takes about three months to research and organize all your permits and visas. Spend the following months selecting and buying your new gear, and once you've done that, use the last three months to train by incorporating exercise into your daily routine. Take the stairs instead of the elevator, and walk instead of taking the bus to work. With these four steps, you will be as ready as you'll ever be to start at the Mexican border sometime in April.

To avoid the snowstorms in the Sierras and Cascades, there is a limited window to hike the PCT. As a result, most northbounders (NOBO) start between April and May, aiming to reach Canada somewhere in September. People going southbound (SOBO) often leave in June and arrive at the Mexican border in November. In recent years, the PCT has become very popular, resulting in a cap on starting permits. The Pacific Crest Trail Association has issued a maximum of 50 permits per day in an attempt to spread the number of hikers through the season and to protect the ecosystem along the trail. On the day that the permits were made available, I sat ready at midnight with three computers on standby to ensure I got a permit.

> Most of the people I met had very modest reserves. They had each worked extremely hard all year, patiently saving up to hike the PCT. Each made their own sacrifices.

Perhaps you're wondering whether a trail like this is something for you. Believe me, practically anybody who is able to stand on two legs can do the PCT. Yes, it's hard work and certainly never gets easy, but the trail itself is well-maintained and is never too steep. After all, it

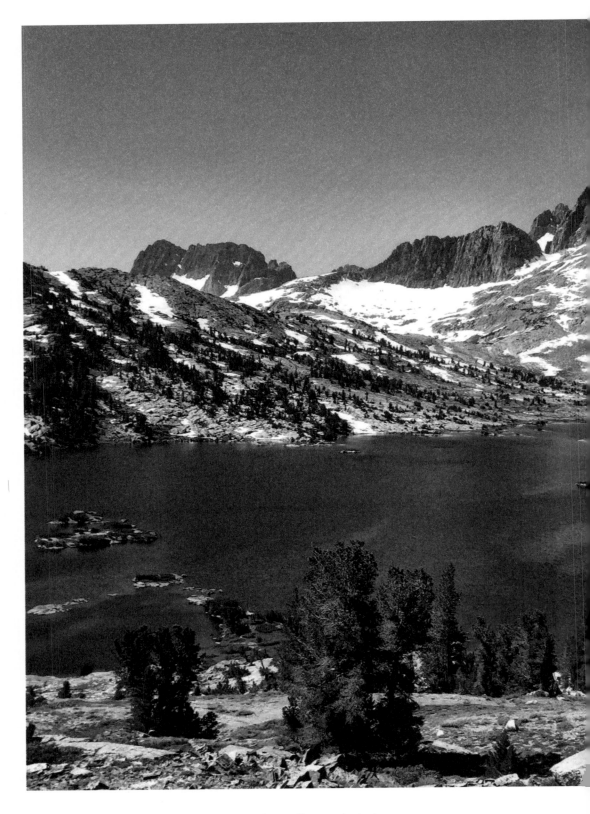

Thousand Island Lake, shortly after Mammoth Lakes.

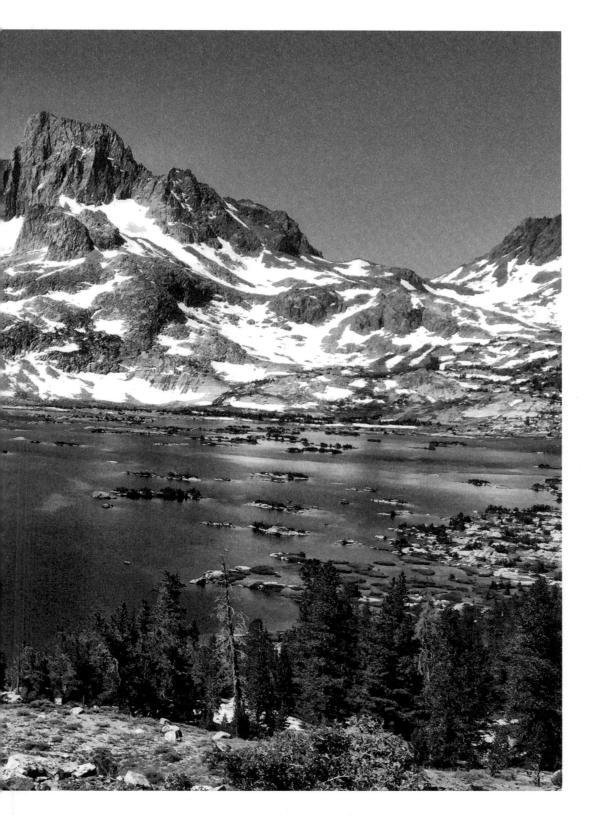

MOUNT WHITNEY TO SOUTH LAKE TAHOE



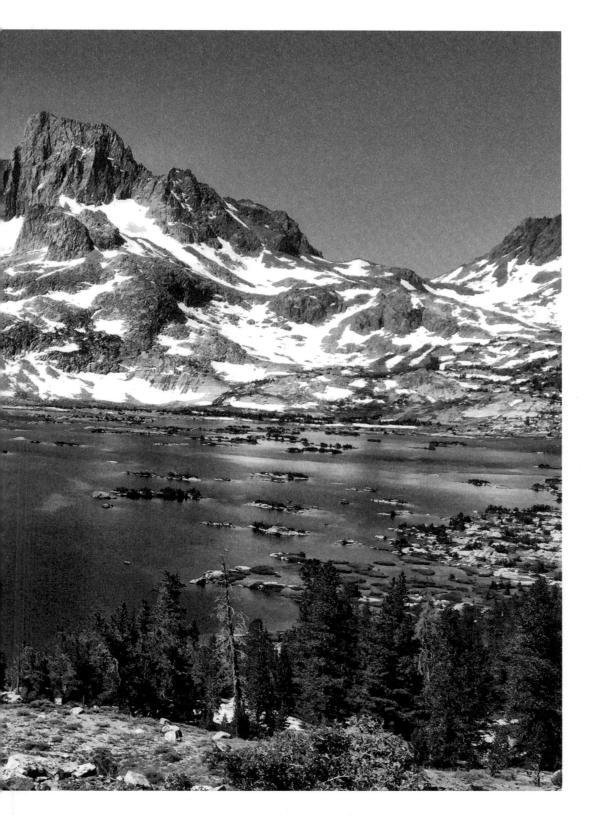

was designed to be accessible for horses. There is always someone who will pass you within a few hours if you need help. They say "the trail provides," but it won't solve all of your problems. It will give you a fresh perspective on life and can hopefully help you clarify a number of issues you may face at home or at work. And there's a good chance you'll enjoy being alone a lot more when you get home. Time will tell.

Survival Skills

Soft Skills & Hard Skills

While preparing for the trail, I felt the need to improve my survival skills. If I was going to survive in the wilderness for up to two weeks, it wouldn't be a bad idea to know how to sew my own wounds like Rambo. A good friend referred me to Maurits de Planque, an experienced survival instructor from whom I hoped to learn a thing or two about making fire, shelters, and what was safe to eat should I get lost.

I met Maurits in an old bar in a small Dutch village. I was totally unprepared for the lessons he taught me that night.

"Everything is interconnected through energy in the universe," Maurits told me. "Each part of nature is connected, with a harmonious sequence of reactions, just like the ripples in the water when you throw a stone into it. It's important to reconnect with your inner instincts and reawaken your senses. By being more aware of your surroundings, you can learn to read the clouds and anticipate changes and storms. By following animal tracks, you can nearly always find water." According to Maurits, city life had weakened many of our instinctive senses, and

by consciously training and reactivating them, we can get closer to nature.

"You should not just focus on the hard survival skills," he said, "but also spend time reaching inward to develop the soft skills. To a large extent, you already have them within you, you simply have to let them out and trust your instincts. Only then can you truly become one with nature."

I was somewhat taken aback by this. Should I trust my instincts? And how could I learn to open up my senses? Was there a book or app for that? I ordered another round of beers.

He continued: "Human beings are born with many survival instincts and inherent skills. We simply have to accept and cultivate them. People have used these so-called *soft skills* for thousands of years to survive and live in harmony with nature."

During our lengthy conversation at the bar, Maurits barely said a word about the so-called *hard skills*, like making fire or a snow cave. He probably figured I could learn that stuff on YouTube.

"It's important to reconnect with your inner instincts and reawaken your senses. You can learn to read the clouds and anticipate changes and storms. By following animal tracks, you can nearly always find water."

When we parted, I thanked him for his advice and drove home a little bewildered. What should I make of all this universe talk? Although I was still puzzled, I could see that it had been a valuable meeting. He opened my eyes to the notion that survival isn't just about the practical skills. It's equally important to trust your

intuition. He had opened a door that I had no idea existed, but one that intrigued me deeply.

During the first weeks of my journey, it felt very unnatural to trust my intuition. I was always looking for reassurance from sources of information and second opinions. I felt insecure about making decisions entirely alone. Was the water safe enough to drink? Was this the best route to get over the mountain? Was the river too dangerous to cross? At home, I tended to ask people's advice on things, but now I had to learn to rely on myself.

After only a few months, I noticed that my sense of smell had become acuter. Smell is a very important survival mechanism, and I could smell and decipher many different animal's droppings far before I saw them. It became something of a game to guess what smell belonged to what animal, and when I finally saw a mountain goat or deer grazing nearby it was fun to see if I had been right or wrong.

I rarely came across day hikers, but when I did, I could smell them from far away. Their strong deodorant, shampoo, perfume, and cosmetic scent was a stark contrast to the smells in nature. Although, I must admit, I probably emanated a pretty extreme fragrance myself. I also noticed that my sense of taste became more sensitive. I found that treated tap water tasted far too chemical after having spent weeks drinking water from the river. I constantly paid attention to changes in my environment and did my best to read the movements in the clouds. My eyes meticulously scanned the ground for snakes, and at night it was almost as if I could twist my ears to detect the smallest sounds. There was still a lot to learn, but I was grateful that Maurits had pointed out the importance of opening up my senses and trusting my instincts.

There was one thing that had dominated my urban life that I had already totally lost: my sense of time. For the first time in years, there was nothing on the agenda. I had become a man without a plan. Back home I've always been an efficient planner with a love for structure, order, and a sense of control. At work, my thoughts are constantly geared towards the future, with fourteen lines of thought at once, endlessly analyzing different possible scenarios. Although this thinking helped me achieve results at work, it also came at a price, creating tension and stress. On the trail, my credo became "Go with the flow." I didn't have a clue what day or week it was. There was no place I had to be at any particular moment. I slept when I was tired. I listened to the stories of others. I wasn't in the lead and didn't follow. I felt free. It was a luxury to experience.

Hitch Your Own Hike

Mile 1,065

"Hey Van Go, wanna ride?" A voice hollered from a passing car.

"I'm good, see you in town." I waved to some familiar faces sitting in the back of the pickup and continued walking along the road. The trail rarely followed the road, but today I had to do a lot of road-walking. By hitchhiking every now and then, bypassing the boring sections of the trail, I could perhaps get some miles done. But that wasn't for me. More and more hikers skipped large sections because they found the Northern California stretch of the trail to be boring, especially after the stunning Sierras. There was even a small group of hikers who practically stopped hiking altogether and simply

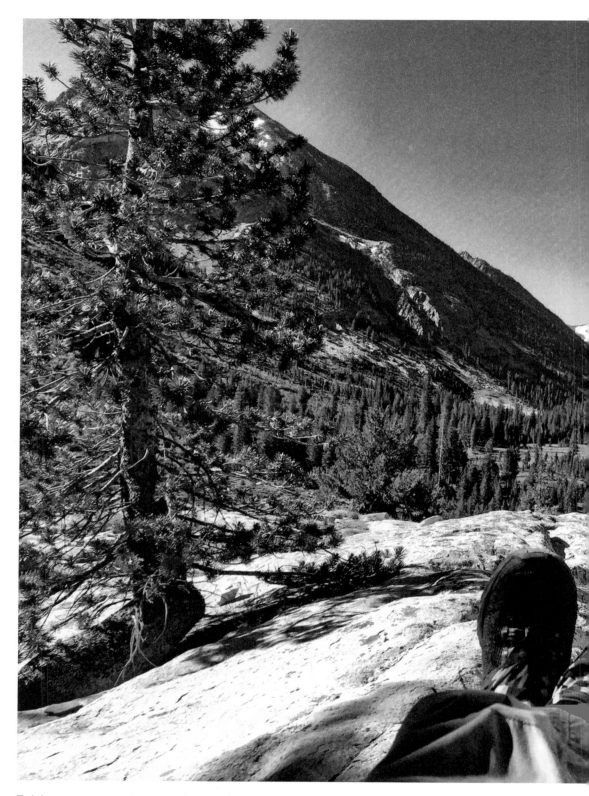

Taking a rest above a deep glacier
valley in the High Sierras.

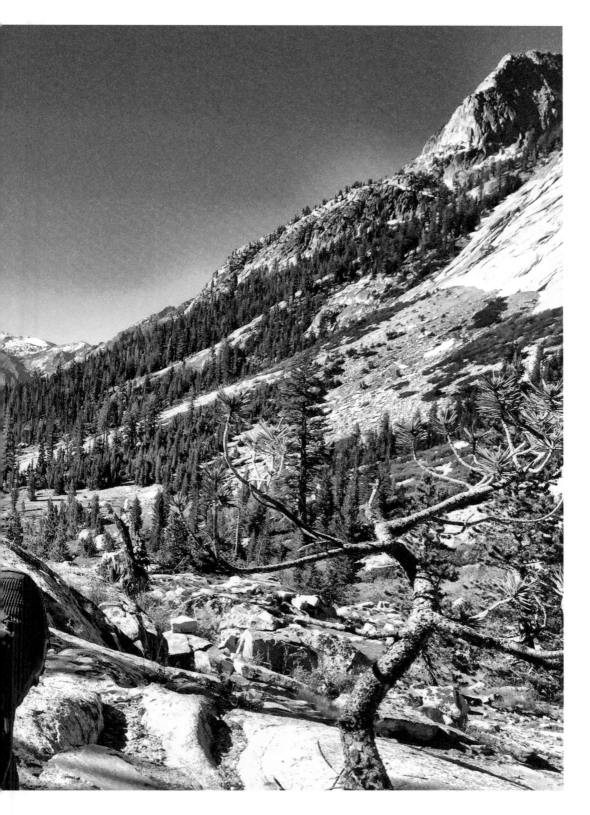

hitchhiked from one trail town to another to party for days. They only hiked the beautiful sections. It was perhaps immature of me and definitely none of my business, but after a while, all the hitchhiking began to irritate me. "Hike your own hike," they always say. I felt "Hitch your own hike" was more applicable. I didn't say much about it, but I can't lie, it did affect me. Especially when familiar faces suddenly popped up fully rested in front of me, pretending nothing had happened. Of course, nothing *had* happened. They had done nothing wrong—they were simply doing the trail their own way. And what's wrong with hitching a ride now and then? Nothing, of course, but it slightly bothered me that many of these same people claimed to have *done* the PCT afterward, while in reality they had sometimes skipped more than 20 percent. It was a frustrating moment when I, too, had to skip a 30-mile (48-kilometer) section due to a trail closure, back in the desert after the wildfire. I could have opted to road-walk 80 miles (129 kilometers) around the closure, but then I would have had to walk

through a dodgy neighborhood, which wasn't my cup of tea either. That's why, just like nearly everyone else, I took a shuttle to Big Bear Lake to resume my journey. But in order to walk the entire 2,650 miles (4,265 kilometers), I later did a number of side trips to make up for the lost miles.

Something had to fundamentally change if I wanted to reach Canada before the winter. I would have to cut back on the number of zeros in town, take fewer breaks, and up my pace.

Hike your own hike and do your own thing. It's a corny cliché, but it's true. There's no right or wrong way to do the trail. Everyone starts with their own reasons and leaves with new insights, as well as a whole host of unforgettable experiences. It's the journey, not the end goal, that makes the trail magic.

But if I wasn't going to hitchhike, something had to fundamentally change if I wanted to reach Canada before the winter. I would have to cut back on the number of zeros in town, take fewer breaks, and up my pace considerably.

In my imagination, I could look down at my body moving effortlessly beneath me. I was in a rhythmic trance, comfortably numb, in a state of mind I had never been in before.

The party was over. The game was on. After having averaged 15 miles (24 kilometers) a day for months, it was time I started churning through the miles. Fortunately, the current landscape was suitable to an increase in pace. After South Lake Tahoe, I really switched gears and walked back-to-back marathons for days. It was the first time I had ever done more than 100 miles (161 kilometers) within four days. I also made changes to my daily routine, getting up early to try to do 10 miles (16 kilometers) before 10 a. m. It had taken me almost four months to walk through California, and it still went on and on. The trail became a little less steep, and it was interesting to see what my body was capable of as I pushed it further and further. I walked rhythmically without stopping, only pausing occasionally for a quick dive in one of the many lakes. Obviously not as flat as at back home in the Netherlands, but significantly less steep than in the Sierra's. The landscape was constantly changing. One moment it was lush green and full of life, and the next it was dry and dusty, looking more like Mars with black lava plains and jutting volcanic cones on the horizon.

It was the middle of summer, and I walked through a warm valley with tall, dry grass up to my armpits, stretching out my arms and letting my fingers glide over the blades. The tickling sensation sent shivers down my back and goose bumps across my arms. The grass swayed graciously in the wind, like waves at sea, and mosquitoes and crickets sang a soft hum all around me. Swallows darted around my ears and dove out in front, inquisitively checking me out. Sometimes they flew so close I could almost touch them as they caught circling, daydreaming insects. The mountains in the distance turned lilac and blue, a beautiful contrast with the earthy colors around me. It felt as if I was floating. In my imagination, I could look down at my body moving effortlessly beneath me. I was in a rhythmic trance, comfortably numb, in a state of mind I had never been in before. My whole being was absorbed in the experience, like meditation in motion.

South Lake Tahoe to Canada

Mile 1,092–2,650

"On the spiritual journey, I lost
all sense of time. For once,
I was free to reflect on my life."

Do I Believe in God?

Mile 1,092

During the desert, my physical stamina had hardened. The mountains had tested me mentally, but I had managed to emerge confident. I felt comfortable living on my own among the trees. For the first time, my body and mind were in sync with each other. As a result, my head was completely empty, perhaps similar to what people experience when meditating. Utterly devoid of worries, plans, and future ambitions. I walked on autopilot, unaware of time, and could feel that there was space to experiment with spiritual questions.

I could focus on one specific question for hours without my mind wandering off or being distracted. I looked at the same subject from multiple angles and subsequently tried to formulate an answer for myself. For the first time in years, I had ample time and peace of mind to ask myself life's profound questions. I saw my head as an empty bowl in which I could place a new question every day. To ponder, evaluate, reassess, and address my values. I searched for answers to questions like: What if I die tomorrow? What have I given to my children? What do I want to learn? Which character traits do I want to improve or change?

I was walking through paradise, a wide valley flanked by the ancient Mount Lassen. In a meandering river beside me, crystal-clear water flowed. Where did all this beauty come from? How was it all conceived? Was it all created in six days? This led me to the question: Do I believe in God?

I've been a religious pilgrim searching for God all my life, but I have yet to find him or her. People often say they don't believe in God but that they do believe in "something." But what does that mean? What is that "something?" I wanted to go beyond it and articulate what God actually meant to me.

Although I was raised in a Protestant family and frequently visit churches, I have never been a big fan of preachers. I would love to believe, but I just don't see it. Yet faith continues to fascinate me. Throughout my life, whenever I moved to a new city, the first thing I would do was check out all the churches in my neighborhood. Each Sunday morning, I would get on my bike and cycle in the direction of some remote church bells to see if the church and its community were something for me. I tried everything, from Protestant to Catholic, Pentecostal, Jewish, and Ecumenical celebrations. After a few months of searching, my choice often fell on

> What if I die tomorrow? What have I given to my children? Where did all this beauty come from? What do I want to learn? Was it all created in six days? This led me to the question: Do I believe in God?

an Ecumenical church, because I felt they were often freer and less dogmatic. There I found more space for interpretations and doubts, and room for discussion. During the services, I rarely listened to what the pastor proclaimed, as I often disagreed with what he had to say. It was often far too removed from everyday life and the reality of human emotions, desires, and imperfections. But these weekly visits to the church did form a welcome break in my hectic workweek and gave

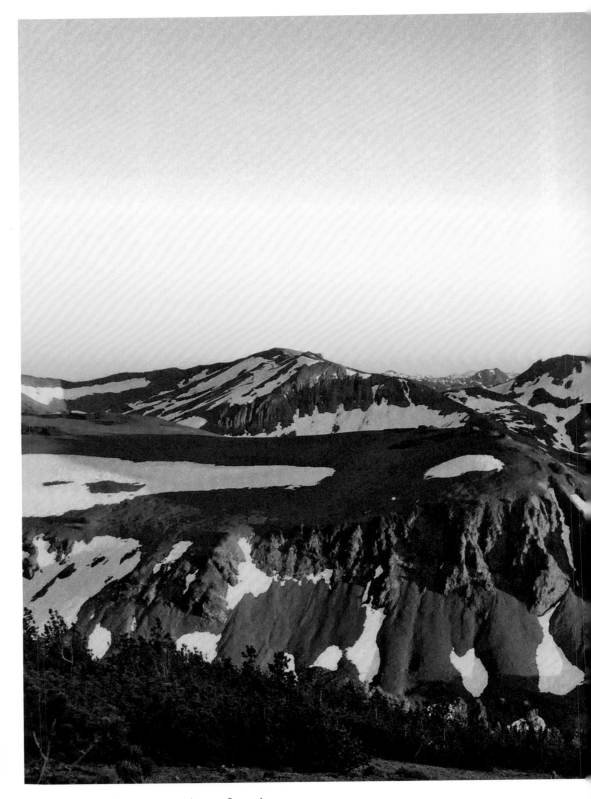

The sun setting over the volcanic
mountains of Sonora Pass.

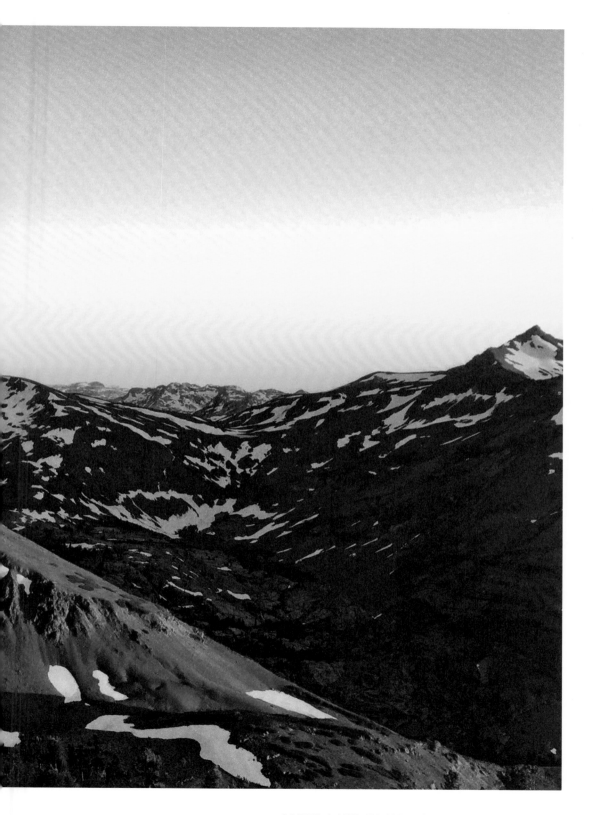

me the opportunity to pause and think about my family and friends. I counted my blessings, reflected on my daily challenges, and thought about the unrest in the world. Above all, I loved the communal singing and the coffee after the service.

In recent years, my Sunday morning trips have no longer led me to churches or institutions but have led me instead to the cathedrals of nature, such as the Yosemite's waterfalls and the high peaks of Kings Canyon. It's now in nature where I find peace and silence to reflect and pray. Even though I'm not Catholic, I often draw a cross across my chest when I see the full moon or when I feel grateful or lucky. It's a gesture of gratitude for the experiences and special people in my life. I've always loved rituals and adopt a few wherever I go. It feels as if the moon and stars have watched over me during the adventures in my life.

I don't believe in God as the third person, with a great master plan for us all, in which we are simply players. God is an idea. It's a choice, not a truth. I'm more a believer in *people* and in the power of positive energy. We could call this energy "God" if we wanted. I would like to believe that our soul lives on after death, but the religious teachings don't seem to add up for me. The souls of our deceased loved ones, rather, live on in the hearts and minds of people who remember them. I believe in the power of nature, in the miracle of the perpetual seasons, and in the interwoven elements, continuously in motion.

Aristotle's philosophy of the *tabula rasa* has always fascinated me. It assumes we are all born as a blank slate, each responsible for our own happiness and failures. Of course, it's not as simple as that: nurture, nature, and the circumstances you're born into play a significant role. But I love the idea that you are responsible for creating your own journey. With a bit of luck, patience, and a whole lot of hard work, you can get pretty far these days.

During my journey, I realized that if God wasn't going to help me during a storm on a mountain, God wasn't going to help me achieve anything in life either. Reaching my dreams was totally up to me, and, of course, I needed a lot of help from people around me, and a good dose of positive energy. If I believed God is my savior, I would automatically take on the role of the victim, and that's the last thing I ever want. Ultimately, faith is all a matter of interpretation and semantics. But throughout the ages these semantic discussions have led to great sorrow and terrible wars between believers around the world.

Of course, neither I nor the gentlemen in tunics have any idea what they are really talking about. It's all interpretation. But you have to believe in something. I'll probably have a totally different view on the matter in ten years' time. The quest continues.

Ouch! A painful sting suddenly gripped me in my left leg, as if a snake had just bitten me from behind. Bewildered and in shock, I looked behind me to see what it was, only to discover a large swarm of wasps chasing me. I had stepped on an underground wasps' nest. The sharp pain suddenly threw me down from heaven, back to earth. Was this karma? Was I being punished for

my thoughts? It felt like I had been stung by thousands of wasps at the same time. I quickly came to my senses and sprinted away, but I was followed and chased by the swarm of angry insects. It was only after 300 feet (90 meters) that I dared to stop and see what the damage was. My left calf seemed to have been the target. It became ever more red and painful by the minute.

Within an hour, my lower left leg was completely swollen, and I could hardly walk. I took two antihistamine pills hoping that the swelling would subside the following day. But it took more than three days before the inflammation and discomfort subsided. The power of nature had once again spoken. For the time being, my quest to find God and the meaning of life were put on hold.

What If I Die Tomorrow?

Mile 1,250

As I followed the river through a narrow valley, the trail led deeper into the backcountry. The water gushed violently through the tight gorge. Large tree trunks were wedged between rocks, stripped bare of their bark under the strong current created by the gallons of meltwater from the mountains above. As the trail continued on the far bank, I had to find a safe place to cross this beast. I followed the river upstream for more than an hour until I finally found an option that was worth a try. A huge tree had fallen across the river, creating a makeshift bridge from one side to the other. The only problem was that the tree was more than 14 feet

(4 meters) above a raging whirlpool. There wasn't anything to hold onto during the 20-foot (6-meter) crossing.

I stared at the log for a while, mustering the courage to cross and questioning how wise it was to do this without anyone around. I unhooked my backpack's hip belt in case I fell into the water, to prevent being pulled under by the weight of my pack. I stuck my trekking pole into the rotting tree trunk and took the first steps across the river. Soon, however, I realized I wasn't going to reach the other side with my cramped posture. I stopped, took two steps back, reassessed the situation, and tried another approach. I dried my clammy hands on my shorts, stood straight, and stuck my trekking poles out to balance like a trapeze artist. My eyes no longer looked down at my feet, but concentrated straight ahead on the other side. Strangely, it was far less scary this way. I didn't look down, and before I knew it, I was on the other side of the river. I gasped, looked back, and realized that one wrong step would have been fatal. It was weird to think that death was so close. But the experience made me feel even more alive. It hit home how fragile and short life can be.

> I gasped, looked back, and realized that one wrong step would have been fatal. It was weird to think that death was so close.

Still a little shaken, I continued on, wondering what would happen if I died tomorrow. What would I leave behind for my children?

In the fast pace of everyday life, I rarely think about death, but in the wilderness, I was frequently faced with decisions that could potentially be fatal. Decisions like whether to cross a

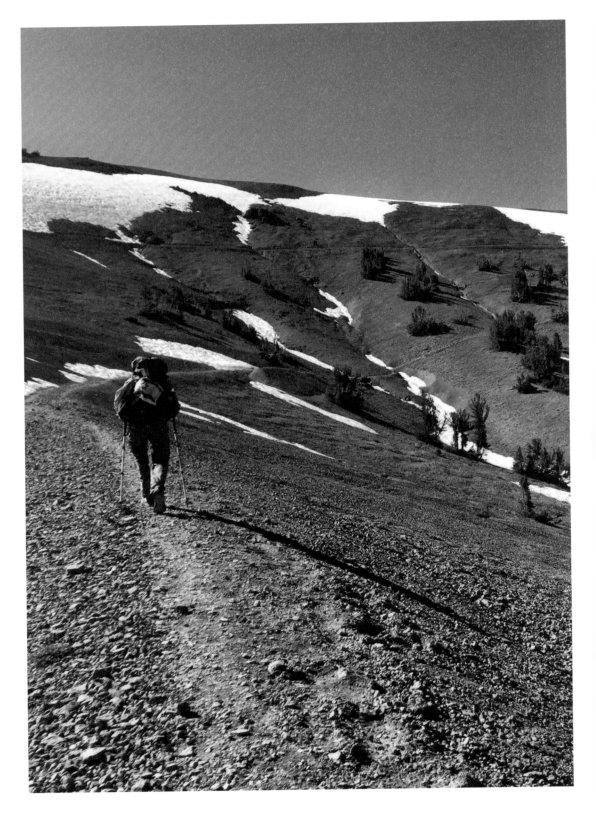

Shortly before Sonora Pass, Northern California.

river or not, walking over a snow bridge, or traversing a mountain during a lightning storm. Each of these experiences illuminated the question of death for me.

After some thought, I decided to write a long letter to my children. A letter full of stories, experiences, values, and suggestions. Lessons from my short life, which had helped me along my path.

Fortunately, I hadn't had much experience with death in my inner circle. My mother, however, had lost her father at 16, when he had unexpectedly passed away at the young age of 60. My grandfather had passed on important values to his children, infused them with his love of music, and had shown them the importance of social responsibility. My mother has beautiful stories about him, and I would sometimes look at old newspaper clippings from the time when he worked as Secretary of Defense for the Netherlands, between 1948 and 1950. It's difficult to imagine the impact that a parent has on a child's life. My eldest daughter had already reached the age of 15. I began to wonder what values and lessons I would leave behind, should I unexpectedly pass away.

After some thought, I decided to write a long letter to my children. A letter full of stories, experiences, values, and suggestions. Lessons from my short life, which had helped me along my path. Perhaps my kids could also benefit from them in the future. At least they would get a better understanding of who their father was.

It turned out to be much harder than I had expected to write such a letter. Not only did I have to think about what themes would be interesting to them, I also had to find the right tone of voice. In the end, it took weeks to complete and grew to over eight pages long. I tried addressing topics such as coping with failure and why it's important, in my opinion, to avoid self-pity. I also shared my thoughts on themes such as relationships, emotions, women, men, children, addiction, fear, and hatred.

It was a wonderful opportunity to share my thoughts about what was important to me and the value of creating opportunities. That life is short, and that time is a gift. How important it is to never give up. I hoped to have shared something that may be of use to them later on in life.

The letter started like this:

Dear children,

I have thought a lot about you and my life during my time on the trail. How unique and confident you each are. Each with your own personality, style, rhythm, and dreams. I feel so lucky, happy, and proud that you have come into our lives. We have tried to raise you to the best of our ability and have seen you grow and flourish. Fortunately, you haven't left home yet, and there is still plenty of time to experience big and small adventures together.

I recently asked myself a question: "What is the most important thing that I could give and pass on to you? Money? Things? Land?"

As I don't have any of these in abundance, I felt I should pass on my thoughts and ideas. Experiences that I have learned from during my own life. However, they are lessons that work for me and undoubtedly won't all apply for you. Please see them as suggestions; values that can guide you during challenging and happy moments in your life.

Don't take them too literally and adapt them to your own generation, time, and reality. Choose your own path, make your own choices,

*and learn your own lessons. And of course, feel
free to burn them all or throw them in the trash.*

*Whatever choices you make in life, I will
always love you and look forward to hearing
about the adventures you are going to experience
in your own life.*

*Knowledge is power
Education leads to knowledge, knowledge
leads to power, power leads to independence.
Never cease to develop yourself, because
independence will put you in a position to make
your own choices. Develop yourself broadly
through asking questions, playing music,
speaking languages, and meeting people
around the world. Continue to learn throughout
your life, as it will help you remain humble
and prevents one from becoming arrogant.*

*Go travel
Explore the world as a nomad. Be open,
inquisitive, and meet new people. They will
inspire you. Discover new horizons, don't be
afraid of the unknown. Travel together, but
also alone. Traveling alone can make you feel
vulnerable, but it also opens the door to so
many unexpected encounters and experiences.
Create your own path; the trail always provides.*

The process of writing the letter com-
pelled me to form an opinion on the larger
questions of life, take a stance, show my true
colors, and write down my perspective without
being too pedantic. I was surprised to discover
what my opinion actually was on some subjects,
just as it was startling to realize that I didn't really
have an opinion on a number of issues. Once
I had sent my children the letter and had spoken
to them about it, I noticed that it made much less
of an impression on them than it had made on
myself while writing it. Perhaps the letter will
only become of value once I am dead and gone.

But I was far from dead. I jumped from
boulder to boulder, feeling full of energy. I sang
at the top of my lungs, even though there was no
one who could hear me. Never before had I felt
so alive. My senses were wide open, and I took in
my surroundings like a sponge. I was in a good
flow and sometimes almost ran up the moun-
tains. At the summits, I would quickly check to
see if there was any internet connection, if there
were any new messages from home. There was
nothing I loved more than listening to the audio
messages my kids frequently sent me. I would
press auto-repeat and listen to their voices over
and over again. The sound of their familiar voices
was magical and made it feel like they were right
there with me. Although they were on the other
side of the world—with nine hours' time differ-
ence—they felt very close through those mes-
sages. But it was still far too early to know if I had
been blind and foolish to have left home for so
long. Time would tell what the consequences of
my lengthy absence would be for my children.

Being away from home for such a long
period made me realize how precious the time
that we have together as a family is. Other
parents don't have to leave home for six months
to work that out. But through my experience,
I also felt a new sense of urgency to use and opti-
mize the time at home in a more conscious way.

Before I left home, I filmed each of my three children and asked them what they thought of my long walk. In the interview, I also asked them a few other life questions, such as their own dreams, fears, and goals. I've been doing these little personal interviews with them from the age of four and look forward to watching them later as they develop and become fully independent. The idea of doing them was originally inspired by Michael Apted, who directed the BBC's *Up Series* of documentaries, which followed the lives of 14 British children since 1964. Each child in the documentary was selected to represent the range of socio-economic backgrounds in Britain. Taking the Jesuit maxim, "Give me a boy until he is seven, and I will give you the man," it suggested that the prospects of the participants were determined by the class into which they were born. I use the same 12 questions as Apted when I interview my own children. It's wonderful to see how differently they react as the years continue.

Narrow Escape

Mile 1,497

I could feel the beginnings of a shin splint playing up and was anxious to avoid a serious injury. I desperately needed to put my feet up. After having walked under the burning sun for days, I left the trail to rest at the Burney Mountain Guest Ranch. The ranch was just what I needed. I spent two days laying on a couch in the living room watching bad movies.

When I hit the trail again, I felt totally re-energized, and the miles flew past. By dusk, however, I could not seem to find a suitable flat spot to sleep on, as there were steep drops and sharp rocks everywhere. It was already dark when I finally came across an unpaved dirt road with a number of one-man tents pitched around the edges. It was quiet, and it appeared that they were already fast asleep. Unfortunately, there was no room left for my tent on the safer edges, so with my headlamp on I found a slanted spot in the bend. In order not to take up too much of the road, I strung out my guylines as wide as possible

It was still pitch dark when I was startled awake by a loud, rumbling noise. A shot of adrenaline rushed through my body.

to make my tent's footprint as small as possible. When I finally lay on my sleeping pad, I couldn't sleep. Something just didn't feel right. What if there was some unexpected traffic at night? They would drive straight over me. I crawled out of my tent again and started resetting all my guylines, pushing my tent even closer to the rocky drop next to the road. In order to make myself more visible, I draped a white T-shirt over the lines, hoping it would reflect in the light as my tent was rather inconspicuous in its green camo print. I also rolled a thick log in front of the entrance of my tent, hoping it would offer some protection from a possible passing vehicle. A little naive perhaps, but it was all I could think of. I returned to my sleeping bag. It had been a long day.

It was still pitch dark when I was startled awake by a loud, rumbling noise. It sounded suspiciously similar the roar of a diesel engine. As I came to my senses, a shot of adrenaline rushed through my body, and in a state of panic, I quickly tried to unzip my mosquito net. Two bright headlights approached me around the corner,

but I was able to stretch my hand out to make myself visible. I screamed and waved as wildly as I could, hoping to catch the driver's attention and stop the gigantic truck. With a screeching hiss, the 16 wheels locked and came to a halt just feet from my tent. A cloud of fine dust covered everything around me. I jumped out and, with one big jerk, pulled my entire tent out of the ground and dove into the undergrowth. It was totally silent for a few seconds, after which the truck shot into gear and continued down the dirt track. He was probably on an early shift to pick up a load of heavy logs in the valley. I looked at my phone: 3:25 a. m. The 24-hour economy apparently didn't stop here in the forest. It rumbled on through the night. My legs were shaking like hell.

It was a little strange to see two small headlamps suddenly come my way. "You alright?" An unfamiliar voice asked from the darkness. They were two hikers who had also been shocked by the logging truck. Within seconds, I had gathered together all my belongings and followed them down the mountain in the dark. One of the guys told me of a similar experience he had had just a few years ago. One night, when he had been camping on a remote dirt road somewhere in the woods, a dirt bike had accidentally driven straight over him and his tent. As a result, several of his

> I jumped out and, with one big jerk, pulled my entire tent out of the ground and dove into the undergrowth. My legs were shaking like hell.

ribs had been broken, and he had had to rehabilitate for months. The only thing he wanted right now was to get down off this mountain as quickly as possible. Understandable. The ordeal had clearly traumatized and scarred him for life.

Just before dawn, the temperature suddenly dropped a few degrees, and as the morning glow arose, we emerged from the dense forest and entered civilization. We road-walked a few miles to the Castella gas station. The sun peeked over the mountain ridge just as breakfast was being served at our picnic table.

Wings

Mile 1,590

It was only a few days after I had passed through Castella that I saw Mount Shasta for the first time. A stunning 14,179-foot (4,322-meter) volcano with a white cone, Shasta was a real sleeping beauty dominating the horizon in the distance.

The trail was tough, but I felt strong and was pleased with the miles I was making. However, I couldn't believe my eyes when someone suddenly passed me at an alarmingly high pace. She walked with such apparent ease that she even twirled her two trekking poles like batons, as if she was leading a marching band. From under a worn baseball cap, two long, blonde braids swayed from side to side. She had the strongest calves I had ever seen. She moved so swiftly, it was just as if she had wings, floating a fraction of an inch from the ground. How on earth can you climb a mountain that fast? In no time, her dusty white backpack had disappeared into the forest ahead of me. After an hour, I saw her again when we met at a small creek.

"Hi, I'm Jetfighter. Where you from?" As we filtered our water, we exchanged all the usual, initial questions to get a better understanding of one another: "When did you start? Are you doing the whole thing? How many liters are

you taking? Where are you camping?" She was the spitting image of Meg Ryan from the movie *The Doors,* with round Lennon sunglasses and an enchanting, carefree attitude.

Tall, energetic, 21-year-old Jet from Madison, Wisconsin, had started at Campo a week before me. The tattoos on her arms and legs suggested her passion for the outdoors. A tall sequoia tree stretched the length of her forearm, with floral patterns and quotes paying homage to nature and hiking. They were a beautiful testament to how she had found freedom within nature.

With sufficient water we continued on together for the rest of the day. She had an infectious enthusiasm, and we soon found ourselves talking about matters such as conventions, childhood, and our pursuit of personal freedom. Our conversation was somehow different to the usual trail talk: it seemed to have a little more depth and nuance. It wasn't every day that I shared detailed experiences of my childhood, and it was interesting to compare our relationships with our parents now and when we were children. She had been a rebellious teenager longing to break free and become independent at a young age, while it had taken me more than 40 years to gradually create space. I am a bit slow at some things, I guess.

As dusk fell like a blanket over the mountains, we stopped to camp on top of a flat, rocky plateau. There were already two tents pitched with rocks holding down their guylines, but we just rolled out our sleeping mats to cowboy camp in the open air. We sat on the ground, and I cooked some pasta while she lit up a joint. Coincidentally, we had both recently left our trail families and were now enjoying the peace of walking alone. Although we both missed our friends, the alone time was a sanctuary of silence after the wild parties and group dramas. After dinner, she had the curious habit of putting a Snickers next to her head for when she got the munchies during the night after her joint. Not very bear-proof, I laughed to myself.

She had an infectious enthusiasm, and we soon found ourselves talking about matters such as our pursuit of personal freedom.

The following days we hiked together during the early hours, but went our own ways for the rest of the day as we both relished time alone. Walking behind one another at dawn, our lively discussions were like a scene from a Woody Allen movie. We overanalyzed ourselves and everyone we had met on the trail. Talking trash with Jet was a field day for me, as I've always loved micro-analyzing behaviors and emotions. We discussed the pros and cons of different types of relationships, sharing our views on marriages, living together, and open relationships, and we came to the conclusion that there wasn't a "one-size-fits-all" solution. We reflected on the many trail romances that we had seen—and why the passionate dynamic on the trail often passes within three weeks. But there were also a number of beautiful stories of trail relationships that continued on after the trail's end.

It was strange: although I was almost twice her age, I felt I could learn a lot from her life experience and relaxed attitude. In her relatively short life she had already been through quite a lot and had in some ways experienced a lot more of the tougher side of life than I had. She had left home at the age of 16 and had promptly learned, with quite a bit of experimentation, how to fend for herself and stand on her own two feet. She was full of contradictions, with so much love to give to everyone she met, disarmingly caring and kind, but could also flare up unexpectedly when something or someone came too close or

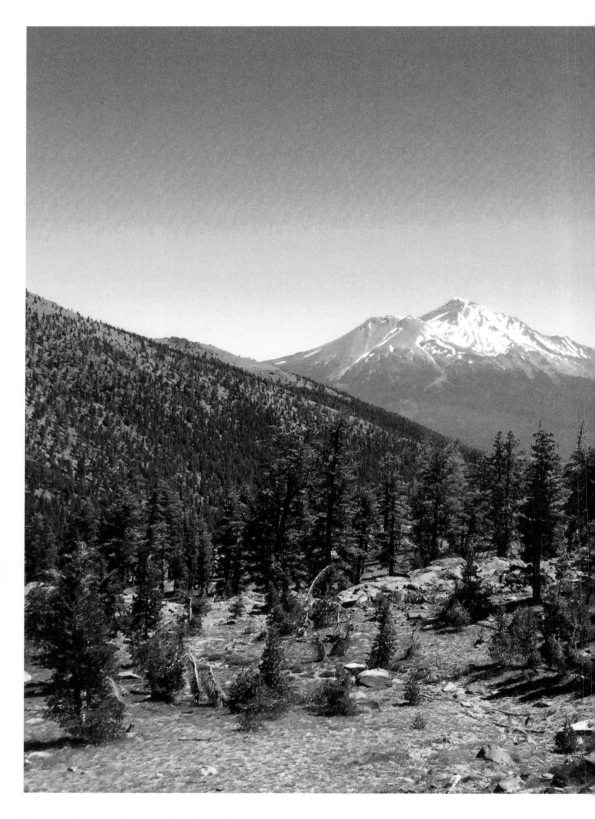

Mount Shasta looms in the distance.

expected too much of her. She joked that she was perhaps a bit of a black widow spider, who killed their partners after being together, since she had had a number of complicated relationships in the past. She wondered why she always attracted so much drama: "I'm not that complex, am I? Guys are generally much too possessive. In that respect, women are much easier and often more beautiful too," she concluded.

"Don't think so much, Van Go. Relax. You've got to go with it. Everything always works out."

Above all, she just wanted to be free and often found relationships to be a bit too restrictive. The most important lesson she taught me was to focus on and live in the present, to spend less time thinking about the future. But that is easier said than done, in my case. When I wavered and drifted into future plans, she always returned to this point. "Don't think so much, Van Go. Relax. You've got to go with it. Everything always works out." She had an amazing gift for inspiring and challenging me at the same time.

Of course, this contrast in attitude was also partly due to our age difference, but I did not want that to deter me or be an excuse. I wanted to become more flexible in life, and this shift in attitude would perhaps make me a more pleasant partner and colleague at home.

One morning, five days later, while we were walking along a steep ridge, she suddenly stopped dead in her tracks. I walked straight into her. She frantically began to search for something in and around her backpack, swearing loudly to hell and back, and then collapsed on the ground, utterly frustrated. I still didn't know what she had lost and assumed that it might have been her cell phone or wallet. But no, she had lost her beloved water bottle, which she had carried

with her since Campo. A piece of plastic, not worth more than a dollar. She had probably left it behind at the last water source, six miles (10 kilometers) back. "Well, you can always buy a new one in the next town," I carefully suggested. But no, she had to have that water bottle. It had a lot of emotional value to her. "How could you be so insensitive?" she blasted. She left her backpack behind and started walking back up the trail at full speed. I thought it was hilarious, but because it was so important to her, I threw my backpack off and joined her in the search. Hours later, she finally found her beloved bottle washed down a creek and full of dents, but I have rarely seen anyone so happy.

Jetfighter wanted to hike the last miles to the Oregon border alone, to reflect on her journey through California in silence. It was a great moment when we reunited at the border between California and Oregon. I had walked 1,697 miles (2,732 kilometers), but still had over 981 miles (1,579 kilometers) ahead of me. I had dragged two cans of beer with me specially for

It was hard to grasp the immensity of this trail. I thought back on all the crazy moments and people I had met during the past four months.

this occasion. We opened them and drank in silence as we stared back at the vast state we had just walked through. It was hard to grasp the immensity of this trail. I thought back on all the crazy moments and people I had met during the past four months. California had been amazing. I totally understood why so many people had been drawn to settle there throughout the years. The state has everything: perfect warm weather, wild seas for surfing, high mountains for skiing,

rolling hills for vineyards, and beautiful trails through immense, protected national parks. I left California behind, feeling a little melancholy. At the same time, though, I felt quite excited and curious to see what Oregon had in store for me.

Walking in Silence

Mile 1,820

"Silence! Silence!" someone shouted aggressively in the distance. It had been a lively evening in Mazama Village, a large campground just a few miles before Oregon's famous Crater Lake. I saw two bright flashlights searching a number of tents where the noise had been coming from for the past few hours. I moved a bit closer to see what was going on and saw two park rangers questioning some hikers about drugs. As federal police officers, rangers have far-reaching authority and can implement serious penalties or fines. We tried to warn the others, but it was too late. Fortunately, they only found weed, which was immediately confiscated. Luckily no fines or penalties were issued that night.

When the rangers had left and peace returned to the campground, I found that I couldn't fall asleep, so I just lay awake thinking about the night's events. The words "silence, silence" kept reverberating in my head. They suddenly triggered an idea in me: to see what it would be like to walk in silence for a while. Total and absolute silence for five days. Could I do it?

The next day I left the hustle and bustle behind me. I resumed the trail with my backpack crammed full of food for the next five days in the

wilderness. The trail was steep and slow-going, but I soon caught up to Genie, who walked even slower. It was strange. I had overtaken her on countless occasions during the past months, but I still kept bumping into her in and around towns. She had the steady pace of a never-ending diesel train, rarely stopping for breaks and walking extremely long days. She was an inspiringly strong and independent young woman, who often chose to pitch her tent or cowboy camp totally alone, far away from the rowdy noise of the campfire.

We briefly stopped to chat, and I asked her what she thought of my idea not to speak for a while.

"Why not? Go for it." After which she wished me happy trails and continued on in her steady tempo.

I was a bit startled by her simple and forthright answer. Start now? It was actually no more than a thought I was playing with, but thanks to Genie's no-nonsense attitude, I decided on the spot not to speak another word for the coming days. Even though I walked alone during the day, I often came across hikers in the forest and towns in the evenings. I was curious to see if I could survive without speaking, because I'm generally a big talker. Perhaps, at times, a bit too much of a talker!

As it turned out, the day became special in more ways than I had expected. As I reached the top of the hill, the trail wound around the immense rim of Crater Lake, a stunning, deep volcanic crater filled with exceptionally clear, blue water. It promised to be a terribly hot day, with no water source for 20 miles (32 kilometers). There was a large visitor center looking out over the lake where I went to fill my six bottles with water. This was easy enough without having to speak to anyone. But unfortunately, my new sunglasses had broken within a day of purchase. I headed into the busy visitor center again,

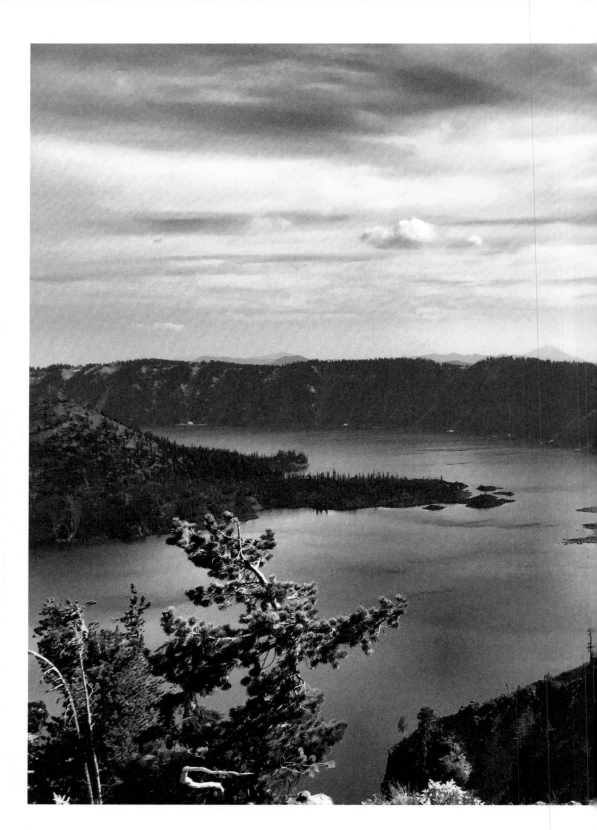

Crater Lake, Oregon.

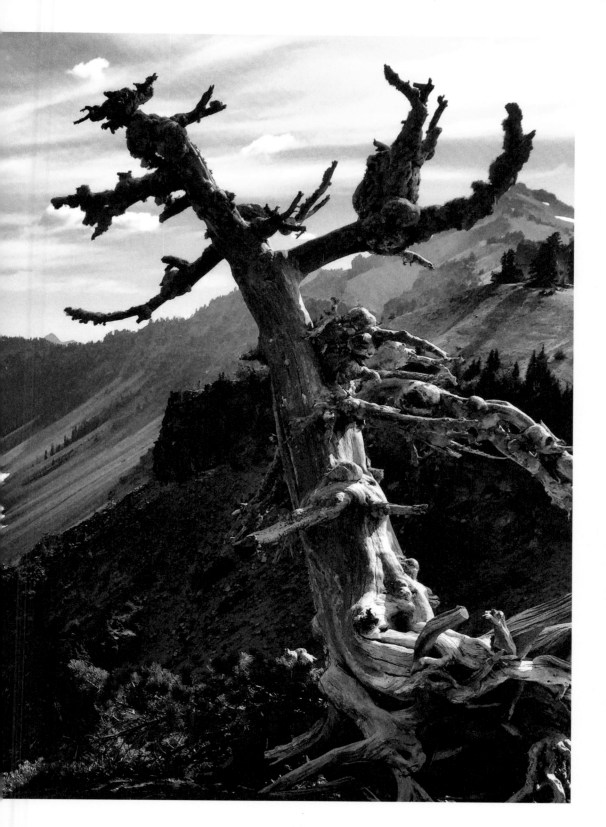

searching for the manager to find some super glue to repair my broken shades. After a lot of complicated hand gestures, I finally succeeded in explaining to the man that I needed super glue. When he returned from his office, I managed to glue the arm back onto the glasses, but unfortunately I also got glue stains all over the lenses. I hoped I could still see something through them, as silence seemed like enough of a challenge.

I was a bit overwhelmed by the number of tourists in the visitor center. They arrived in large buses, took a few pictures, bought an ice cream, and rushed off to the next attraction in their clean, white T-shirts. There was a lot of noise in the souvenir store, so I slipped out and returned to the silence of the trail, walking to the cliff's edge of the crater. It was suddenly utterly quiet again, and I felt full of wonder as I stared down into Crater Lake and saw the deep, blue water shimmer in the sunlight.

My voice is perhaps the most important tool in my life. I am a very verbal person, both socially as well as in my work. I use my voice to tell stories, to convince, and to charm.

I left the tourist buses behind me and followed the trail along the crater rim for several miles. The last sign of civilization was an information board stating the history and depth of the crater. The 10-mile-wide (16-kilometer-wide) crater had been formed 7,700 years ago following the eruption of Mount Mazama, creating a 1,949-foot (594-meter) lake, the deepest in the United States. The local Klamath tribe believes it to be a very sacred and spiritual place, where the spirits of the underworld come up to speak with the sky gods. As I stared down at the lake, I tried

to imagine how this place had inspired so many people throughout the centuries. The intensity of the blue water contrasted starkly with the light-gray rock wall that towered around it like a giant bowl. The perfectly symmetrical, small cone that rose up from the center of the lake was a sight straight out of a fantasy world. I could see how this could be a perfect place for gods and spirits to gather to discuss their differences.

After a few hours, I left the crater to follow the trail, which undulated through a grassy, parched landscape stretching out as far as the eye could see. In silence, I listened to the gentle sigh of the wind swaying through the grass. I thought back on my experience with the manager in the visitor center. Did I use my voice too much in life? Had I forgotten the power of listening?

My voice is perhaps the most important tool in my life. I am a very verbal person, both socially as well as in my work. I talk a lot. I use my voice to tell stories, to convince, and to charm. Through the years, my voice has become a powerful and effective instrument. When I was young my elementary-school teacher used to say that I seemed to suffer from perpetual verbal diarrhea because I was always talking. Therefore, my voice at times has also deprived others of the opportunity to express their views. I sometimes take up more than my fair share of airtime. On occasion, I've come home from work with a stiff jaw from endlessly gabbing all day.

It turned out to be surprisingly easy to stop talking. When I bumped into friends on the trail, I was suddenly much less at the center of the action. I also became less dominant and found that I had to be a lot more flexible. I didn't always get my own way. I noticed a slight shift in the group dynamic, as there was suddenly more space and attention for the quieter characters in the group. Without my voice, I could no longer interrupt, curse, gossip, or judge. It was actually a pretty healthy experiment to shut up

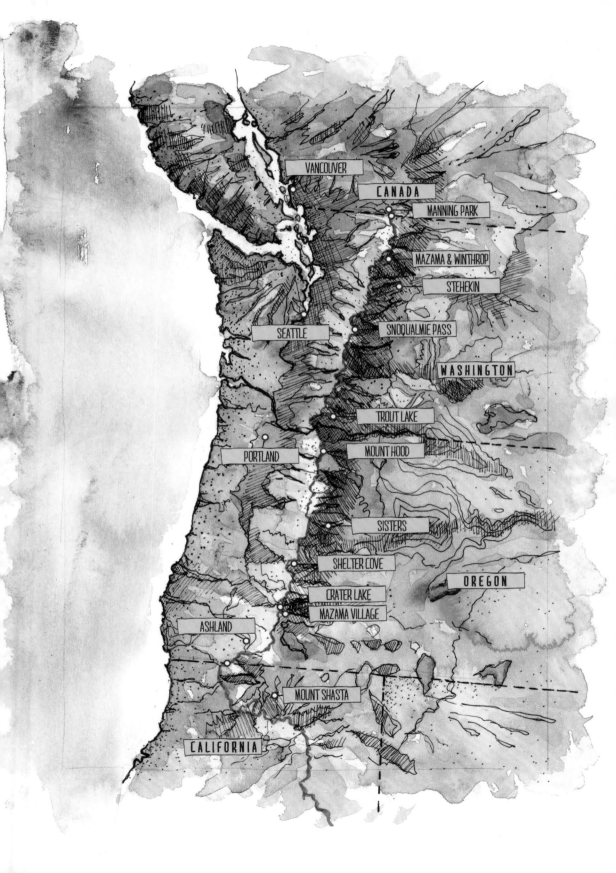

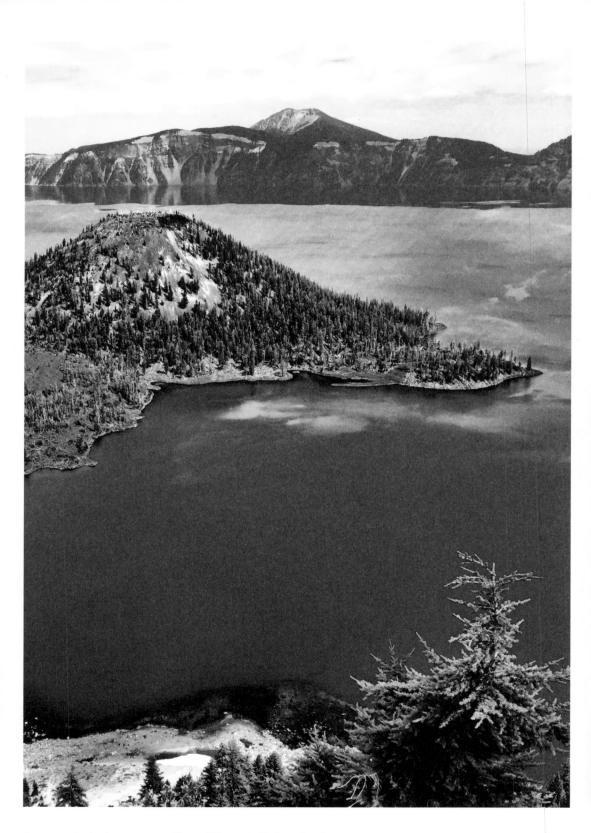

Crater Lake's protruding Wizard Island, Oregon.

for a while. I soon discovered that it would become a lesson in humility.

As I reactivated my listening skills, I discovered the sounds of nature around me were much more layered than I had previously experienced. I listened to all the birdsong at different distances from me, the constant humming of the crickets at my feet, and the high-pitched sighs of the wind in the treetops. I began to decipher the distances of the different sounds around me and started guessing how far away they were before actually seeing them. It was fascinating to observe what effects silence was having on me and my surroundings.

At first I thought I wouldn't have much fun during this silent experiment. I even wondered if the other hikers would ignore me. But on the contrary, I hadn't laughed so much in years. Even in towns, I was able to get by. In the remote fishing resort of Shelter Cove, I took a day off to swim in the lake. My sign language was pathetic, although my friends soon learned to decipher my hints. Goldie thought I had finally gone mad and enjoyed ridiculing me by marching into camp blindfolded, using his trekking pole as a cane stretched out in front of him. He declared that he would be doing the rest of the trail blind, an experiment to see less and feel more. The whole thing totally cracked him up.

"You're full of shit, Van Go, you know that, right? From now on I'm calling you Dickhead," he declared. And that was that. A new trail name that only he was allowed to use, and which I then immediately tried out in sign language. Goldie clearly found my previous trail name way too pretentious. He had witnessed far too many of Van Go's experiments, like the time when he and I switched iPods, only for him to discover that Mozart's *Requiem* couldn't get him through the entire day. He clearly wasn't impressed by my taste in music. It was high time he put me in my place. Goldie had a good feel for things and

he was right. I decided to continue my silent experiment alone and not bother the group with my charades any longer. I headed back to the trail in silent solitude. I thought, despite this, it would be very interesting to try a day of silence at the office one day: nine to five without saying a word. After all, good work always sells itself, they say.

I was setting up my tent one evening when I was joined by a skinny, 22-year-old guy who asked if he could camp next door. But he didn't ask me out loud. He wrote down his question on a small notepad. I gave him the thumbs up. He was silent! Was he like me? Or did he actually have no voice? As darkness fell around us, I became ever more intrigued and couldn't wait to "speak" with him. Once he'd set up his tent, he joined me to prepare his dinner.

I began to decipher the distances of the sounds around me. It was fascinating to observe what effects the silence was having.

"What's your story?" I scribbled in his notepad. I was super curious to learn about his experiences on the trail.

"I don't think I have one," he wrote in response.

"Of course you do! Everyone has a story," I insisted. He hesitated for a moment, then smiled and started to share his story with me through writing one-liners and gestures.

He was walking the trail southbound (SOBO), in the opposite direction. He had decided to hike the entire five months of his PCT in total silence. He told me that he wanted to get a better understanding of himself, reigniting his imagination and inner creativity. While he cooked, I told him that I had also been hiking in silence for a short while, that it had taught me

quite a bit, and that I'd like to do it again some-time in the future. But five months? My friends and family wouldn't appreciate that very much, I presumed. Our silent conversation lasted no longer than an evening but made a profound im-pact on us both. Before going to our respective tents for the night, we embraced with a big hug and retreated to our spots in the woods.

The following morning, I woke early at 4 a.m. and found that he, too, was packing up to head out. Upon leaving, he smiled and gave me an apple. We saluted each other with the peace sign and, without having spoken a sin-gle word, headed our separate ways, to Mexico and Canada. I switched my headlamp on and walked down the valley in the pitch dark. We would never see or speak to each other again. You meet the most beautiful people while walk-ing alone through the woods.

Time Alone Is Good for Your Relationship

The Prophet by Kahlil Gibran

During my week of silence, I was delighted to come across Jetfighter again. We immediately stopped to have lunch in the tall grass together. As I couldn't say anything, she took a book out of her backpack and said, "You know what, Van Go? This poem about marriage reminded me of how you and your wife have arranged things together. I think it's great how much freedom you give one another after 20 years together."

After taking a bite of her wrap with chocolate spread, she began to read aloud from *The Prophet* by Kahlil Gibran.

"And what of Marriage, master?
And he answered saying:
You were born together, and together you
shall be forevermore.
You shall be together when the white wings
of death scatter your days.
Aye, you shall be together even in the silent
memory of God.
But let there be spaces in your togetherness.
And let the winds of the heavens dance
between you.

Love one another, but make not a bond of love:
Let it rather be a moving sea between the
shores of your souls.
Fill each other's cup but drink not from one cup.
Give one another of your bread but eat not from
the same loaf.
Sing and dance together and be joyous,
but let each one of you be alone,
Even as the strings of a lute are alone though
they quiver with the same music.

Give your hearts, but not into each
other's keeping.
For only the hand of Life can contain
your hearts.
And stand together yet not too near together:
For the pillars of the temple stand apart,
And the oak tree and the cypress grow not
in each other's shadow."

—An extract from the Lebanese-American writer Kahlil Gibran in his book *The Prophet*.

"Isn't it beautiful, how words written a century ago are still so relevant to this day?" Jetfighter said with a big smile on her face. She

swept the crumbs off her shirt, lifted her heavy backpack, and left at her unparalleled, swift pace.

I remained laying in the grass for a while, pondering the words she had just read. The funny thing was, I had frequently heard this chapter from *The Prophet* read at weddings by a proud father or uncle, only this time it was different. The last sentence especially, about the oak tree and the cypress, continued to resound in my mind. They were beautiful, wise words, but I wondered how one could put this advice into practice. As Gibran pointed out, a relationship needs space from time to time in order for both parties to develop and grow. But as we all know, life just gets in the way, our days and schedules are jam-packed, and there is often very little time left to spend time alone.

Jetfighter had a point. Even though being apart for six months was somewhat extreme, Herminia had given me the space to go on an adventure. How can the oak tree and the cypress grow if they are too close to one another? How can two people stay happy in a long relationship and not suffocate in each other's shadows? At times, physical distance is needed to develop

as a person. I joked that perhaps I had spoken more with my wife during my long hike than I usually would back home, because of our long conversations via FaceTime, audio messages, and old-fashioned letters. Life gets pretty full and practical when you see each other every day.

Of course, every couple is different and has its own dynamics and needs, but I'm convinced that a little bit of space would do a lot of relationships a bit of good. Perhaps it should even be added to the marriage agreement as a mandatory clause: spend one to two weeks per year alone. Without your partner, siblings, or friends. Venture into the world alone. I believe it could prevent quite a bit of stress and misery.

"I would never let him do anything like that," was a powerful sentence I had heard on several occasions before leaving. It haunted me as I walked. My initial reaction was one of complete shock. I was baffled by the amount of control couples have over one another, but I also grew to understand the underlying subconscious fears people have. Perhaps this was easy for me to say, since I had someone at my side giving me so much space and liberty.

I understand people are afraid of the unknown—anxious at the thought of losing their partner or being stuck at home, alone and lonely. But it really surprised me that people with dreams often never pursue their big ideas and inevitably often postpone them indefinitely because of the relationship they are in. After all, life is so short and already full of compromises. Time alone can be difficult to organize for hard-working, two-income households, but a short period of time is generally achievable. You can come a long way with a good long-term plan, becoming more frugal with daily expenditures, persistent, thrifty savings, and taking the occasional unpaid leave. It's important to discuss these dreams and ideas once in a while, otherwise Kahlil Gibran's wise words remain no more than hollow speeches during a delightful wedding ceremony. In the end, it's all pretty simple: you have to give each other a little space. Everything generally falls into place once there's space.

Painting for Malala

Mile 1,991

While I hiked, I often listened to endless audiobooks, but was struck by one in particular. The book was written by Malala Yousafzai, a young Pakistani woman, and I found it especially inspiring. She described the fate of girls like herself, who aren't allowed to go to school under the Taliban regime. I was touched by the strength and determination of this girl in her quest to help others. At such a tender age, she had managed to create a worldwide movement,

persuading millions of people to support her cause. Her story also inspired me to do something for her foundation.

When I arrived at Big Lake Youth Camp, a tiny, isolated, Christian summer camp in Northern Oregon, I logged online to search for the most suitable website to help me raise funds. It turned

> I was touched by the strength and determination of this girl in her quest to help others. At such a tender age, she had managed to create a worldwide movement, persuading millions of people to support her cause.

out to be a lot easier than I had expected. Within an hour, I had set up my crowdfunding page and sent out a message asking my friends back home to donate some money. I thought it would be fun to ask for $1 for every kilometer I had hiked, hoping to raise a total of $4,265 (ca. €3,700). Additionally, I offered to make a personal painting for every donation I received. Each time I arrived at a town to resupply and saw all the new donations rolling in, I would sit down to make a new series of paintings to thank them all. As a result, I made more than 300 paintings as the weeks continued. I have rarely painted so much in my life. All I had with me were the two small cubes of yellow and blue watercolor paint. Beautiful, melancholic, contrasting colors. Throughout my journey, I had been painting the flowers, mountains, and landscapes that I had been walking through. But I also painted a series with the defiant Malala standing on a mountain with the world at her feet.

To kick the whole thing off, I decided to donate the first 10 percent myself, inspired by Malala's own father, who gives 10 percent of his teacher's salary to underprivileged people in

Oregon's yearly wildfires have
left the forests scorched.

his community each year. This meant the first 426 kilometers (265 miles) were in the bag. I was surprised and overjoyed to see how many people responded, and within two weeks, we had already hit my target.

Future dreams

Mile 2,112

I took a long run up and jumped into the crystal-clear water of Little Crater Lake, a tiny pond no more than 100 feet (30 meters) wide. It was nothing in comparison to its 6-mile-wide (10 kilometer-wide) bigger brother, Crater Lake, which I had passed only a few days earlier. The water was so clear that I could distinctly see the bottom of the lake, 50 feet (15 meters) below me. Fear danced through me. It was strange to suddenly be overcome by my fear of heights as I swam. Seldom had I swum in such icy water—34 degrees Fahrenheit (1 degree Celsius) to be precise—and I was back on the shore as quickly as I'd gotten in.

An unfamiliar hiker had come out of nowhere and lay stretched out in the sun, covered from head to toe in an array of tattoos. Thru-hike tattoos. Countless maps and trail emblems had been immortalized over the lengths of his legs. He had appropriately been named Tats, and turned out to be a so-called Triple Crowner, someone who had completed all three U.S. long-distance trails: the Appalachian Trail, the Continental Divide Trail, and the Pacific Crest Trail. Tats had hiked more than 18,000 miles (28,968 kilometers) during the past eight years. I had heard quite a bit about the Triple Crowners but had never actually met one in person.

As it turned out, Tats was doing PCT for the second time because he enjoyed the vibe so much. According to him, each trail has its very own distinctive characteristics. The PCT is all about community.

We got to talking about the journeys he had taken. The Appalachian Trail is generally referred to as the long green tunnel, with its 2,185 miles (3,516 kilometers) through the unforgivingly steep forests of the East Coast. It is exceptionally physically demanding, the equivalent of scaling Mount Everest 16 times from sea level to summit and back. It's the *grande dame* of the American trails, first hiked a hundred years ago. The Continental Divide Trail was only completed a few years ago and is known for its isolated, untouched wilderness. It is attempted solely by fearless adventurers. Very few people dare to embark on this lengthy 3,100-mile (4,989 kilometer) trail, which runs straight through the middle of the United States, from Montana to New Mexico. With bear spray on your hip belt to keep the grizzlies at bay, it ventures into no-man's-land for weeks. At times, it is so wild and deserted that there isn't even a real trail to follow. You really have to figure

Someone who has completed all three U.S. long-distance trails, the Appalachian Trail, the Continental Divide Trail, and the Pacific Crest Trail, is called a Triple Crowner.

everything out for yourself out there. Each of these legendary trails takes more than five months to complete, with around 8,000 miles (12,875 kilometers) between them. The unofficial honor of becoming a Triple Crowner has currently fallen to no more than 250 people worldwide.

I follow Oregon's volcanoes north.

Olallie Lake, with Mount Jefferson on the horizon.

However, neither of the other trails was particularly high on my wish list, primarily due to the fact that I enjoy hiking through different landscapes and countries, each with their unique cultures, cuisines, rituals, and nature. I had eaten enough burgers and pizzas to last me for the coming years.

Just like Tats and I, many passionate thru-hikers dream of the next long-distance trail and add it to their imaginary hiker CV. You could see it as some kind of weird hiker career path. But to us, it isn't at all strange. Tats told me that he hopes to hike across as many trails and countries as possible, eventually traversing entire continents by foot. It's a very addictive lifestyle, quite challenging to combine with a normal life in the city, with work, relationships, and children. Thru-hikers often live on a tight budget off-trail, saving for the next adventure and frequently earning money with seasonal jobs. Some become independent entrepreneurs. It was interesting to hear Tats's take on the trails he had hiked, and I enjoyed chatting with him about all the new thru-hikes that are being developed around the world.

Many thru-hikers dream of the next long-distance trail. It is a very addictive lifestyle.

I had heard a lot of good stories about the Israel National Trail from a few young Israelis I had met during the past months. The more I heard about this 636-mile (1,023-kilometer) trail through the length of Israel, the more intrigued and interested I became in doing it. Apparently, the first 200 miles (322 kilometers) go straight through the arid Negev Desert near Egypt, where you have to carefully bury all your own water supply before you start the trail. There is simply no water for days. After the Negev, the trail takes you through many ancient cities, such as Jerusalem, Haifa, and Nazareth, and you can spend the night with Trail Angels who open their homes to hikers. The food and nature are supposed to be amazing, and it's a great way to meet the locals and get a better understanding of their culture. There are approximately 50 people who do the trail each year, so there is plenty of space to roam and reflect. I would love to make a pilgrimage through the Holy Land one day.

I told Tats about an interesting story I had heard about a trail in Korea. Apparently there had been a pilgrimage through the length of the peninsula for centuries, the Baekdu-Daegan Trail. However, due to the country being divided into North and South Korea in 1945, it is no longer possible to hike the trail in its entirety. The only accessible part is presently the South Korean section of 460 miles (740 kilometers), stretching along the length of the Baekdu-Daegan mountain range. It is supposed to be a stunning trail, and I would love to do it, especially to experience Korean culture and food.

Tats told me about a trail he had done a few years ago through New Zealand. The Te Araroa Trail, referred to by the indigenous Māori as "The Long Pathway," which meanders 1,900 miles (3,000 kilometers) across the country's two islands, passing through endless, enchanting *Lord of the Rings* landscapes.

"New Zealand is like a tropical version of Scotland, dude," Tats said enthusiastically. "It has jungles, 60 million sheep, and a ton of dangerous rivers."

After his fiery pep talk, the Te Araroa instantly jumped to the top of my list.

Now it was my turn to impress him with my own backyard. I told him of our European Alta Via trails that run from Austria through the Italian Dolomites. The trails are centuries old and were created by smugglers and shepherds

back in the day. There are 10 different routes that can now each be hiked in 10 to 18 days.

"But it's not the amazing mountains that you will remember if you ever get the chance to hike there," I told him. "It's the food. The Italian food in the mountain huts is divine. Imagine finishing a day's hike with handmade pasta and a local red wine from the valley below. And to top it all off, the following morning you can start the day off with a real espresso and select one of the 25 local cheeses for your lunch pack," dreamed aloud. "Is that still hiking? Man, that sounds more like a cruise!" Tats teased.

But Tats had bigger plans. Two trails in particular had captured his imagination. "I want to do the Great Trail across Canada. They say its 15,000 miles (24,000 kilometers) long, so I'll be pretty preoccupied the coming few years. It's either Canada or the Great Himalaya Trail. That's only 150 days long, but I don't know if I'm quite up for it to do it totally alone, since it passes Everest Base Camp and traverses 20,000-foot (6,096-meter) passes. We'll see." Silence returned and we both stared into the clear water, visualizing our next adventures.

The following day, I tried to imagine how New Zealand would compare to my present surroundings. I couldn't imagine that anything could be more beautiful than the landscapes I'd walked through the past weeks. Enormous Mount Hood, with its white capped glacier, loomed in the distance. The river beds that I had to wade through

each day became ever more milky-turquoise due to the powdered rock sediment created by the grinding together of rocks beneath the glacier. I had just reached one of the glacier lakes when Goldie suddenly appeared out of nowhere.

"Wanna go for a swim?" and before I knew it, he had jumped into the icy, turquoise lake. I couldn't wait behind and soon joined him.

While we had lunch shivering on the banks of the lake, I asked him if he had any plans to do other trails in the future. His happy mood abruptly changed, and he gave me a long death stare and ask me why my head was already fantasizing about the next trail. "Can't you just be happy with what you have now?" This was the wise lesson my young friend gave me. "Cherish what you have and don't dilute your PCT experience with future plans. Enjoy today, dude!"

And Now for Something Completely Different: Where Do You Leave Your Trash?

Leave No Trace

How do you go to the bathroom in the wilderness? Well, the same way humans have gone about their business for centuries, but with the most amazing views imaginable. When nature called, I would leave the trail to find a good view and dig a hole about three inches (8 centimeters) deep with my pooper scooper. After all, it's

filthy to see human excrement and toilet paper flying around.

The Leave No Trace movement was strongly supported within the hiker community. This also meant that I carried my used toilet paper with me in a ziplock bag to the next town. Now believe me, I'm not at all squeamish, but this did take some getting used to in the beginning. But you learn to deal with it, and soon it was no big deal at all. You can imagine how relieved I was every time I ran into a trash can in town to dump my load of paper. I managed to keep this ritual up for the first half of the trail, but I eventually caved and resorted to burying it.

One day, while having a beer at a bar in some tiny trail town, I got talking to the bartender about a guy called Seth Orme. The barman, who had met the fellow a few weeks earlier, told me Seth was picking up all the trash he found on the trail. This 26-year-old guy from North Carolina, whose trail name was Cap, had a fascinating mission. During his many hikes in the national parks, he was shocked to see how much trash and toilet paper was left lying around. So, in 2015, he and two friends hiked the Appalachian Trail and decided to pick up and carry out all the trash they came across. They were soon dubbed the Pack It Out Crew.

"It was time to stop complaining about all the trash I saw," Seth had told the barman. "When you're outside, it doesn't matter whose trash it is." During their five months on the trail, the crew carried out more than 1,100 pounds (500 kilograms) of trash. They even dragged an old mattress with them for three miles (5 kilometers). The following year, Seth and his Pack It Out Crew decided to hike the PCT, where they removed more than 715 pounds (324 kilograms) of trash, sometimes even carrying it with them for more than 90 miles (145 kilometers). They primarily found toilet paper, cigarette butts, cans, bottles, and food packaging lying around. But sometimes they even came across odd items, such as a plastic tricycle, a pair of leather boots, and a beer bottle with a dead mouse in it.

"Our goal is to inspire others," Seth said to the barman. "It's fantastic when people tell us that they're also going to collect trash on the trail now, too."

While having a beer in some tiny trail town, the bartender told me about a guy called Seth Orme. Seth was picking up all the trash he found on the trail with two friends. They were dubbed the Pack It Out Crew.

Personal hygiene is of course quite an issue if you only shower once every ten days. Scout and Frodo, Trail Angels I had stayed with in San Diego at the start of my trail, urged me not to use any soap or shampoo in the backcountry. They suggested a daily wash with a wet bandana, and that a quick bath in the river was more than enough to keep myself clean. Even organic soap was out of the question. Just don't use any soap at all was their compelling advice. For the first few weeks, I used wet wipes to freshen myself up in the evening, removing the dust and sweat, but soon found the wipes far too heavy to carry with me everywhere. After a while, I paid less attention to hygiene altogether, because nothing really seemed to work, and I was always filthy within an hour after a swim anyway.

I don't exactly know how women address issues such as menstruation. There is a special women's PCT Facebook group (*Women of the PCT*) where women share tips and tricks. I never heard anyone complain about this during the trail, so it seems there is an adequate solution for everything.

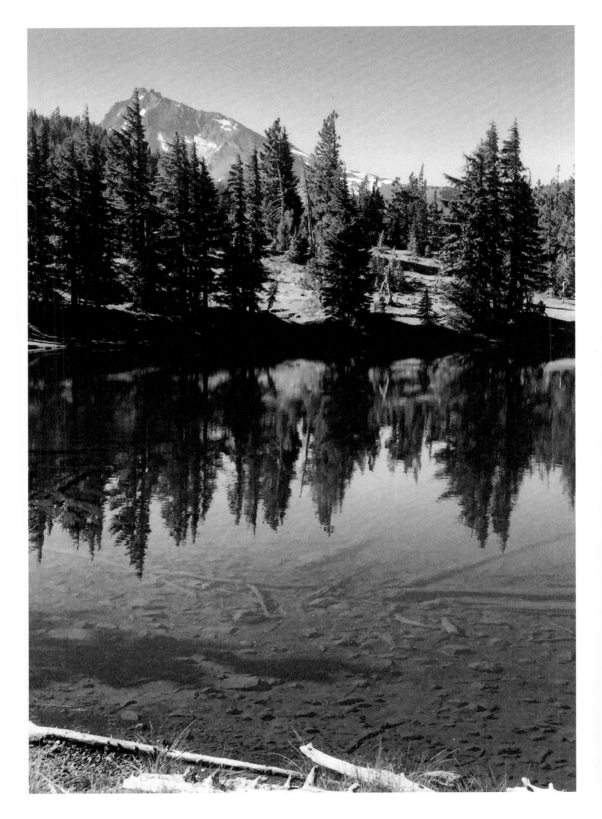

One of Oregon's crystal-clear lakes.

Girl Power

Mile 2,155

Apart from Jetfighter, I frequently saw Genie along the trail in Oregon. Genie listened more than she spoke, was smart, but also had something mysterious about her. It was difficult to fully fathom. She preferred to walk alone under her silver umbrella to avoid the bright sun. Every other week or so, Genie, Jetfighter, and I met up for breakfast in a local café to catch up and sift through the recent trail gossip. We were not a typical trail family, rarely actually hiking together, but we were a strong trinity that looked out for one another. It always felt safe and fun to spend time together when we saw each other.

The differences in our three characters could not have been bigger, but it was perhaps because of this that we got along so well. Genie, the student from Australia, Jetfighter, the vagabond from the USA, and Van Go, the suburban father of three from the Netherlands. We were a cocktail of extremes (in random order): loud, funny, quiet. Drugs, alcohol, water. Wild, cautious, curious. Living in the past, present, and future. The entertainer, the charmer, and the teaser. Kind, caring, listening. Frugal, wasteful, and eco-friendly. No similarities whatsoever. We were each very independent and doing the hike on our own terms.

During our frequent breakfasts, we had long conversations about the changing landscapes, faith, reincarnation, and how trees communicate with each other through a network of fungi underground. But in the end, it always came down to the latest trail dramas. Somehow the conversations with these girls were always inspiring, but they cursed just as much as the average dude, farted as much, smoked just as much weed, and hiked equally fast.

One morning, Jetfighter came up with the idea to give all the miles we did each day their very own name. It was a playful way to soften the pain of the long stretches we walked each day. A Marathon was of course 26 miles (42 kilometers), a Dead Celebrity was a 27-mile (43-kilometer) day, a Winchester was 30 miles (48 kilometers), and a Scottie Pippen no less than 33 miles (53 kilometers). A Bond was 007 miles (11 kilometers), and my longest day ever was 40 miles (64 kilometers), which was quickly christened a Mid-lifer.

> The differences in our three characters could not have been bigger, but it was perhaps because of this that we got along so well. We were a cocktail of extremes. We were each very independent and doing the hike on our own terms.

The last time we were together was on my 44th birthday in the border town of Cascade Locks, between Oregon and Washington. I hadn't seen the girls for more than 10 days and was so exhausted after having just completed my Mid-lifer. But when I saw Jetfighter, Genie, and Goldie walking into town that afternoon, I jumped for joy. It was always a ball when they were around. They had enough energy to fill the town, and we went for a beer at the local Ale House, where the wonderful Trail Angel Julie Caldwell made us feel right at home. That evening, to my surprise, they made me a special birthday cake out of an old resupply box. 44 candles flickered on it. There was a gallon of ice cream and plenty of beers to go

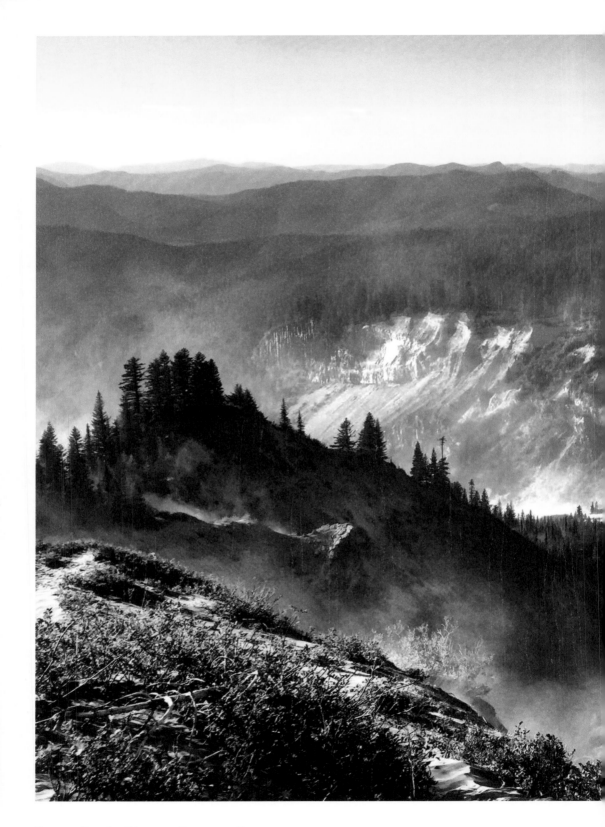

Mount Hood, Zigzag Canyon, Oregon.

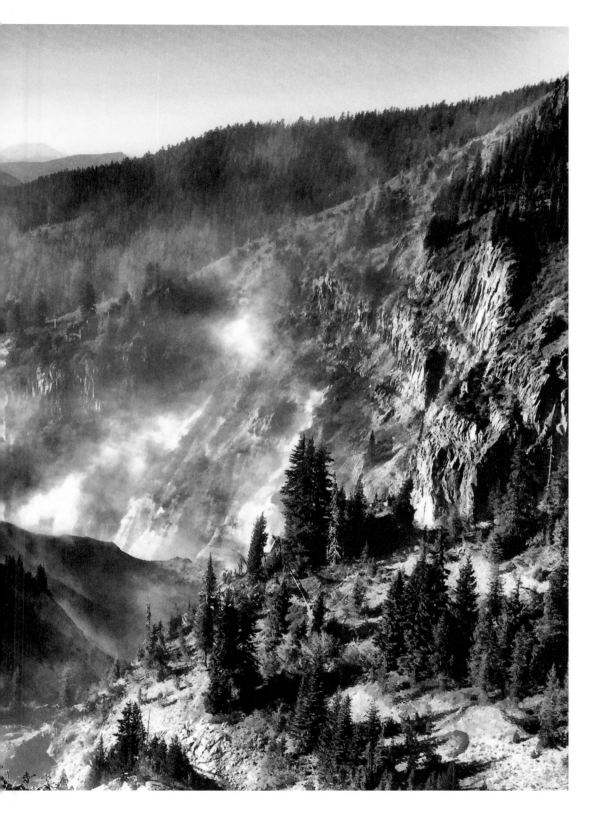

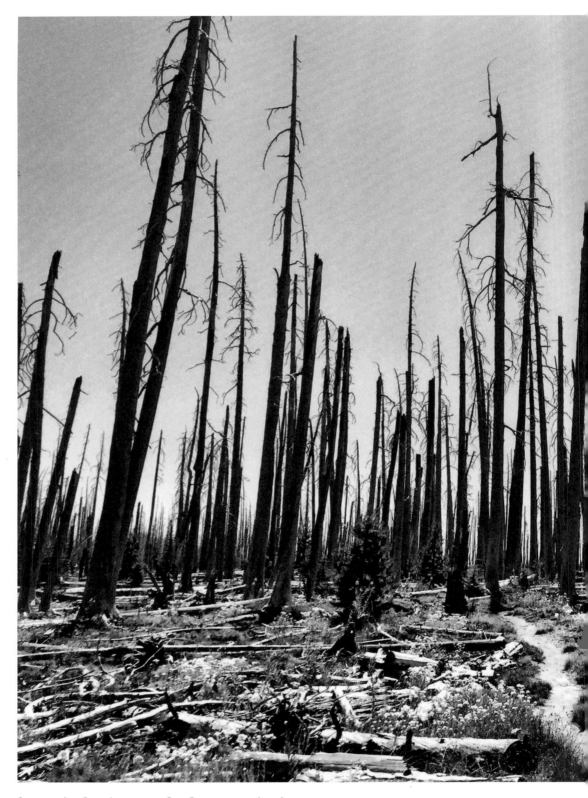

Oregon's landscape slowly comes back
to life with wildflowers.

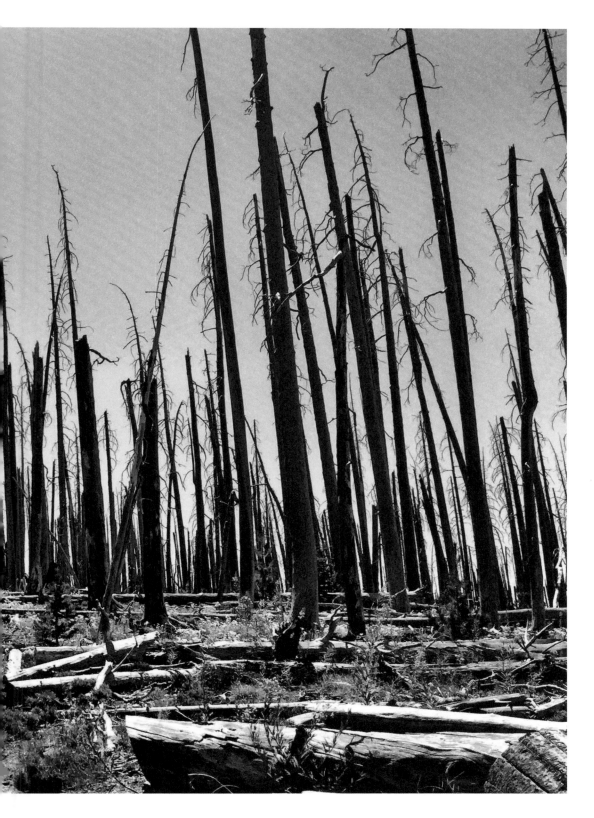

around. What else could you want? We all slept on the floor at the local Trail Angel Shrek's house, where we talked deep into the night.

It turned out to be our last supper together. We each went our own ways, completing the final section of the trail through Washington alone.

Angels

Similar to Scrooge in *A Christmas Carol,* I was visited by three angels during my journey: the angels of time past, present, and future. Three strong, confident, inspiring women. I believe in angels, not from the heavens, but the earthly kind: people. People who come into your life and give. They give unsolicited advice, messages, or insights. They present questions to think about, offer protection, or give warning. But angels don't give the answers; you have to figure them out yourself. I believe that we are all visited by angels from time to time, and it is a choice

to accept them, recognize their advice, and do something with it.

The first angel visited me during my ordeal on top of Mount Whitney. I remember lying awake during that endless, stormy night on the summit, terrified by every thunderbolt. It was at this moment that my thoughts raced back in time, and I saw the image of a woman clearly in my mind's eye. The angel was my wife, whom I've spent the past 20 years of my life with and who always encourages me to be grateful and content. In that moment of extreme fear, I suddenly realized how fortunate I had been in life—in that moment and in the past. She loves history and has a deep appreciation for the past. She always knows what we did exactly one year ago to the day. Thanks to her, I often re-lived the special moments we had experienced as a family in years past.

The second angel came as a slap in the face, which shook me awake to start appreciating the present more. I had forgotten how to enjoy the present and had to search for new ways to live in the now. I had to learn how to let go of my sense of time altogether. The angel came in the form of Jetfighter, a young woman full of raw energy, with a powerful conviction to be free. She taught me to be more flexible, adjust, and move with whatever

came my way. "Go with it. Things always work out," she told me. "Try to accept that things don't always go as you have planned. That you have to be flexible to be free."

The angel of the future was Malala, who woke me from my privileged bubble and urged me to take a closer look at the problems people face around the world. Her book taught me that without an education, girls have no future. In her quest for equality and justice, Malala is fighting for the future of millions of girls worldwide. It triggered something in me to go out and help those in need, culminating in my fundraiser for her foundation. But above all, it made me realize how fortunate I am to live in a free country, where my daughters can peacefully go to school, unhindered by any fears.

But let's not get carried away and take angels too seriously or declare them all holy immediately. They are not always right, and you can have a lot of fun with them too. Angels: they're a choice, not a truth.

Autumn and Winter at Once

Mile 2,143

It started to rain just as I crossed the Bridge of the Gods over the Columbia River to Washington. And yet I was overwhelmed with a sense of joy. Somehow everything felt just right. I was totally at home in the wilderness and thoroughly enjoyed the sound of silence.

Something strange happens to your body and mind if you walk the whole day. A peculiar cocktail of hormones is created, activating a

unique mix that flows wildly through your veins. An exquisite blend of endorphins, serotonin, dopamine, oxytocin, and testosterone are thrown through the blender. When all these hormones are stimulated at once, they produce a wonderful feeling that is just as addictive as any hard drug. An indescribable feeling, just like being in love.

> Something strange happens to your body and mind if you walk the whole day. A peculiar cocktail of hormones is created, activating a mix that flows wildly through your veins.

The steep Cascade mountains in Washington were as tough as, if not tougher than, the Sierras. The trail crept past one dormant volcano after another: Mount Rainier, Mount Adams, Mount St. Helens. Fortunately, however, the trail didn't go up and over each of their summits, sticking instead to the mossy green valleys. In 1980, Mount St. Helens partially collapsed, resulting in one of the largest volcanic eruptions in the history of the United States.

For days on end, I walked through mountain meadows strewn with innumerable blueberry bushes. Every once in a while, I stopped to pick a bunch of the sweet berries, which soon turned my hands purple from their juice. I ate so much that I became nauseated and got the runs in no time. Apparently, an overdose of blueberries isn't that healthy.

The trail went up and over a large round hill, forming a light, ocher line through the green and red carpet of growth that stretched out as far as the eye could see. I peered in the distance and thought I saw something moving on the other side of the valley. It wasn't hikers—the movement was too slow. I could make out two light-brown

dots stirring in a field of blueberries. Bears! My first bears at last. Two black bears that had turned golden brown in the bright sunlight throughout the summer months. They were at a safe enough distance from me that I sat down to study them extensively. They were even bigger blueberry fans than I. For some reason, I had imagined something totally different for my first bear encounter—namely, that there would suddenly be one right in front of me on the trail when I least expected it, or perhaps one sneaking and sniffing around my tent in search of food, as some of my friends had experienced.

In the past decade, black bears have caused fewer than 10 fatal accidents across America. That's including eight in Alaska. They are generally very peaceful and run away at the slightest noise. The grizzly, though much more aggressive, is extremely rare along the West Coast. You always have to treat bears with respect and common sense, but the chances of being eaten by a bear on the PCT are practically zero. Dehydration, hypothermia, lightning strikes, mountain lions, and crossing rivers form much bigger dangers. But because I had already survived a thunderstorm on top of Mount Whitney, I was somehow less worried about these other risks.

> It wasn't hikers—the movement was too slow. I could make out two light-brown dots stirring in a field of blueberries. Bears! My first bears at last.

I could hardly imagine that the landscape could get even more beautiful, but the farther north I walked, the more impressive the views became. The Northern Cascades between Seattle and Vancouver were exceptionally stunning.

Washington stole my heart. I passed several ancient glaciers that had clearly shrunk in size during the previous millennium. The rugged mountain terrain, which extended into Canada, was awfully steep and tough-going. According to the legendary, 79-year-old thru-hiker, Billy Goat, "The Cascades will whip your ass." He was right. Although things seemed to become more stunning, the trail also became tougher. Standing

> For some reason, I had imagined something totally different for my first bear encounter—namely, that there would suddenly be one right in front of me on the trail.

at the top of a cliff, I could see the next mountain so close, with the trail zigzagging up its face. It was so steep that the trail had been blasted into the rock wall, creating endless switchbacks up the face of the mountain. There was no shade, and my head dripped with sweat as I walked up and down, up and down. But it wasn't hot every day, and the one good thing about all the rain in Washington was that there were frequently beautiful cloud formations. At times the trail reached such heights that a soft bed of clouds stretched out far beneath me with the white-capped volcanoes piercing through, rising high into the sky. The trail often followed the crest of the mountains for miles, offering some of the best ridge walking I have ever done. As I walked along the ridges, the mountains fell straight down on either side of me, and I felt like I was walking a tightrope on top of the world. The clouds often engulfed me at night, and I sometimes woke up to a white mist, in which case I pulled my hat over my eyes again and slept on another hour, waiting for the mist to rise under the warmth of the morning sun.

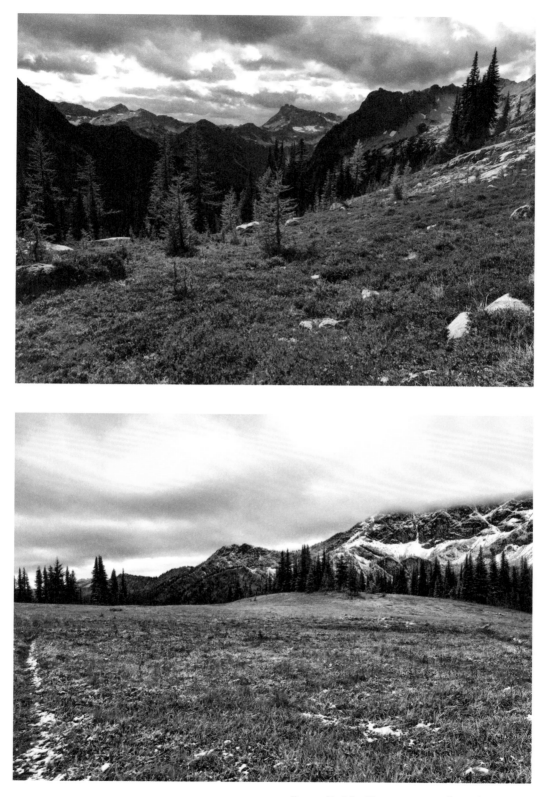

Top: Fall flowers at Hart's Pass.
Bottom: The first snow falls over Washington.

Fall was clearly visible all around me. The hills had transformed into a patchwork of vibrant colors. Everywhere I looked there was color: rust-red autumn leaves, lush ocher-yellow meadows, moss-green forests, bright turquoise lakes, and fresh white mountain peaks. Unfortunately, I could also feel the seasons changing: for days I walked through the pouring rain. I had forgotten how demoralizing cold rain can be and could clearly notice it affecting my state of mind. The rain was so cold that my hands went numb, and I could no longer close the zip of my raincoat. I lost all sense of touch in my fingers, but the only sensible thing to do was to keep moving so as not to become hypothermic. Winter was approaching fast. The nights quickly turned stone cold, and I slept with all my clothes on. Everything I did now became focused on reaching Canada as soon as possible. I could feel the snow was coming, which would make the trail imperceptible and ultimately impassable.

American Hospitality

Mile 2,228

Tucked away in Washington's mountains is the quaint rural town of Trout Lake. I had gone through all my food, and it was high time to resupply. I left the trail and got a ride to town from a friendly old man sporting an old pair of dungarees, a red lumberjack shirt, and a small gun on his belt. Lively country music filled the truck, and he kindly invited me to stay in the guesthouse on his farm. Back in Europe, we are constantly exposed to an image of extremely

outspoken Americans, an image full of contrasts and contradictions. The media portrays a picture of Americans as either super-beautiful, with Botox and fake breasts, or extremely opinionated and loud. Rednecks are supposedly all gun-lovers, and people are often portrayed as pretty superficial.

I knew this was far from the truth, but during my preparations, I did sometimes worry about the fact that mental healthcare is not always freely available for all who need it, and if you combine that with a trigger-happy landowner whose land I accidentally crossed as a trespasser, things could get ugly.

But this wasn't the America that I experienced during my recent months on the trail. On the contrary. Walking through the many small mountain towns, I grew to realize that normal American people were extremely wholesome, respectful, and remarkably hospitable. Europeans can learn a lot from how welcoming these local folks were to me. Hitchhiking is supposedly the most dangerous thing you can do in the States, but I got a ride to town every week and found it to be a great way to meet the local people. Of course, you always need to use common sense, and I usually waited for a fellow hiker to hitchhike together. The folks I met were always enthusiastic, full of questions, and often offered advice or welcomed me into their homes. I was overwhelmed by their generosity and genuine kindness. God bless America.

During my journey, I spoke to a lot of veterans who had been to Iraq, Afghanistan, and Vietnam. Men who had served their country in the name of freedom. Almost everyone in the States seemed to have a connection with the Armed Forces. Many had signed up by the age of 18, looking for adventure or a way to pay for college, because the army often covers the tuition if you sign up for several years. Some were not even 30 but had fought in various wars for over 10 years.

One night I sat staring into the flames of a campfire, listening to a guy who had recently returned from the frontline in Afghanistan. He hoped to finally get some peace of mind by walking this trail, to find answers to the endless questions that came at night. He had lost friends and taken lives. It was hard to imagine what he had experienced and how it would be for him to pick up a normal civilian life after such extremes in the war.

What also struck me was that by traveling alone, I interacted with the locals in a very open way. Our mutual vulnerability enabled us to develop a genuine impression of each other's characters, cultures, and views. By walking alone, I was compelled to have a positive attitude and be more creative in my survival. I regularly had to approach strangers, but strangers would also often come to me to offer help, as there is something approachable about a person by himself. It opens unexpected doors. Strangers are simply friends you haven't met yet.

As I walked through Washington, I encountered more and more friendly strangers who surprised me with unexpected gifts, also known as Trail Magic. It has puzzled me for quite some time why all these people give up their precious free time for a bunch of smelly, unknown hikers who they will never see again. I stumbled upon Trail Magic in the strangest places: in secluded parking lots, at trailheads high in the mountains, along remote rivers, or deep in the woods. There, like an oasis in the desert, I was offered fresh fruit, greasy hamburgers, or cold beer. And it always seemed to come at exactly the right moment, after days of noodles and mash. As a token of thanks, I often made them a small painting on the back of a piece of cardboard.

The ultimate master of Trail Magic was CopperTone, whom I encountered more than eight times between Mexico and Canada. He followed the herd northwards the entire summer, driving his self-constructed RV, resurfacing in the craziest places. I would be walking in the middle of nowhere and suddenly see a makeshift sign lying on the trail with the words "CopperTone Is Here!" He always had his famous root beer float ready: sweet vanilla ice cream in a plastic cup filled with root beer. There was nothing better than CopperTone's float after a long hot day on the trail. He was a beautiful, carefree eccentric; he donned a chin curtain beard, just as Abraham Lincoln had done two centuries before him, and often appeared wrapped in a skirt. Everyone was overjoyed to take a brief break and rest in one of his comfortable camping chairs under the RV's awning. Hikers were his family.

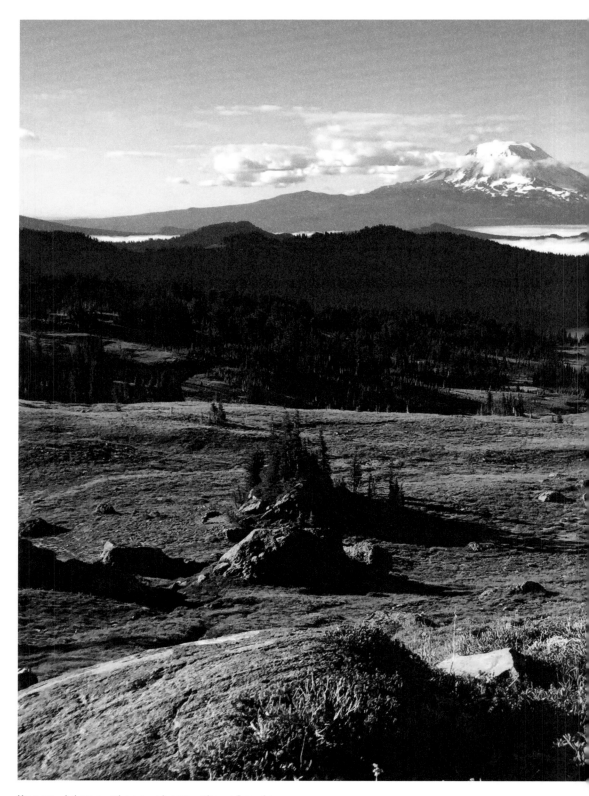

Mount Adams rises above the clouds
as I walk through Goat Rocks Wilderness.

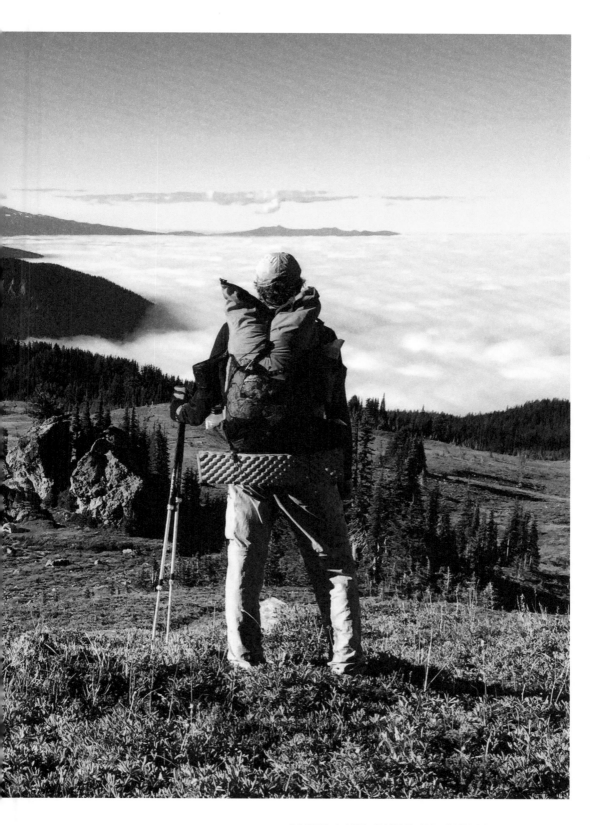

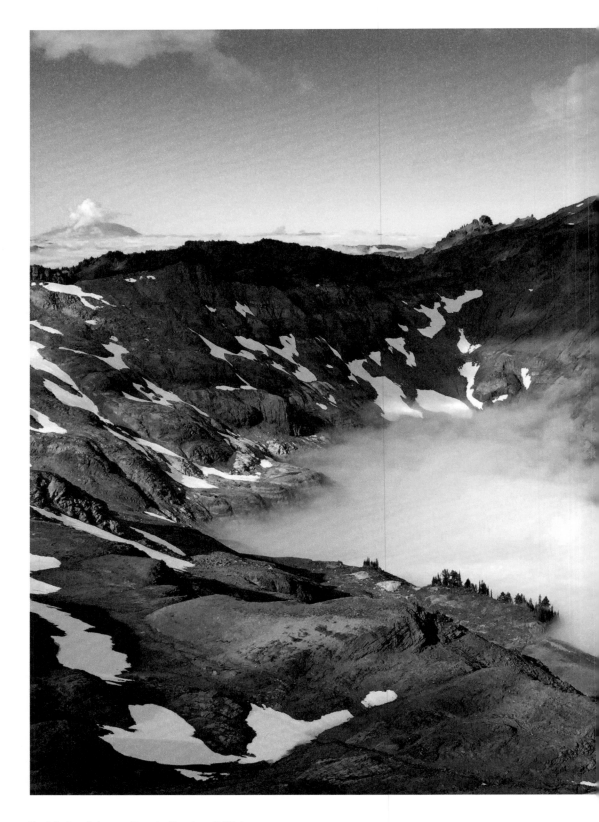

Knife's Edge, Goat Rocks Wilderness.

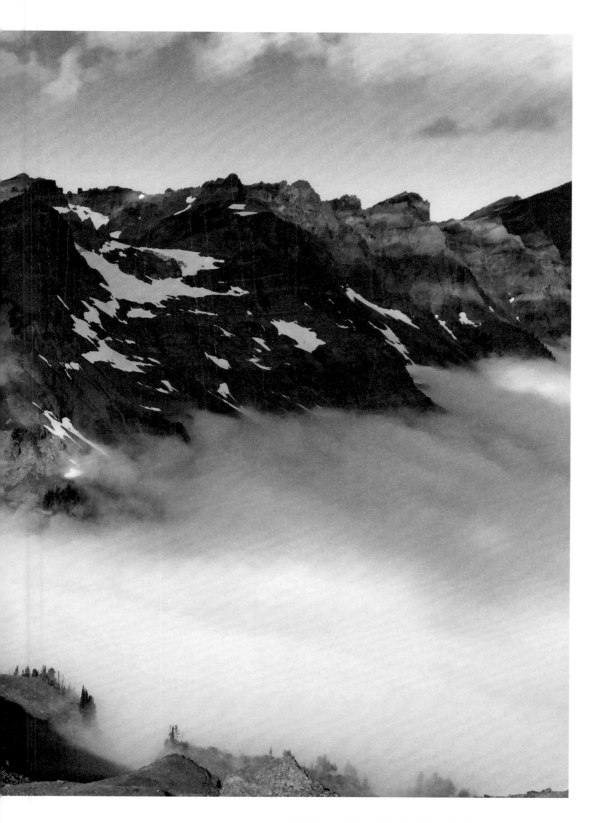

There were also those who had hiked the PCT in previous years, who now wanted to give back and surprise us with some Trail Magic. I came across a rowdy bunch from the PCT Class of 2014, who had set up a complete bistro café between the trees. I was welcomed with a trumpet serenade and invited to change into one of their Burning Man dress-up outfits. I was presented with a self-made, one-of-a-kind menu, and encouraged to choose from burgers, sandwiches, salads, pasta, coffee, beer, or weed. The guitars soon came out, the campfire was lit, and my intention of covering 25 miles (40 kilometers) evaporated into thin air.

There was a remarkable amount of weed being smoked on the PCT. The Americans loved their ganja, bud, reefer, skunk, chiba, dro, chicken, dank, sticky-icky, kush—whatever you want to call it. Perhaps this was some kind of counter-reaction against the strict war on drugs. Personally, I had no experience with the stuff, as I had never been tempted to try a joint with the tolerant legislation back in Holland. I had often been offered a spliff on the trail, and everyone always gave me a crazy look when the Dutchman politely declined. Thanks, but no thanks.

I had always been a little proud that I had never smoked a joint, but came to realize that this might also have become the rigid attitude of an aging man. In my attempt to become more flexible in life, it seemed like a good idea to give it a try at 44. I wanted to break away from my stringent, uncompromising habits, and perhaps cannabis could even help me relax during stressful times.

So I figured, what better place to learn than out here in the woods with the experts? I took a few drags from a spliff after my bistro meal, but nothing really happened to me. I was probably expecting too much. The following morning, I tried it again, this time inhaling even deeper, but it still had little to no effect. What was all the excitement around weed? I didn't get it.

The following evening, I found a beautiful spot next to a lake and continued my experiment in peace and quiet. This time I smoked two thick joints one after the other in the hope of finally discovering where the magic lay. The effect, however, was that I got completely knocked out within a few minutes and fell asleep right where I sat. It was only after four days of extensive experimentation that I finally figured out what dosage worked for me. I was soon hiking through the mountains as high as a kite. But my stash didn't last me long, and the novelty soon wore off. When I later called my wife to tell her that I had smoked my first joint, she replied that she had also started trying CBD oil two months ago. What an absurd coincidence. Both discovering something new on either side of the world. Her bottle of non-hallucinogenic CBD oil casually stood between the mayonnaise and eggs in the refrigerator.

Inspiring Lives

Mile 2,460

There is nothing more inspiring to me than listening to people tell how they have restructured their lives around their dreams. Stories of how they have creatively organized their lives to combine their dreams with the reality of everyday life. Several hikers I spoke with have found that the key to successful living and being rich isn't found in money but in time. Not a bit of free time, but lots of free time. Being frugal and smart with money, finding you can do more with less. Less stuff, fewer things and obligations.

It had been months since I had seen my buddy England for the last time, but often

reminisced and reflected on the way he had managed to organize his life back home. I found it extremely inspiring how low he had managed to keep his recurring monthly costs—and how free it had made him as a result. The lifestyle he had created was very basic, and therefore, he didn't need much to get by. Since he rarely worked, he had very little money, but he tried to spend as little as possible and lived a creatively frugal life. And as a result, he had lots of time for his friends and family. He spent months each year wandering across the great trails of the world.

His minimalist lifestyle was impressive, and I started thinking about ways I could drastically reduce my fixed monthly costs, in particular the mortgage debt that weighed us down. I wondered if we as a family would be able to change our habits and live much more economically, to ultimately become totally debt-free. Herminia has always loved a bargain and used to have a subscription to our local frugality magazine (*De Vrekkenkrant*), a weekly paper dedicated to promoting minimalism and an economical way of life. She always thought that we should spend less money. Not out of necessity, but because it can also be a lot of fun. More isn't always better, and limitations can be very healthy at times. We have become absorbed with our addictions to things and debts. I slowly began to see that living with less stuff could also create many new possibilities.

By spending less and aggressively saving, we could perhaps rapidly pay off our mortgage, and, in the long run, work less and hike more, creating more time for each other and time to be alone. Time for dreams and time for adventure.

I was keen to hear how people changed their lives through clever, frugal habits, by simply spending less money, changing their career, or otherwise. I spoke to a young father, for example, who had made a drastic change in his life when he started a family. He wanted more nature in his daily routine but also wanted to pursue his high-tech career. He searched for a way to combine his work as a virtual reality specialist at a leading tech company in the city, while also living off the grid, debt-free. So he decided to buy a deserted, single-room, 20-by-30-foot (55-square-meter) log cabin in the woods, more than ninety minutes' drive from his work. He was not rich and to do it all up by hand, but he was able to repay the small loan within three years and currently lives debt-free with his wife and two children, off the grid, in nature. He was still connected to the rapid developments within the business world, but also with the continuous changes in the seasons, experiencing the wonders of natural life. Who says you can't have it all?

Similarly, one night on the trail I spoke to a woman who told me how she had managed to combine her work with yearly long-distance

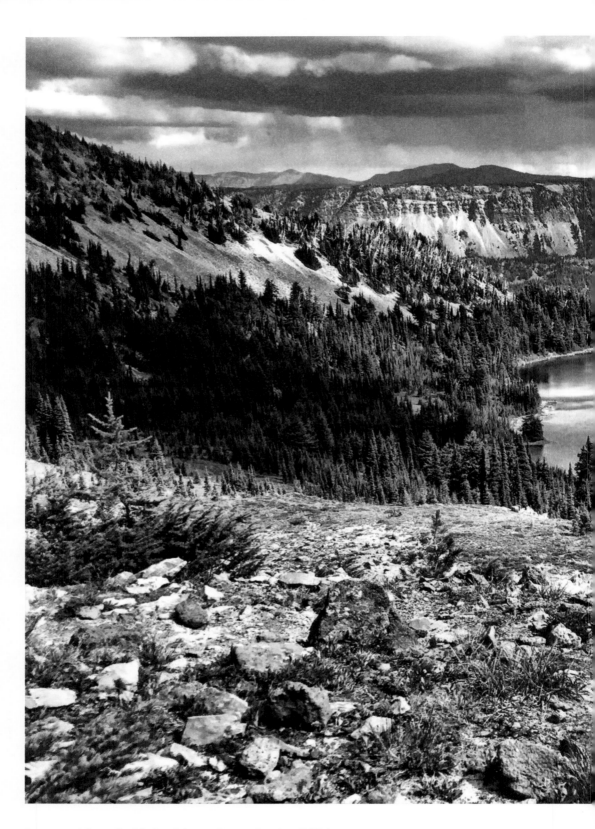

Approaching Knife's Edge, Goat Rocks Wilderness.

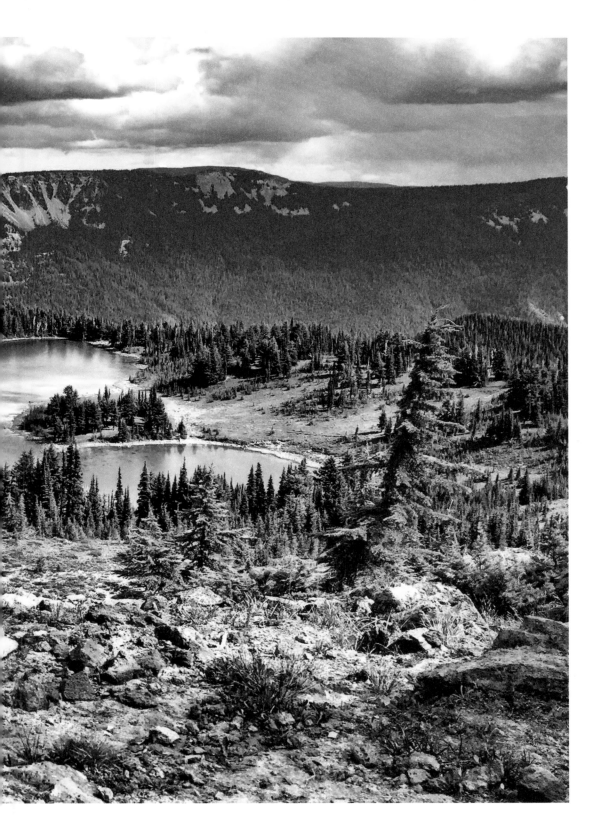

thru-hikes. She went by the name of Happy Feet, although she often complained about pain in her feet. She told me how she worked with asylum seekers in her homeland of Sweden half of the year, and spent the other half walking trails throughout the world. It was this mix, she said, that gave her a sense of balance. She had recently crossed Sweden three times from top to bottom: on foot, in a kayak, and on skis. Subsequently, she had been named Swedish adventurer of the year in 2015, hailed as an "ordinary person doing extraordinary things." She had dubbed her adventure *Trippelbandet* (the Three Ribbons): the green ribbon for the hike, the blue ribbon for kayaking the length of the coast, and the white ribbon for skiing the length of her nation. She managed to complete the three ribbons together with her two dogs within a year. What an incredible way to discover your own backyard. "Traveling in your own country is seriously underestimated," she said with a big smile.

I absorbed all these stories like a sponge and hoped to transform my own life into something different when I returned home. In my absence, Herminia had already made a start by converting our old bicycle shed into a bed-and-breakfast. She had turned it into a shining, white hotel room with its own bathroom, catering to the many tourists that come to Amsterdam each year. Thanks to her frequent guests, that one room now covers the mortgage interest for our entire

house, and we can also slowly start paying off our mortgage debt. I honestly looked forward to finding more creative ways to do more with less.

And why not start now, here on the trail? I decided to get rid of a lot of unnecessary stuff I was carrying. I filled a postal box with my excess trousers, fleece sweater, windbreaker, socks, and half of my first aid kit. I sent it ahead to Canada. Why not try this minimal living out on the trail and experience what a lighter, freer life could mean? It was actually surprisingly liberating to head into the mountains with less stuff on my back. Unpacking became a lot easier each night. I should've done it months ago.

The Impatient Man

Mile 2,500

"The last one to Canada wins," Goldie always said. Yet I hastened to reach Canada as quickly as I could. I am not a patient man. On the contrary, I'm very impatient, a quality I am not particularly proud of, but one that is difficult to shake. I often rush through life.

Life on the trail was relatively easy with just one single deadline: reaching Canada before the snow fell. But even there, my impatience occasionally came back to haunt me. Fortunately, there were always lots of young people nearby who could put things into perspective: "Relax. Try something new. Go with it. Everything will be fine."

I made a vow to myself to become more flexible and let go of my preconceived plans more often. Perhaps it's just me, but I get the impression

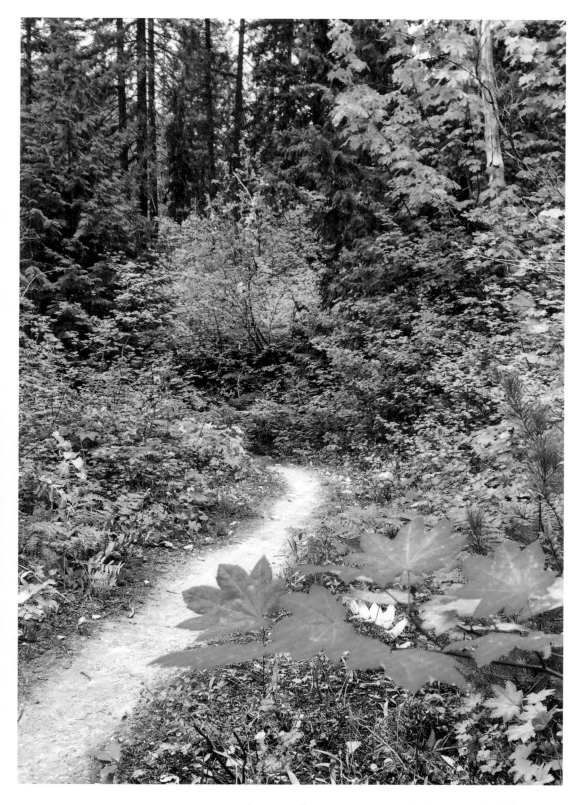

Autumn leaves, near Winthrop, Washington.

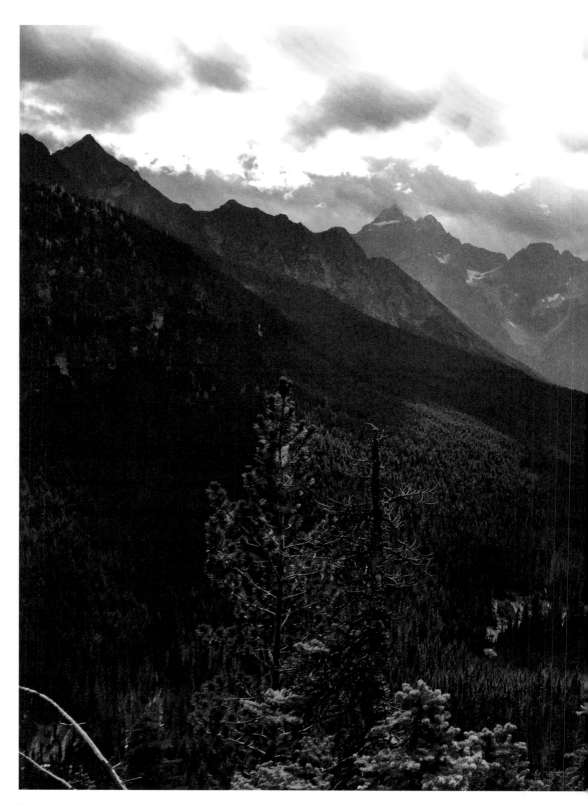

Days after crossing Rainy Pass, I see Canada
in the distance for the first time.

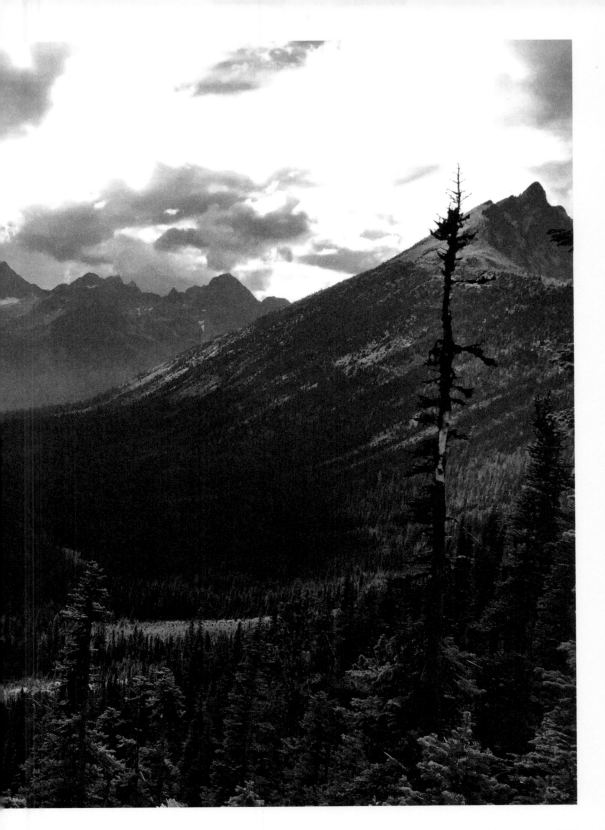

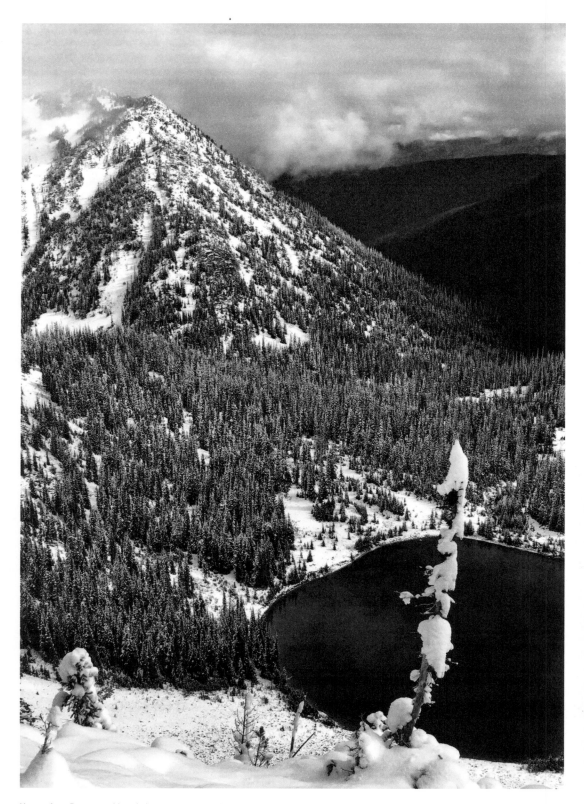

Hart's Pass, Washington, only a few miles
from the Canadian border.

that lots of people slowly become rigid and inflexible as they get older. It is almost as if we slowly find it harder and harder to adapt to unexpected changes. It is never too late to improve yourself, and it is always a choice whether you want to go through life grumpy or joyful. Life is short, no time to waste. You choose the lens you want to see the world through. I used to frequently say that I hated surprises. Well, I've decided never to say that again, to let surprises enter my life a little more. It would be great if I could hold onto this feeling after my trail, if I could become much more flexible at home. Perhaps we should all stop to swim in the lakes of life more often.

Canada

Mile 2,650

The last week of the trail was strange. Conflicting emotions flowed through my body and soul. On the one hand, I couldn't wait to see my family again after six months, but on the other hand, I felt sad to leave the trail and friends behind so soon. I could already feel the longing for this simple existence. Oh, how I would miss sleeping under the stars and drinking from the rivers. It would probably be harder than I could anticipate to leave the wilderness behind me. I would also miss being alone. The peace and simplicity of being alone in silence for days resounded in my mind. I had tasted what it meant to be alone in nature for a while, something I had never experienced before, and which I now longed to give a more structural place in my life.

On the penultimate day, I was struck by a snowstorm that lasted into the night. The wind howled throughout the day, dumping more than six inches (15 centimeters) of snow around me. My beard, which had grown as long as the snow was deep, froze solid in the process. I put on all the clothes I had with me, wore my sleeping socks as gloves, and put my feet in ziplock bags to prevent them from freezing off. I hadn't been this cold the entire journey. This was clearly a message from the trail, letting me know who was boss. "Don't ever forget me," she hollered. For the first time I could see the Canadian mountains stretching out in the distance in front of me. With no more than 20 miles (32 kilometers) to the border, tears gently rolled down my cheeks. It was somehow an emotional moment.

That night, I set up my tent for the very last time in the howling wind. I peeled off my soaking clothes layer by layer and crept into my sleeping bag to restore my temperature. I was exhausted and could not believe that the following day it would be over after all those months.

It was a beautiful, radiant day when I rolled up my tent for the last time. I walked through an enchanting, white world, realizing that I couldn't have reached the border two weeks later because of the excessive snowfall that was to be expected. The trail would have become thoroughly impassable and dangerous. I had arrived at my destination in the nick of time.

The Pacific Crest Trail hadn't disappointed me in any way imaginable. She was

indeed the queen of all trails. I had lived in a totally different world, but had it really changed me? Physically, I had definitely changed. I had lost almost 19 pounds (9 kilograms) of body weight and could count each of my ribs. There were only 148 pounds (67 kilograms) of me left, so I would have to eat a ton when I got back home. And my feet had grown nearly two sizes up. But for the most part, it didn't feel like I had totally changed into something new. It was more that I had rediscovered myself, childlike, my eyes re-opened and looking at the world in wonder. I was happy and naive again, like the goofy pup I used to be. I felt confident and full of bold ideas. I could feel my emotions had resurfaced, allowing even the smallest events to make an emotional impact on me. I had become that curious boy who loved listening to strangers' stories once again. What struck me most was that I had reconnected with my fantasy and ignited my imagination. Each day I had painted or written stories. The people I met had triggered something in me, inspired me with new ideas. I was eager to learn and experiment, develop my writing, perhaps create a fashion brand, and redesign my life on a frugal basis.

> **I had become that curious boy who loved listening to strangers' stories once again. What struck me most was that I had reconnected with my fantasy and ignited my imagination.**

Everything moved slowly. I had slowed down, lost my haste, and felt a new sense of time. I woke when the sun came up and went to sleep when it got dark. The days melted together, and I moved without any notion of what day of the week it was. Completely engulfed in the present, I was able to focus on the necessities of health, food, and a safe shelter. At times I was a secluded hermit, solely in the company of my own thoughts. I discovered that solitude didn't drive me crazy and that, in fact, I thoroughly enjoyed spending time alone.

> **It would only be when I had returned home that I could truly see what lasting effects the trail would have on me. I couldn't wait to discover what would stick and what would fade.**

As time progressed, I also gradually lost all sense of age. In some ways I felt timeless, but also younger, since I primarily hung out with the youngsters. Genie once remarked that she felt as if she was having breakfast with an overexcited child. "Calm down, you're all over the place, Van Go. Where is this story going?" she asked. I chose to take this as a compliment. It's sometimes hard to follow my line of thought, because I can sometimes get carried away, flying off on minor tangents. Nevertheless, it was great to shake off that somewhat grumpy, stressed-out side of me.

It would only be when I had returned home that I could truly see what lasting effects the trail would have on me. I couldn't wait to discover what would stick and what would fade. What would remain of the relaxed attitude I had developed during my journey? It was hard to predict from my perspective in the mountains.

As I walked the final few miles, all the memories of the trail came flooding back, perhaps something like the film people see in a near-death experience. Flashes of dusty deserts, cactus flowers, mountain rivers, rain, and snow, but especially the wonderful people I had met, powerful new friendships and emotions. For months my life had been primitive: walk north,

provide food, find water, create shelter, sleep, and look after my body and mind. Canada had been a clear goal that had always been very far away, giving me plenty of time to think and relax.

I descended deep into the last valley, leaving the snowline behind me. I walked through the muddy forest, where I finally reached the border. In a small clearing in the woods, I saw the Northern Terminus. I had reached Canada after almost six months on the trail. I gave the thick Terminus poles a hug and sat on the ground. I was exhausted, felt empty. What an anti-climax. Yet I was also relieved that it was over. I opened a small bottle of cinnamon whiskey and drew a cross across my chest, pointing to an imaginary moon in the sky. I downed the drink in one go. It was my way of giving thanks to the moon for watching over me during my journey.

After some time, I walked up to a nearby tree, got out some duct tape, and strapped three plastic bags filled with Trail Magic to it. It was a sentimental farewell gift to my three friends hiking a few days behind me. A surprise package full of silly things I had bought a week earlier in a thrift store. I had made a personal painting for each of them to say goodbye. For Jetfighter, I had printed a T-shirt with her trail name on it and made a cap printed with her motto, "ultra lazy." For Genie, I had bought an old lace blouse straight from *Little House on the Prairie.* And for Goldie, an iron horseshoe, because he always seemed to have a lucky charm. From day one, a remarkable bond had developed between us. Goldie had been able, amongst very few people in my life, to see right through me. He took all my whipped up, enthusiastic stories with a thick grain of salt and invariably referred to me as Dickhead. In some ways, he was a younger version of myself. I recognized his big mouth, his irritatingly enthusiastic attitude, somewhat naive but always positive. He had this unpolished bravado about him, was hopelessly idealistic, and had big,

romantic dreams to improve the world. Thanks to this 18-year-old, I was able to rediscover who I used to be.

With six million steps, I had managed to reach Canada in one piece. It felt like I had gone through a wild romance with the wilderness. I knew my heart would bleed now that it had come to an end.

Five Measurable Goals

5 ×

In my attempt to hold on to my newly-acquired attitude, I devised five goals with clear, measurable attributes. This way I could look back after a year had passed and fairly determine whether I had developed and achieved these personal goals.

The five goals I came up with were:

1. Become more flexible
2. Go on micro-adventures with my children
3. Live a frugal life
4. Write a book
5. Hike more trails

Become More Flexible
My primary goal was to become more flexible in life. I hoped to develop into a more patient person and enjoy living in the present. But also, to simply become a more pleasant companion at home. I hoped to achieve this by slowing down a few notches, being more aware of my rigid attitude, and becoming open to unexpected

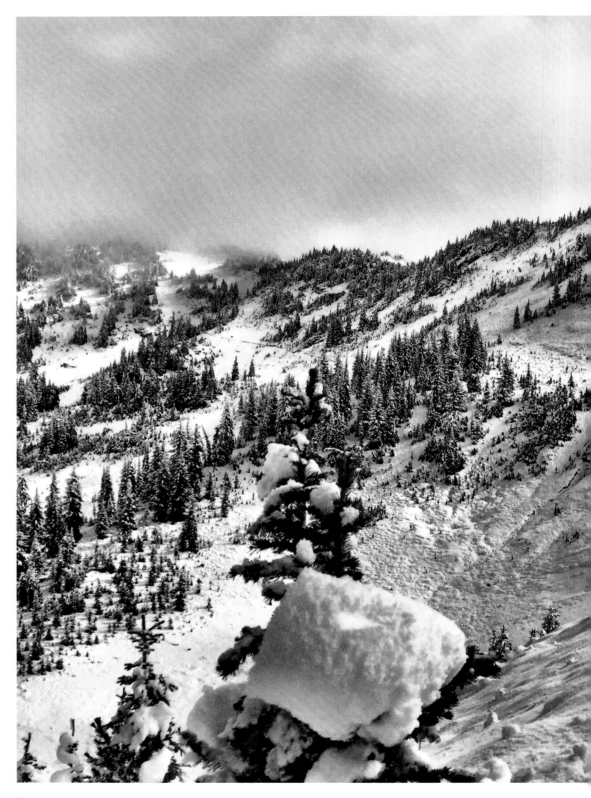

The final descent from Castle Pass to the
Northern Terminus at the Canadian Border.

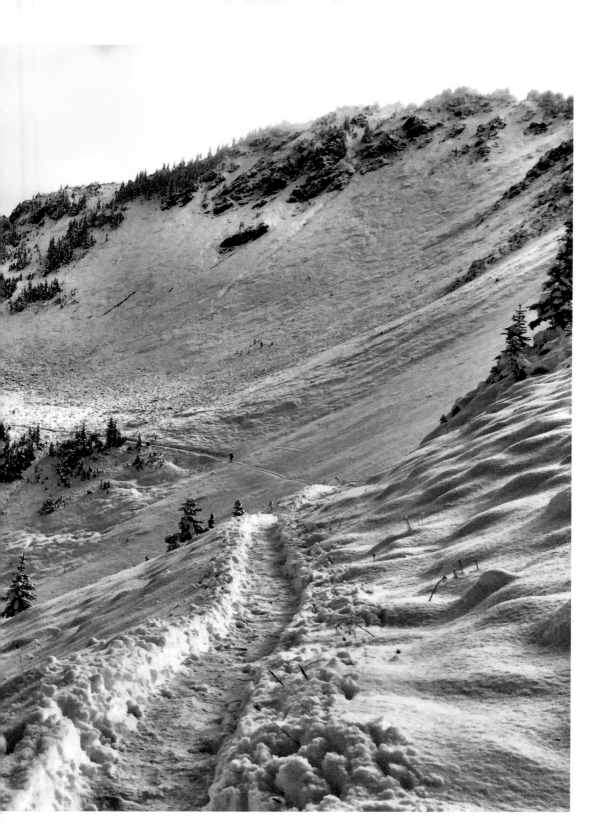

changes in my daily life. Basically, try to be less tenacious about all my plans.

It is one thing to be all zen on top of a mountain with admirable intentions, but it is something completely different to actually implement them in the commotion of daily life. Back home, it proved to be a lot harder than I thought. I tried to be less absent when I got home from work, since my thoughts usually continued to grind over the latest project. But I made a conscious effort each day to go along

> It is one thing to be all zen on top of a mountain, but it is something completely different in the commotion of daily life.

with other people's ideas instead of always pushing my own plans forward. I had good days and bad days. What struck me most was that there always seemed to be a choice between my old, rigid ways or to let go and let the circumstances guide me to unexpected places. I saw that I could choose who I wanted to become. It was up to me. It was difficult to stay focused at times, however, and I found it tough to remain relaxed at work when the stress levels rose. Luckily, there was always my family, patient as ever, to give me a reality check. I started drinking less coffee, ate less meat, worked out, and frequently swam in a nearby river, rain or shine. The occasional joint in the evening as the sun set brought the fond memories of the trail flooding back.

Micro-Adventures with My Children
As a family we often went out on day trips to the beach or the city, but rarely did I do something separately with one of my children. It simply wasn't a custom to regularly do things separately. But time flies, and before you know it, the kids will have left home. I wanted more quality

time, nature, and adventures with each of them. So I decided to go on micro-adventures with each of them, every month of the year. Nothing big or fancy, just time to share stories and connect. These one-on-one moments allowed for different conversations than the usual banter in the family dynamic, and perhaps my relationship with each of them could then develop in unexpected new directions.

As soon as I got home, I initiated the first of our monthly adventures. I went stealth camping for a night in a nearby field with my youngest son. We cooked dinner over a campfire. We went on short boat trips or visited an unfamiliar city to search for Pokémon. Sometimes we would just spend an afternoon playing pool in Amsterdam or kicking a ball around on the nearby soccer field. It was during these small adventures that I got a better understanding of his thoughts, through our one-on-one talks. My middle daughter and I often went shopping

> They're usually short, affordable little adventures. It didn't really matter what we did or where we went. Out into nature, down to town, by day or at night. It was about the time and attention.

in the city or scavenged through thrift stores looking for unique items. The great thing was that, not long after, she started her very own little side-business reselling trendy second-hand clothing to teenagers online, earning quite a healthy profit.

It wasn't always easy to arrange a date with my eldest daughter due to her busy teen schedule, but she made an effort, and I frequently got my time slot. We decided that road trips

were the thing for us. Staring at the road ahead, listening to music, with long conversations about school, life, and future dreams. As the Netherlands is pretty small, we decided to go on a tour and visit each of our 12 provinces in search of the best steak in the country. We drove three hours north to stay the night at my old student house in Groningen, and we found a great affordable steak in town. During these road trips, I grew to see a different side of my daughter and was grateful for these moments, seeing that she would soon be leaving the family home. It didn't really matter what we did or where we went. Out into nature, down to town, by day or at night. It was about the time and attention.

They're usually short, affordable little adventures. Sometimes I come up with a plan and sometimes they suggest an idea. I sure hope to keep these micro-adventures going for as long as I live.

Live a Frugal Life

Like many people, my ultimate goal is to be free. Debt-free. Many of us have become slaves to debt, and I am no exception to this trend. Mortgages often absorb more than a third of one's income, obliging us to work until the bitter end in order to repay the bank their loan and interest. My new goal was to start living as economically as possible, to try to pay off my mortgage sooner rather than later. My initial idea was to buy no new products for an entire year, solely depending on second-hand thrift stores. However, I soon found that you can't get second-hand food, gas, and light, and subsequently was unable to strictly follow my newly created rules. Fortunately, I have always been a fan of thrift stores, so it was not a huge punishment to live cost-effectively. I wanted to make it a fun, creative experiment instead of a serious, pretentious, eco-warrior-save-the-planet thing. When I called home to share the idea with my wife, I guessed she would probably

be up for it. Being frugal is second nature to her, and she immediately started making plans to see where we could save.

"Perhaps we should shower in the dark," she laughed, "or flush the toilet with the bath water." But I knew this could perhaps soon become my reality. We could stop eating out, buy fewer gadgets, drive less, and take the bus. By cancelling all our monthly subscriptions, we could find new, cheaper providers elsewhere. Every little penny would help towards our new goal.

It is an understatement to say that the kids weren't all that impressed with this new philosophy. But all in all, it felt good to have started this experiment towards a new lifestyle.

On arriving home, I reveled in my new, thrifty lifestyle. I scoured the bottom shelf of the supermarket, searching for inexpensive products and bargains. I took the bus to work more often, no longer bought superfluous stuff, and weighed up every decision, whether I really needed something new or not. Across the board, I just spent a lot less than previously. We managed to make the family holidays financially neutral by renting out the house, and we bought as much as we could at thrift stores. Yet it was harder than I had anticipated to actually stop spending money. Especially when eating out with friends, I found it quite challenging to be the only one sticking to soup and bread. And at times, I slipped back into my old habits altogether, especially when I was out on the town with my friends. It is an understatement to say that the kids weren't all that impressed with this new philosophy. But all in all, it felt good to have started this

experiment towards a new lifestyle, on our road to a debt-free life. Even though there are still lots of steps to be taken.

Write a Book

During the trail I had painted and written practically every day. I wondered how I was going to maintain this creative flow, because life would only get fuller on my return to society. I wanted to find a way to incorporate these activities on a structural basis and decided that a book would be the best way to bring them together.

Excited by the prospect of this new project, I set about writing down my thoughts and composing the first stories. However, I soon discovered that painting with words was a totally different ball game than with colors—and it took five times as long too. A whole new world unfolded itself to me, and I explored all kinds of narratives and styles. In my profession as an art director in the advertising industry, I have always had to focus on the visual side of storytelling, through film, photography, and illustrations. From an early age, my spelling had always been atrocious, which I mistakenly attributed to my bilingual upbringing in England and Holland. I consequently never mastered either language perfectly. Completing this book was therefore an enormous adventure, fairly similar in some ways to walking from Mexico to Canada. An adventure full of ambition and dreams, but also one of unexpected turns, lessons, and uncertainty. But I wouldn't have missed it for the world.

Hike More Trails

With hiking, I had found a new purpose in my life. Temporarily isolating myself within nature had become a welcome addition to my busy life, and I felt fully revitalized when I returned home. The perpetual rhythm of walking 70,000 steps a day formed an inner cadence, culminating in a meditative trance. Scientists claim that this continuous movement between the two halves of your brain leads to new, inventive ideas. It is no surprise that creative entrepreneurs like Steve Jobs always went for a walk to brainstorm or discuss important business. Beethoven, Goethe, and Darwin also took long walks to come up with new ideas or develop their concepts. Stanford University published a study in 2014 which showed multiple advantages of regular long-distance walking. Apart from the fact that it's free and that being in nature is generally seen as pretty healthy, the study claims that active walkers have significantly lower risk of cardiovascular disease, colon cancer, breast cancer, and dementia. Walking as little as 30 minutes a day showed a serious health benefit.

Sitting is the new smoking. Businesses are implementing "meetings on the move" and "walk-and-talk job interviews." In recent years, countless people have put on their hiking boots to embark on a pilgrimage, to follow a calling, heal a broken heart, or recover from a burnout. I am thoroughly convinced that hiking, spending time alone, and disconnecting from society can help the process of healing. But I also believe that hiking can actually prevent certain issues, such as burnout and certain forms of depression.

I had found a new purpose in my life. Temporarily isolating myself within nature had become a welcome addition to my busy life, and I felt fully revitalized when I returned home.

Burnout is currently the number one occupational disease. Recent statistics show that, in a given year, more than 14 percent of Dutch employees suffer from burnout symptoms. Approximately five percent of my country's

workforce is home on absent leave for an average of 242 days per year. Fortunately, our socialized healthcare system means that most can recover at home while they continue to get their monthly wage. Some articles now refer to the U.S. as the United States of Burnout, as millions of people are forced to work two jobs to make ends meet. It is difficult to compare the States to the Netherlands, but there can't be that many differences in stress levels at work on either side of the pond. In response to this epidemic, more and more companies and governments are creating new policies to address this issue. After all, it's costing them millions. After a number of loyal years of service, employees are awarded several months of paid leave to recharge their batteries, often returning reinvigorated, instead of job-hopping to the competitor. In Australia, it is actually regulated by law with "Long Service Leave," where every employee automatically receives lengthy paid leave after a number of years at a given company.

It might actually be healthy to go for a walk for a few days each year to perhaps prevent a latent burnout yourself. But be warned, it is extremely addictive, and before you know it, you will have quit your day job to walk from Mexico to Canada. But there are no package tours or cruises that go that way, so you will have to figure it out by yourself.

The six months on-trail had given me a lot of new insights. Was it possible to make these trails a structural part of my life, instead of a sporadic sabbatical? The idea of regularly alternating between society and nature gave me a sense of peace. But how? I didn't quite know how I would organize and finance it yet, but I decided to walk trails more regularly. Both alone and together with my wife. Life is too short to postpone dreams. Hopefully my new frugal lifestyle would also contribute to creating a different balance between work and adventure. Perhaps I could find a way to create a new routine of nine months on

and three months off in nature. Crazy, perhaps, but this way, both worlds would remain equally compelling and inspiring. And even if nothing came of my new resolutions, at least the trail had made me fitter than I had ever been. So, in order not to fall back into my old bad habits, I signed up for the Amsterdam Marathon, which was exactly two weeks after my return. After all, I had walked a marathon practically every day, and how different could running it be? It was worth a try. I did a few practice runs building up to the event and managed to complete my first marathon in 4 hours and 18 minutes on my trashed trail runners.

It might actually be healthy to go for a walk for a few days each year. But be warned, it is extremely addictive, and before you know it, you will have quit your day job to walk from Mexico to Canada.

My wife and I can't run off and hike long-distance trails together at present, since we have three school-aged teenagers to look after. So we alternate. Shortly after my return, Herminia left to hike the Camino de Santiago by herself for the sixth time. We are currently experimenting with a new balance between work and hiking in our lives. Meanwhile, the children have also gradually gotten used to this new rhythm. They don't act surprised when their father heads off again for a while. My youngest son sometimes teases me by asking, "Mom, who's that unemployed hobo who cuts the roast once a year?"

Call me stupid, egotistical, blind, or just damn lucky, but after a year of work and the comforts of society, I left for New Zealand's Te Araroa Trail to be alone again. I started the trail solo and once again found the first days to

be a little scary and exciting. But within days I had made new friends with whom I hiked across the mountains. The Te Araroa stretches 1,875 miles (3,017 kilometers) across New Zealand's two volcanic islands, and it took me five months to complete. The country definitely lived up to its reputation. It turned out to be just as stunning as people had said.

Family

Home

When I settled back into the family rhythm, I soon realized that my role in the family dynamic had slightly shifted. This should have come as no surprise. After all, I had been gone for six months, and the family had moved on and developed in my absence. Everything had gone perfectly smoothly without me around—husbands are so overrated—and on my return there was suddenly a lot less space for my somewhat strict rules and upbringing. Quite a healthy development really, especially for myself. I had to readjust and adapt to my maturing teenagers; I found it to be a great test of my new flexible attitude. Time will tell, but if the positive vibes in the house are anything to go by, perhaps I have become a slightly better person to live with. One day my eldest daughter said, "When you're home now, you're actually really here." Ever since I had returned from the PCT, she felt I was actually present and gave her my full attention. Before the trail, for the most part, I was constantly preoccupied with work when I got home. My daughter used to always tease me by nonchalantly saying, "Can you please pass me the peanut butter, and oh, by the way, I'm pregnant and am moving out next week. Is that OK?" Absently, I would reply, "Yeah, fine."

Fortunately, there had never been any tension or grudges between me and my wife regarding the trail, which I believe had a positive effect on the children. However, it wasn't always that easy for the kids. My youngest son found the last month really tough. The first five months had flown by effortlessly for him, but as my homecoming approached, he was done with the whole thing. Dad had to come home. I also missed him terribly and yearned to hold him in my arms. It was perhaps even more agonizing when my daughter split up with her boyfriend. Damn! I felt like a bad father that day, unable to console her, far away on the other side of the world. You could argue there is not much a father can do to

help his daughter in these kinds of situations, because it's mainly her friends that will comfort her and hear her out. But that's not the point. I felt dreadfully guilty that I wasn't there for her at this significant moment in her young life. She later told me that she had found it difficult that I wasn't home at the time, because she felt I was now less able to understand the nuances and effects the split had had on her. During our lengthy road trips, we took the time to talk it out, and I was proud that she had the strength to confront her old man with it.

My absence certainly had quite an impact, but I dare say no one suffered any permanent damage. They have come to see and appreciate that having a relationship doesn't always necessarily mean that you are constantly together. Like many kids their age, my children are not big fans of hiking. And I don't see them heading off on some lengthy trail any time soon. They even find a short family walk in the woods awfully boring. But I sincerely hope that perhaps later in life they will dust off their boots and venture into the wilderness.

"When you're home now, you're actually really here." Ever since I had returned from the PCT, I was actually present and gave my family my full attention.

There has also been a slight shift within my relationship with my wife. We have discovered that we can do pretty well without each other, but that life together is a lot more fun and special. One plus one equals three. Still going strong after 22 years. I find it to be a powerful expression of love and trust to give each other time alone. Having someone at your side in life is great, but the cypress and the oak tree cannot grow if they stand too close to one another. In my opinion, you cannot flourish in each other's shadows. Occasionally one needs time and space alone. To be honest, I think it would be great for everyone to take some time to be on their own. Don't wait until you are struck by burnout or find yourself in a troublesome situation. Consider it preventative. Start out with small, short day trips alone, and you will be surprised what comes your way. Time and distance create space for a new perspective. The combination of physical endurance and an empty mind is magic.

Last but Not Least: Let's Talk About *You*

Is hiking something for you? Perhaps six months away from home is a little too impractical and crazy for your liking, but would you enjoy some time alone on the trail? There will probably be countless fears, obstacles, and issues you will face regarding traveling alone into the unknown. But this should not deter you from trying. What could possibly go wrong? I highly recommend it to anybody. It is no magic potion to cure and solve all your problems, but it can be a strong catalyst to help you to see things in a fresh perspective. Personally, I found the trail has opened numerous new doors in my life.

The trail will challenge and perhaps even change you a little. You will probably discover that you can achieve a lot more than you initially anticipated, both physically as well as mentally. And who knows, you may even stumble upon a few spiritual questions along the way.

"But where do I begin?" you may be thinking. "Am I fit enough? What gear do I need? Can I get extra days off? It probably costs a fortune. I'll go crazy within a few hours of being by myself." But the hardest part of the entire trip will likely be the decision to actually go out and do it. Funnily enough, all the steps that follow will naturally fall into place once the decision is made.

My advice is simple: start small, start soon, and don't postpone. Life is short. Time is precious. The world is waiting.

For the Americans among you, my proposal would be to drive to the nearest national park and do a multiple-day hike, sleeping out in the woods. Get some affordable gear and follow one of the marked loops. The great thing is that walking is free and you are allowed to camp freely practically wherever you want. Just ask the park ranger for some advice—they are great sources of knowledge. Start today by marking a date in your calendar within the coming six months and get yourself some trail runners. The great American outdoors is something we Europeans are super jealous of, so go out and enjoy your own backyard. It's amazing!

My advice is simple: start small, start soon, and don't postpone. Life is short. Time is precious. The world is waiting.

For the Europeans among you, my suggestion would be to go on a six-day hike along the Camino del Norte, which runs across the Basque coast in Spain. All you need are some trainers, a sleeping bag, a rain poncho, a small backpack, and a ticket to Bilbao. Of course, it depends where you're flying from, but there is usually a ticket for around €100 (ca. $115) to get you there. Then take the bus from Bilbao to San Sebastián and walk 78 miles (125 kilometers) in six days along

the beautiful Basque coast back to Bilbao. 15 + 12 + 14 + 15 + 13 + 9 miles (25 + 18 + 23 + 25 + 21 + 14 kilometers). It's that simple. The Camino del Norte route has many advantages over the traditional Camino Frances, which also goes to Santiago de Compostela. There are far fewer people on the north route but still enough to not feel lonely. The Camino del Norte is also a lot more pleasant during the extremely hot summer months in Spain because there is always a fresh breeze blowing in from the sea. Enjoy the picturesque coastal villages. Relish the delicious tapas and wine on the local town square after a refreshing dip in the sea.

Whatever you do, start by writing your departure date in your calendar now, and don't forget to send me a postcard when you hit the trail. I would love to get a small taste of your future adventure.

So what are you waiting for? The trail awaits.

— CANAD

A Word
of Thanks

First and foremost, I would like to thank all the hikers and Trail Angels that I met along the trail. It was these wonderful people who made the trail magical.

I would particularly like to thank my wife, Herminia, for all her editorial advice, always giving me realistic feedback. I simply could not have written the book without her guidance. But more importantly, I couldn't have hiked the trail without her blessing and support, and I am eternally grateful for the freedom she gave me.

My gratitude also goes out to my mentor, René Boender, who believed in my story from the start. He motivated me to publish and think big.

A special thanks to Goldie and Jetfighter for reading through the manuscript to filter out all the BS and for their valuable feedback. Thanks also to Pascal Boogaert, who meticulously read the very first version of the story.

I am very grateful to Robert Klanten and Maria-Elisabeth Niebius of Gestalten for believing in the story and helping me to improve it and take it around the world. It was Jessica J. Lee who helped me refine the text and take it to another level— thank you so much.

I would also like to thank Martin Fontijn, Annemie Michels, Majelle Wams, and Lynn Plagmeijer for creating the Dutch version with me. I am greatly indebted to Krijn van Noordwijk for the amazing portrait that he photographed for the cover. Special thanks go to Seth Orme and Amy Morin for allowing me to quote them and reference their inspiring work. I would also like to thank Claude Ludovicy for contributing photos of Forester Pass.

Finally, many thanks go to Huib Maaskant, Carlo Groot, Pieter van der Heuvel, Nils Adriaans, Baukje Brugman, Christine Dedding, and Char Polak for their advice. I would also like to posthumously thank Eefje Brugman for the encouragement she gave me to tell and publish this story.

Sources

Gear List
All measurements converted with:
www.kilograms-to-pounds.com

Surviving on a Snickers
Hummingbird's food list on her blog:
www.followingthearrows.com

Quitting
Coffey, Maria. *Where the Mountain Casts Its
 Shadow: The Dark Side of Extreme Adventure.*
 New York: St. Martin's Griffin, 2003.

Coffey, Maria. "Survivors."
 Outside Online. September 1, 2003.
 www.outsideonline.com/
 1909491/survivors

The Mental Game
Morin, Amy. "13 things mentally
 strong people don't do."
 www.amymorinlcsw.com/
 mentally-strong-people

Ultra-light or Ultra-cool
Grandma Gatewood:
www.wikipedia.org/wiki/Grandma_Gatewood

The album that Necktie (aka Piers Ellison)
made in Bishop, *California:*
www.soundcloud.com/piers-ellison

What Does It Cost to Hike the PCT?
If you would like to learn more
about my gear list, please check out:
www.lighterpack.com/r/ajxm9r
www.randomtrailtales.com

What If I Die Tomorrow
The Up Series. Directed by Paul Almond and
Michael Apted. ITV and BBC. 1962–present.
www. wikipedia.org/wiki/Up_Series

Walking in Silence
Klamath tribe:
www.craterlakeinstitute.com/online-library/
historic-resource-study/4d.htm

Time Alone Is Good for Your Relationship
Gibran, Kahlil. *The Prophet.*
 New York: Alfred A. Knopf, 1923.

Painting for Malala
The Malala Fund builds schools,
pays teachers, and reimburses
school fees for girls around the world.
Feel free to give a donation at:
www. gofundme.com/2kyca8yk

Future Dreams
Thru-hike trails around the world:

Pacific Crest Trail
www. pcta.org

Continental Divide Trail
www. continentaldividetrail.org

Appalachian Trail
www. appalachiantrail.org

Canada: The Great Trail
www. thegreattrail.ca

Nepal: The Great Himalaya Trail
www. greathimalayatrails.com

Japan: 88 Temples Trail
www. shikokuhenrotrail.com

Spain: Camino de Santiago
www. oficinadelperegrino.com

Where Do You Leave Your Trash?
The Pack It Out Crew:
www. packingitout.org

Women of the PCT:
www. facebook.com/groups/581405101915686

Autumn and Winter at Once
Donahue, Bill. "Billy Goat's Never-
 Ending-Thru-Hike." *Backpacker*.
 November 28, 2016.
 www. backpacker.com/news-and-
 events/billy-goats-never-ending-hike

Five Measurable Goals
Oppezzo, Marily and Schwartz, Daniel L.
 "Give Your Ideas Some Legs: The Positive
 Effect of Walking on Creative Thinking."
 *Journal of Experimental Psychology:
 Learning, Memory, and Cognition 40,
 no. 4* (2014).

Wong, May. "Stanford Study Finds
 Walking Improves Creativity."
 Stanford News. April 24, 2014.
 https://news.stanford.edu/2014/
 04/24/walking-vs-sitting-042414

Tate, Andrew. "Why everyone from
 Beethoven, Goethe, Dickens, Darwin
 to Steve Jobs took long walks and
 why you should too." *Canva.*
 www. canva.com/learn/taking-long-walks

Burnout figures in the Netherlands in 2017:
 Tiggelaar, Ben. "Burn-out: beroepsziekte
 nummer één." *NRC.* January 27, 2017.
 www. nrc.nl/nieuws/2017/01/27/
 beroepsziekte-nummer-een-
 6413240-a1543324

Let's Talk About *You*
Camino del Norte:
www. santiago-compostela.net

Buy a credential for €2 at
www. santiagodecompostela.me
This is a pass that allows you
to stay at a hostel (refugio) every
eight miles (13 kilometers) for
between €5 and €15.

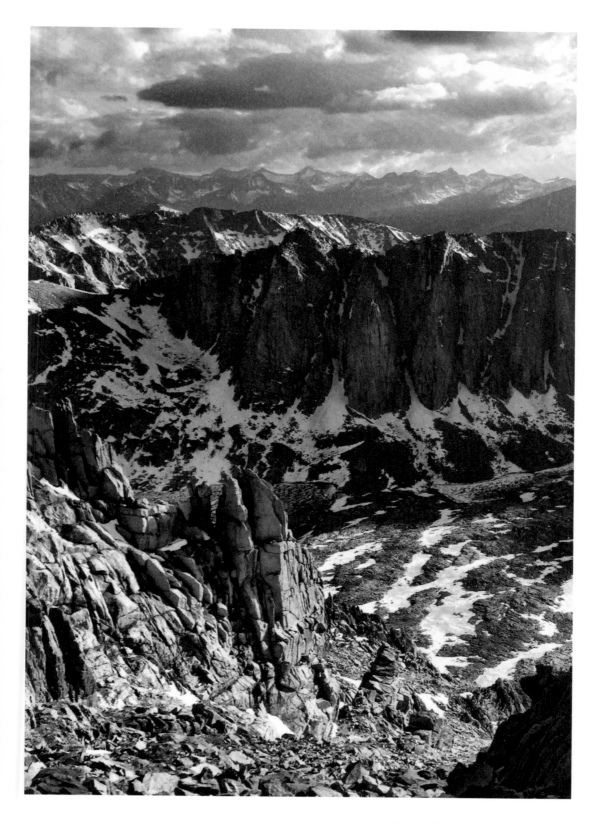

View from Mount Whitney.

About
the Author

Tim Voors has walked across countries and continents into the unknown. In addition to the Pacific Crest Trail, he has walked across New Zealand on the Te Araroa Trail (1,881 mi / 3,027 km), around the Japanese island Shikoku on the ancient 88 Temples Trail (815 mi / 1,312 km), and through Spain to Santiago de Compostela on the Camino de Santiago (437 mi / 700 km).

Tim lives near Amsterdam where he works in advertising as a creative director.

He has worked for Google, The North Face, and Nikon, among others. Tim is also a speaker and has given keynote speeches at the Creative Mornings conference and at leading companies in the Netherlands and beyond. He loves to inspire audiences with tales of ordinary people doing extraordinary things.

www.randomtrailtales.com
www.timvoors.nl
Instagram: @timvoors

THE GREAT
ALONE

Walking the Pacific Crest Trail
TIM VOORS

Text, photography, and illustrations by Tim Voors

Edited by Robert Klanten and Tim Voors

Editorial Management by Sam Stevenson

Design, layout, and cover by Stefan Morgner

Typefaces: Burgess by The Entente (Colophon Foundry) and Lars Mono by Mads Wildgaard (Bold Decisions)

Cover photography by Krijn van Noordwijk
Back cover photography and illustration by Tim Voors

Printed by Printer Trento S. r. l., Trento, Italy
Made in Europe

Published by gestalten, Berlin 2019

ISBN 978-3-89955-977-4

Respect copyrights, encourage creativity!

For more information, and to order books, please visit www.gestalten.com.

Bibliographic information published by the Deutsche Nationalbibliothek.
The Deutsche Nationalbibliothek lists this publication in the Deutsche Nationalbibliografie; detailed bibliographic data are available online at www.dnb.de.

This book was printed on paper certified according to the standards of the FSC®.

MIX
Paper from responsible sources
FSC® C015829
FSC
www.fsc.org

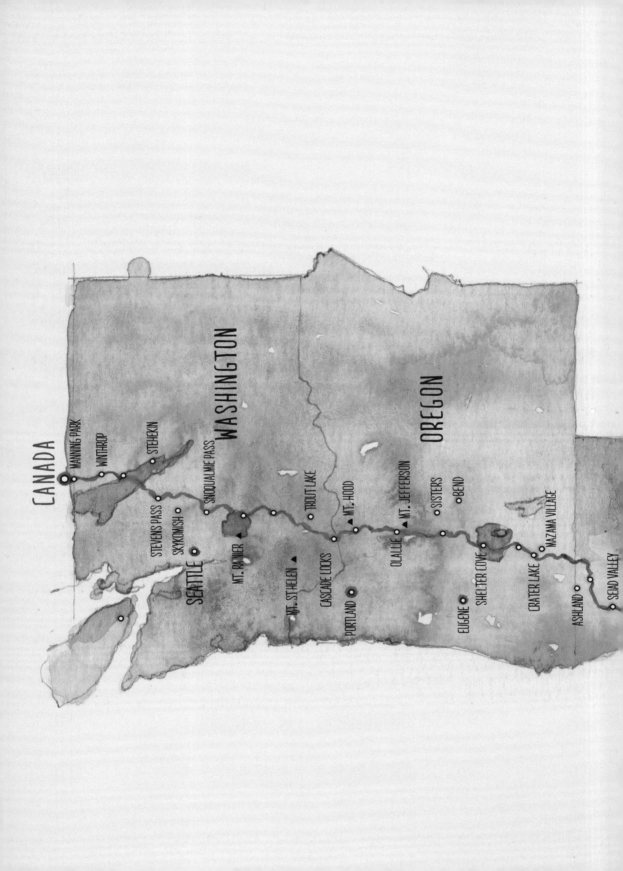

DATE DUE

JAN 0 4 1995

DEMCO, INC. 38-2931